WITHDRAWN

The
APPLE TREES
at OLEMA

Time and Materials: Poems, 1997–2005

Field Guide

Praise

Human Wishes

Sun Under Wood

Twentieth Century Pleasures: Prose on Poetry

Now and Then: The Poet's Choice Columns, 1997–2000

Poet's Choice: Poems for Everyday Life

The Essential Haiku: Versions of Bashō, Buson, and Issa

Czesław Miłosz, The Separate Notebooks (with the author, Robert Pinsky, and Renata Gorczynski)

Czesław Miłosz, Unattainable Earth (with the author)

Czesław Miłosz, Facing the River (with the author)

Czesław Miłosz, Provinces (with the author)

Czesław Miłosz, Road-side Dog (with the author)

Czesław Miłosz, Treatise on Poetry (with the author)

Czesław Miłosz, New and Collected Poems (with the author and various hands)

Czesław Miłosz, Second Space: New Poems (with the author)

Rock and Hawk: A Selection of Shorter Poems by Robinson Jeffers

Tomas Tranströmer: Selected Poems, 1954–1986

Into the Garden: A Wedding Anthology (with Stephen Mitchell)

The Addison Street Anthology: Berkeley's Poetry Walk (with Jessica Fisher)

Czesław Miłosz, Selected Poems, 1931–2004

Robert Hass

The
APPLE TREES
at **OLEMA**

NEW AND SELECTED POEMS

An Imprint of HarperCollins*Publishers*

HarperCollins books may be purchased for educational, business, or sales promotional use. For information, please write: Special Markets Department, HarperCollins Publishers, 10 East 53rd Street, New York, NY 10022.

FIRST EDITION

Designed by Mary Austin Speaker

Library of Congress Cataloging-in-Publication Data has been applied for.

ISBN: 978-0-06-192382-1

10 11 12 13 14 OV/RRD 10 9 8 7 6 5 4 3 2 1

For Brenda

Contents

Setup without the punchline:

Once there were two sisters called Knock Me and Sock Me;

"Why?" he asked. "Because she was lonely,

It is good to sit down to birthday cake

Stories about the distribution of wealth:

How Eldie Got Her Name

Punchline without the setup:

He had known, as long as he'd known anything,

Because she, not her sister, answered the door,

A Ballad:

She looked beautiful, and looked her age, too.

Two jokes walk into a bar.

In the other world the girls were named Eleanor and Filina,

from FIELD GUIDE

from PRAISE

from HUMAN WISHES

from SUN UNDER WOOD

from TIME AND MATERIALS

New Poems

July Notebook: The Birds

Sleep like the down elevator's
imitation of a memory lapse.

Then early light.

Why were you born, voyager?
One is not born for a reason,
though there is a skein of causes.
Out of yellowish froth,
cells began to divide, or so they say,
and feed on sunlight,
for no reason.
After that life wanted life.

You are awake now?
I am awake now.

<div align="center">✳</div>

In front of me six African men, each of them tall
and handsome, all of them impeccably tailored;
all six ordered Coca-Cola at dinner (Muslim,
it seems, a trade delegation? diplomats?);
the young American girl next to me
is a veterinary assistant from DC;
I asked her if she kept records
or held animals. A little of both,
she says. She's on her way to Stockholm.
The young man in the window seat, also American,
black hair not combed any time
in recent memory, expensive Italian shirt,
gold crucifix fastened to his earlobe,

scarab tattooed in the soft skin
between thumb and forefinger of his left hand,
is reading a Portuguese phrasebook.
A lover perhaps in Lisbon or Faro.
There should be a phrase for this passenger tenderness,
the flickering perceptions like the whitecaps
later on the Neva, when the wind
off the Gulf of Finland, roughens the surface
of the river and spills the small petals
of white lilacs on the gray stone
of the embankment. Above it two black-faced gulls,
tilted in the air, cry out sharply, and sharply.

✳

They are built like exclamation points, woodpeckers.

✳

Are you there? It's summer. Are you smeared with the juice of cherries?

The light this morning is touching everything,
the grasses by the pond,
and the wind-chivvied water,
and the aspens on the bank, and the one white fir on its sunward side,
and the blue house down the road
and its white banisters which are glowing on top
and shadowy on the underside,
which intensifies the luster of the surfaces that face the sun
as it does to the leaves of the aspen.

Are you there? Maybe it would be best
to be the shadow side of a pine needle
on a midsummer morning
(to be in imagination and for a while

on a midsummer morning
the shadow side of a pine needle).

The sun has concentrated to a glowing point
in the unlit bulb of the porchlight on the porch
of the blue house down the road.
It almost hurts to look at it.

Are you there? Are you soaked in dreams still?

The sky is inventing a Web site called newest azure.
There are four kinds of birdsong outside
and a methodical early morning saw.
No, not a saw. It's a boy on a scooter and the sun
on his black helmet is concentrated to a point of glowing light.
He isn't death come to get us
and he isn't truth arriving in a black T-shirt
chevroned up the arms in tongues of flame.

Are you there? For some reason I'm imagining
the small hairs on your neck, even though I know
you are dread and the muse
and my mortal fate and a secret.
It's a boy on a scooter on a summer morning.
Did I say the light was touching everything?

＊

After Coleridge and for Miłosz: Late July

I didn't go hiking with the others this morning
on the dusty trail past the firehouse,
past the massive, asymmetrical, vanilla-scented
Jeffrey pine, among the spikes of buckbrush

and the spicy sage and the gray-green ceanothus,
listening to David's descriptions of the terrifying
efficiencies of a high mountain ecosystem,
the white fir's cost-benefit analysis
of the usefulness of its lower limbs,
the ants herding aphids—they store the sugars
in the aphid's rich excretions—on the soft green
mesas of a mule ear leaf. I think of the old man's
dark study jammed with books in seven languages
as the headquarters of his military campaign
against nothingness. Immense egoism in it,
of course, the narcissism of a wound,
but actual making, actual work. One of the things
he believed was that our poems could be better
than our motives. So who cares why
he wrote those lines about the hairstyle
of his piano teacher in Wilno in the 1920s
or the building with spumy baroque cornices
that collapsed on her in 1942. David and the others
would by now have reached the waterfall.

There were things he could not have known
as he sat beside her on the mahogany bench,
that he could only have seen, or recomposed,
remembering the smell of her powder,
as a sixty-five-year-old man on another continent.
Looking out a small window at an early spring rain:
that, if she taught piano, she was an artistic girl,
that she didn't have family money, that she must have
dreamed once of performing and discovered
the limits of her gift and that her hair,
piled atop her head and, thickly braided,
wound about her beautifully shaped skull
(which the boy with his worn sheaf of Chopin études

would hardly have noticed) was formed
by some bohemian elegance and raffishness
in the style of her music-student youth, so that he,
the poet at the outer edges of middle age,
with what comes after that visible before him
could think unbidden of her reddish Belle Epoque hair
and its powdery faint odor of apricot
that he had not noticed and of the hours
she must have spent, thousands in a lifetime,
tending to her braids, and think that the young,
himself then with his duties and resentments,
are always walking past some already perished
dream of stylishness or beauty that survives
or half-survives in the familiar and therefore tedious,
therefore anonymous, outfitting of one's elders,
and that her gentility would have required
(the rain in green California may have let up
a little and quieted to dripping in the ferns)
the smallest rooms in the most expensive quarter
of the city she could manage—he'd have recalled
then rows of yellow bindings of French novels
on her well-dusted shelves—and this was why
he visited her in that gleaming parlor room
on the Street of St. Peter of the Rock, and why,
he would hear years later in a letter
from a classmate, the stone that crushed her
was not concrete or the local limestone,
but pure chunks of white, carefully quarried
Carerra marble. Something in him identified,
must have, with the darkness he thought
he was contending against. A child practicing
holding its breath, as a form of power,
a threat (but against whom? To extort
what?). Or a lover perfecting a version

of the silent treatment from some strategy
of anticipatory anger at the failure of love.
So he may have had to rouse himself
against the waste, against the vast stupidity
and cruelty and waste and wasted pathos,
to hear the music in which to say that he'd noticed,
after all the years, that her small body
had been crushed expensively. One summer
by that waterfall I saw a hummingbird,
a calliope, hovering and glistening
above the water's spray and the hemlock,
then dropping down into it and rising
and wobbling and beating its furious wings
and dropping again and rising and glistening. The others
should be there by now, and it's possible the bird
is back this year. They'd have made their way
down the dusty trail and over the ledge of granite
to the creek's edge and that cascade of spray.

<div align="center">✳</div>

<div align="right">For C.R.</div>

What do you mean you have nothing?
You can't have nothing. Aren't there three green apples
on the table in an earth-brown bowl? Weren't there
three apples for three goddesses in the story
and the fellow had to pick—no, there was one apple
and three goddesses, as in the well-known remark
that all of politics is two pieces of cake
and three children. Aren't there three yellow roses
on the counter in a clear glass vase among purple spikes
of another flower that resembles a little
the Nile hyacinth you saw in lush borders
along the green canal at Puerto Escondido?

Do you remember Juan called them "Lent flowers,"
which made you see that the white gush of the calyx
was an eastering, and you looked at Connie
with her shaved head after chemo and her bright,
wide eyes that wanted to miss nothing,
and do you remember that the surface of the water
came suddenly alive: a violent roiling and leaping
of small fish, and Juan, pointing into the water
at what had got them leaping, shouted "Barracuda,"
and that the young pelicans came swooping in
to practice their new awkward skill of fishing
on the small, terrified, silvery river fish? And
the black-headed terns, a flock of them,
joined in, hovering and plunging like needles
into the churning water? All in one explosion:
green lagoon, barracuda, silver fish, brown pelicans,
plunging terns, Juan's laugh, appalled, alive,
and Connie's wide blue eyes and the river smell
coming up as the water quieted again. Of course,
there were three apples, one for beauty,
and one for terror, and one for Connie's eyes
in the quiet after, mangrove swallows in the air,
shy, white-faced ibises foraging among the hyacinths.

※

Late afternoons in June the fog rides in
across the ridge of pines, ghosting them,
and settling on the bay to give a muted gray
luster to the last hours of light and take back
what we didn't know at midday we'd experience
as lack: the blue of summer and the dry spiced scent
of the summer woods. It's as if some cold salt god
had wandered inland for a nap. You still see
herons fishing in the shallows, a kingfisher or an osprey

emerges for a moment out of the high, drifting mist,
then vanishes again. And the soft, light green leaves
of the thimbleberry and the ridged coffeeberry leaves
and the needles of the redwoods and pines look more sprightly
in the cool gray air with the long dusk coming on,
since fog is their natural element. I had it in mind
that this description of the weather would be a way
to say things come and go, a way of subsuming
the rhythms of arrival and departure to a sense
of how brief the time is on a summer afternoon
when the sun is warm on your neck and the world
might as well be a dog sleeping on a porch, or a child
for whom an afternoon is endless, endless. Time:
thick honey, and no one saying good-bye.

August Notebook: A Death

1. River Bicycle Peony

I woke up thinking abouy my brothr's body.
that q That was my first bit of early morning typing
so the first dignity, it turns out, is to get the spelling right.

I woke up thinking about my brother's body.
Apparently it's at the medical examiner's morgue.
I found myself wondering whether he was naked

yet and whose job it was to take clothes off
and when they did it. It seemed unnecessary
to undress his body until they performed the exam

and that is going to happen later this morning
and so I found myself hoping that he was dressed
still, though smell may be an issue, or hygiene.

When the police do a forced entry for the purpose
of a welfare check and the deceased person is alone,
the body goes to the medical examiner's morgue

in the section for those deaths in which no evidence
of foul play is involved, so the examination
for cause of death is fairly routine. Two policemen,

for some reason I imagine they were young,
found my brother. His body was in the bed
which was a mattress on the floor. He was lying

on his back, according to Angela, my brother's friend,
who lives nearby and has her own troubles
and always introduced herself as my brother's

personal assistant, and he seemed peaceful.
There would have been nothing in the room
but the mattress and a microwave, an ashtray,

I suppose, cartons and food wrappers he hadn't
thrown away and the little plastic subscription
bottles that he referred to as his 'scrips.

They must have called the ME's ambulance
and that was probably a team of three.
When I woke, I visualized this narrative

and thought it would be shorter. I thought
that what would represent my feelings
would be the absence of metaphor.

But then, at the third line, I discovered
the three line stanza and that it was
going to be the second dignity. So

I imagine he is in one of those aluminium
cubicles I've seen in the movies,
dressed or not. I also imagine that,

if they undressed him, and perhaps washed
his body or gave it an alcohol rub
to disinfect it, that that was the job

of some emigrant from a hot, poor country.
Anyway, he is dressed in this stanza,
which mimics the terza rima of Dante's comedy

and is a form that Wallace Stevens liked
to use, and also my dear friend Robert.
And "seemed peaceful" is a kind of metaphor.

2. Sudden and Grateful Memory of Mississippi John Hurt

Because I woke again thinking of my brother's body
and why anyone would care in some future
that poetry addresses how a body is transferred
from the medical examiner's office,
which is organized by local government
and issues a certificate establishing that the person
in question is in fact dead and names the cause
or causes, to the mortuary or cremation society,
most of which are privately owned businesses
and run for profit and until recently tended
to be family businesses with skills and decorums
passed from father to son, and often quite ethnically
specific, in a country like ours made from crossers
of borders, as if, in the intimacy of death,
some tribal shame or squeamishness or sense
of propriety asserted itself so that the Irish
buried the Irish and the Italians the Italians.
In the south in the early years of the last century
it was the one business in which a black person
could grow wealthy and pass on a trade
and a modicum of independence to his children.
I know this because Judith wrote a piece about it
for which she interviewed fourth-generation
African-American morticians in Oakland
whose grandfathers and great-grandfathers
had buried the dead in cotton towns on the Delta
or along the Brazos River in Texas, passing on
to their children who had gone west an order

of doing things and symbolic forms of courtesy
for the bereaved and sequences of behavior
at wakes and funerals, so that, for example,
the eldest woman in the maternal line
entered the chapel first, and what prayers
were said in what order. During Prohibition
they even sold the white lightning to the men
who were allowed to slip outside and take a nip
and talk about the dead while the cries
and gospel-song-voiced contralto moans
of grief that could sound like curious elation
rose inside. Also the rules for burial or burning.
Griefs and rituals and inside them cosmologies.
And I thought of Mississippi John Hurt's
great song about Louis Collins and its terrible
tenderness which can't be reproduced here
because so much of it is in the picking
of the six-string guitar and in his sweet,
reedy old man's voice: "And when they heard
 that Louis was dead,
 all the women dressed in red.
 Angels laid him away.
 They laid him six feet under the clay.
 Angels laid him away."

3.

You can fall a long way in sunlight.
You can fall a long way in the rain.

The ones who don't take the old white horse
take the morning train.

When you go down
into the city of the dead
with its whitewashed walls and winding alleys
and avenues of autumnal lindens and the heavy bells
tolling by the sea, crowds
appear in all directions,
having left their benches and tiered plazas,
laying aside their occupations of reverie
and gossip and the memory of breathing—
at least in the most reliable stories,
which are the ones the poets tell—
to hear what scraps of news they can
from this world where the air is thin
at high altitudes and smells of pine
and of almost perfect density in the valleys
where trees on summer afternoons sometimes
throw violet shadows across sidewalks.
Only the arborist in the park never stirs
for the new arrivals; he is not incurious,
but he has his work. It is he who decides
which limbs get lopped off
in the city of the dead.

You can fall a long way in sunlight.
You can fall a long way in the rain.

The ones who don't take the old white horse
take the evening train.

4.

Today his body is consigned to the flames
and I begin to understand why people

would want to carry a body to the river's edge
and build a platform of wood and burn it
in the wind and scatter the ashes in the river.
As if to say, take him, fire, take him, air,
and, river, take him. Downstream. Downstream.
Watch the ashes disappear in the fast water
or, in a small flaring of anger, turn away, walk back
toward the markets and the hum of life, not quite
saying to yourself *There, the hell with it, it's done.*
I said to him once, when he'd gotten into some scrape
or other, "You know, you have the impulse control
of a ferret." And he said, "Yeah? I don't know
what a ferret is, but I get greedy. I don't mean to,
but I get greedy." An old grubber's beard, going gray,
a wheelchair, sweats, a street person's baseball cap.
"I've been thinking about Billie Holiday, you know
if she were around now, she'd be nothing. You know
what I mean? Hip-hop? Never. She had to be born
at a time when they were writing the kind of songs
and people were listening to the kind of songs
she was great at singing." And I would say,
"You just got evicted from your apartment,
you can't walk and you have no money, so
I don't want to talk to you about Billie Holiday
right now, okay." And he would say, "You know,
I'm like Mom. I mean, she really had a genius
for denial, don't you think? And the thing is,
you know, she was a pretty happy person."
And I would say, "She was not a happy person.
She was panicky, crippled by guilt at her drinking,
and she was evasive to herself about herself,
and so she couldn't actually connect with anybody,
and her only defense was to be chronically cheerful."
And he would say, "Worse things than cheerful."

Well, I am through with those arguments,
except in my head, and not through, I see, with the habit—
I thought this poem would end *downriver downriver*—
of worrying about where you are and how you're doing.

Variations on a Passage in Edward Abbey

A dune begins with an obstacle—a stone, a shrub, a log,
anything heavy enough to resist being moved by wind.

This obstacle forms a *wind shadow* on its leeward side,
making eddies in the currents, now fast, now slow, of the air,

exactly as a rock in a stream causes an eddy in the water.
Within the eddy the wind moves with less force and less velocity

than the airstreams on either side, creating what geologists call
the surface of discontinuity. And it is here that the wind

tends to drop part of its load of sand. The sand particles,
which hop or bounce along the earth before the wind,

begin to accumulate,
 creating a greater eddy in the air currents
and capturing still more sand.
 It's thus a dune is formed.

Viewed in cross section, sand dunes display a characteristic profile.
On the windward side the angle of ascent is low and gradual—

twenty to twenty-five degrees from the horizontal. On the leeward side
the slope is much steeper, usually about thirty-four degrees—

the angle of repose of sand and most other loose materials.
The steep side of the dune is called the *slip face*
 because of the slides
that occur as sand is driven up the windward side

and deposited on or just over the crest.

The weight of the crest
eventually becomes greater than can be supported by the sand beneath,
so the extra sand slumps down the slip face

and the whole dune
advances in the direction of the prevailing wind, until some obstacle
like a mountain intervenes.

This movement, this grand slow march
across the earth's surface, has an external counterpart in the scouring
movement of glaciers,

and an internal one in the movement of grief
which has something in it of the desert's bareness
and of its distances.

THE BUS TO BAEKDAM TEMPLE

The freeway tracks the Han River, which flows
west out of the mountains we are heading toward.
This morning it is river-colored, gray-green,
streaked with muddy gold, and swift. August,
an overcast morning after rain, the sky one shade
of pearl and the sheen of the roadside puddles
is so empty it seems to steady the world
like the posture of zealous young monks.

SONG OF THE BORDER GUARD

When I sat in the square in Cuernavaca
outside the Church of the Conquistador,
wondering if Malinche had ever loved Cortés
and watching the streams of people go by
in their white shirts and blouses in the heat
and the brightly colored cellophane papers
in which small candies are wrapped and unwrapped
being blown about in the slight breeze,
what was all that racket in the trees?
Boat-tailed grackles and white-winged doves.

And in Houston in the park on a Sunday
among the dragon kites and soccer balls
and the families on picnics in the heat,
not far from the Chapel of the Sacred Heart
where Rothko had made that solemnity
of stained glass windows for the suffering god
in cardinal red and a sorrowing blue,
what was louder than all the transistor radios?
The hip-hop and mariachi? What was that racket in the trees?
Boat-tailed grackles and white-winged doves.

And in Waco in the riverside park along the Brazos
where the city fathers might spend a little more money
picking up the blown-about wrappers of fast food,
even if it would constitute an activity of government,
not far from the marker commemorating the founding
of this city of Baptists by a Caribbean Jew who arrived
from Jamaica on a riverboat, or from the Browning Chapel
at Baylor where the words of two English poets
are lit by the heat of the spring sun and the reds and blues

of Arts & Crafts glass, what is that racket in the trees?
Boat-tailed grackles and white-winged doves.

And in San Antonio where Louisiana live oaks on the campus
of the university are married to red brick in paradise
and along the river that the Cozhuitlan people called Yanaguana
where the Canary Island families settled with inducements
by the Spanish crown, so that two hundred years later
General Antonio López de Santa Anna crushed those Yankee insurgents
and tax resisters at the old Pueblo of the Alamo
or where, in the other telling, Travis and Bowie and Crockett,
under the spindly cottonwoods, would not be brought to their knees.
Cottonwood by the river, live oaks in the park and what is that racket?
Boat-tailed grackles and white-winged doves.

North of there the air changes a little and imperceptibly,
in this valley or that, so the species of willow along the river
change and the insects in the leaves and the size of fruit
and the seeds scattered on the lawns of small towns
with their statues of soldiers from the various wars
are not so large and require different claws or beaks
and you come to a place of mourning doves and Inca doves
with their fluting coos and mute blackbirds with yellow eyes.
So what is this business of walls and border guards?
Who owns that country anyway? What was that racket in the trees?
Ay-yi-yi-yi. Boat-tailed grackles and white-winged doves.

September Notebook: Stories

Everyone comes here from a long way off
(is a line from a poem I read last night).

<p style="text-align:center">✳</p>

Driving up 80 in the haze, they talked and talked.
(Smoke in the air simmering from wildfires.)
His story was sad and hers was roiled, troubled.

<p style="text-align:center">✳</p>

Alternatively:

A man and a woman, old friends, are in a theater
watching a movie in which a man and a woman,
old friends, are driving through summer on a mountain road.
The woman is describing the end of her marriage
and sobbing, shaking her head and laughing
and sobbing. The man is watching the road, listening,
his own more diffuse unhappiness in abeyance,
and because, in the restaurant before the film
the woman had been describing the end of her marriage
and cried, they are not sure whether they are in the theater
or on the mountain road, and when the timber truck
comes suddenly around the bend, they both flinch.

<p style="text-align:center">✳</p>

He found that it was no good trying to tell
what happened that day. Everything he said
seemed fictional the moment that he said it,
the rain, the scent of her hair, what she said
as she was leaving, and why it was important
for him to explain that the car had been parked
under eucalyptus on a hillside, and how velvety

and blurred the trees looked through the windshield;
not, he said, that making fictions might not be
the best way of getting at it, but that nothing he said
had the brute, abject, unassimilated quality
of a wounding experience: the ego in any telling
was already seeing itself as a character, and a character,
he said, was exactly what he was not at that moment,
even as he kept wanting to explain to someone,
to whomever would listen, that she had closed the door
so quietly and so firmly that the beads of rain
on the side window didn't even quiver.

<center>✳</center>

Names for involuntary movements of the body—
squirm, wince, flinch, and shudder—
sound like a law firm in Dickens:
"Mr. Flinch took off his black gloves
as if he were skinning his hands."
"Quiver dipped the nib of his pen
into the throat of the inkwell."

<center>✳</center>

The receptionist at the hospital morgue told him
to call the city medical examiner's office,
but you only got a recorded voice on weekends.

<center>✳</center>

Setup without the punchline:

three greenhorns are being measured for suits
by a very large tailor in a very small room on Hester Street.

<center>✳</center>

Once there were two sisters called Knock Me and Sock Me;
their best friend was a bear named Always Arguing.

What kind of animals were the sisters? one child asked.
Maybe they could be raccoons, said the other.
Or pandas, said the first. They could be pandas.

*

"Why?" he asked. "Because she was lonely,
and angry," said the friend
 who knew her better,
"and she'd run out of stories.
Or come to the one story."

*

It is good to sit down to birthday cake
with children, who think it is the entire point
of life and who, therefore, respect each detail
of the ceremony. There ought to be a rule,
he thought, for who gets to lick the knife
that cuts the cake and the rule should have
its pattern somewhere in the winter stars.
Which do you add to the tea first, he'd asked,
the sugar or the milk? And the child had said,
instantly: "The milk." (Laws as cool
and angular as words: *angular*, *sidereal*.)

*

Stories about the distribution of wealth:
Once upon a time there was an old man
and an old woman who were very, very poor.

*

How Eldie Got Her Name

The neighborhood had been so dangerous,
she said, there was one summer when the mailmen
refused to deliver the mail. Her mother

never appeared and her grandmother,
who had bought a handgun for protection
and had also taught her how to use it,
would walk her to the post office for the sweet,
singsong, half-rhymed letters that smelled,
or that she imagined smelled, of Florida.
She had, when she was ten, shot at an intruder
climbing in the window. The roar,
she said, was tremendous and she doesn't know
to this day whether she hit the man or not.
(A big-boned young woman, skin the color
of the inside of some light-colored hazelnut
confection, auburn eyes, some plucked string
of melancholy radiating from her whole body
when she spoke.) Did her mama come back?
They had asked. She never came back.
The mail started up again but the letters stopped.
Turned out she was good in school, and that
was what saved her. She loved the labor
of schoolwork. Loved finishing a project
and contemplating the neatness of her script.
Her grandmother shook her head, sometimes,
amused and proud, and called her "Little Diligence."

<center>*</center>

Punchline without the setup:
and the three nuns from Immaculate Conception
nodded and smiled as they passed,
because they thought he was addressing them in Latin.

<center>*</center>

He had known, as long as he'd known anything,
that he had a father somewhere. When he was twelve,
his mother told him why he had no shadow.

*

Because she, not her sister, answered the door,
she was the first to hear the news.

*

A Ballad:

He loved to watch that woman sew.
She let her hair grow long for show.
Riddle's a needle (a refrain might go)
and plainly said is thread.

*

She looked beautiful, and looked her age, too.
She'd had a go at putting herself together;
she had always had the confidence that,
with a face like hers, a few touches
to represent the idea of a put-together look
would do, like some set designer's genius
minimalism. It had a slightly harridan effect
and he remembered that it wasn't what was
headlong or slapdash about her, but the way
they gestured, like a quotation, at an understanding
of elegance it would have been boring to spell out,
that had at first dazzled him about her.
He felt himself stirring at this recognition,
and at a certain memory that attended it,
and then laughed at the thought that he had
actually stimulated himself with an analysis
of her style, and she said, as if she were remembering
the way he could make her insecure, "What?
What are you smiling about?" and he said, "Nothing."
And she said, "Oh, yes. Right. I remember nothing."

*

Two jokes walk into a bar.
A cage went in search of a bird.
Three rabbis walk into a penguin.
A boy walks out in the morning with a gun.

*

In the other world the girls were named Eleanor and Filina,
and one night it was very warm and they could not sleep
for the heat and the stillness, and they went outside,
beyond the wall of their parents' garden and into a meadow.
It was dark, moonless, and the stars were so thick
they seemed to shudder, and the sisters stood a long time
in the sweet smell of the cooling grasses, looking at the sky
and listening in the silence. After a while they heard a stirring
and saw that a pair of bright eyes was watching them
from the woods' edge. "Maybe it's their friend, the bear,"
one of the children said. "I don't like this story," said the other.

SOME OF DAVID'S STORY

"That first time I met her, at the party, she said,
'I have an English father and an American mother
and I went to school in London and Providence, Rhode Island,
and at some point I had to choose,
so I moved back to London and became the sort of person
who says *puh-son* instead of *purr-son*.'
For the first *person* she had chosen an accent
halfway between the other two.
It was so elegant I fell in love on the spot. Later,
I understood that it was because I thought
that little verbal finesse meant
she had made herself up entirely.
I felt so much what I was and, you know,
that what I was was not that much,
so she just seemed breathtaking."

✳

"Her neck was the thing, and that tangle of copper hair.
And, in those days, her laugh, the way
she moved through a room. Like Landor's line—
she was meandering gold, pellucid gold."

✳

"Her father was a philosopher,
fairly eminent in that world, and the first time
I was there to dinner, they talked about California wines
in deference to me, I think, though it was a subject
about which I was still too broke to have a thing to say,
so I changed the subject and asked him
what kind of music he liked. He said, 'I loathe music.'
And I said, 'All music?' And he said—

he seemed very amused by himself but also
quite serious, 'Almost all music, almost all the time.'
and I said 'Beethoven?' And he said
'I loathe Beethoven, and I loathe Stravinsky,
who loathed Beethoven.'"

※

"Later, in the night, we talked about it.
'It's feelings,' she said, laughing. 'He says
he doesn't want other people putting their feelings into him
any more than he wants,' and then she imitated
his silvery rich voice, 'them putting their organs
into me at great length and without my consent.'
And she rolled onto my chest and wiggled herself
into position and whispered in my ear,
'So I'll put my feelings in you, okay?'
humming it as if it were a little tune."

※

"Anyway, I was besotted. In that stage, you know,
when everything about her amazed me.
One time I looked in her underwear drawer.
she had eight pair of orange panties
and one pair that was sort of lemon yellow, none of them
very new. So that was something
to think about. What kind of woman
basically wears only orange panties."

※

"She had the most beautiful neck on earth.
A swan's neck. When we made love, in those first weeks,
in my grubby little graduate student bed-sit,
I'd weep afterward from gratitude while she smoked
and then we'd walk along the embankment to look at the lights

just coming on—it was midsummer—and then we'd eat something
at an Indian place and I'd watch her put forkfuls of curry
into that soft mouth I'd been kissing. It was still
just faintly light at midnight and I'd walk her home
and the wind would be coming up on the river."

<p style="text-align: center">✳</p>

"In theory she was only part-time at Amnesty
but by fall she was there every night, later and later.
She just got to be obsessed. Political torture, mostly.
Abu Ghraib, the photographs. She had every one of them.
And photographs of the hands of some Iranian feminist journalist
that the police had taken pliers to. And Africa,
of course, Darfur, starvation, genital mutilation.
The whole starter kit of anguished causes."

<p style="text-align: center">✳</p>

"I'd wake up in the night
and not hear her sleeper's breathing
and turn toward her and she'd be looking at me,
wide-eyed, and say, as if we were in the middle of a conversation,
'Do you know what the report said? It said
she had been raped multiple times and that she died
of one strong blow—they call it blunt trauma—
to the back of her head,
but she also had twenty-seven hairline fractures
to the skull, so they think the interrogation
went on for some time.'"

<p style="text-align: center">✳</p>

"—So I said, 'Yes, I can tell you exactly
what I want.' She had her head propped up on one elbow,
she was so beautiful, her hair
that Botticellian copper. 'Look,' I said,

'I know the world is an awful place, but I would like,
some night, to make love or walk along the river
without having to talk about George fucking Bush
or Tony fucking Blair.' I picked up her hand.
'You bite your fingernails raw.
You should quit smoking. You're entitled, we're entitled
to a little happiness.' She looked at me,
coolly, and gave me a perfunctory kiss
on the neck and said, 'You sound like my mother.'"

<p style="text-align:center">✳</p>

"We were at a party and she introduced me
to one of her colleagues, tall girl, auburn hair,
absolutely white skin. After she walked away,
I said, 'A wan English beauty.' I was really thinking
that she was inside all day breathing secondhand smoke
and saving the world. And she looked at me
for a long time, thoughtfully, and said,
'Not really. She has lymphoma.'
I think that was the beginning of the end.
I wasn't being callow, I just didn't know."

<p style="text-align:center">✳</p>

"Another night she said, 'Do you know
what our countrymen are thinking about right now?
Football matches.' 'Games,' I said. She shook her head.
'The drones in Afghanistan? Yesterday they bombed a wedding.
It killed sixty people, eighteen children. I don't know
how people live, I don't know how
they get up in the morning.'"

<p style="text-align:center">✳</p>

"So she took the job in Harare and I got ready
to come back to Berkeley, and we said we'd be in touch

by e-mail and that I might come out in the summer
and we'd see how it went. The last night
I was the one who woke up. She was sleeping soundly,
her face adorably squinched up by the pillow,
a little saliva—the English word *spittle* came to mind—
a tiny filament of it connecting the corner of her mouth
to the pillow. She looked so peaceful."

✳

"In the last week we went to hear a friend
perform some music of Benjamin Britten.
I had been in the library finishing up, ploughing
through the back issues of *The Criterion* and noticing
again that neither Eliot nor any of the others
seemed to have had a clue to the coming horror.
She was sitting beside me and I looked at her hands
in her lap. Her beautiful hands. And I thought about
the way she was carrying the whole of the world's violence
and cruelty in her body, or trying to, because
she thought the rest of us couldn't or wouldn't.
Our friend was bowing away, a series of high, sweet,
climbing and keening notes, and that line of Eliot's
from *The Wastelan*d came into my head:
'*This music crept by me upon the waters.*'"

SNOWY EGRET

A boy walks out in the morning with a gun.
Bright air, the smell of grass and leaves
and reeds around the pond October smells.
A scent of apples from the orchard in the air.
A smell of ducks. Two cinnamon teal,
he thinks they are teal, the ones he'd seen
the night before as the pond darkened
and he'd thought the thought that the dark
was coming earlier. He is of an age
when the thought of winter is a sexual thought,
the having thoughts of one's own is sexual,
the two ducks muttering and gliding
toward the deeper reeds away from him,
as if distance were a natural courtesy,
is sexual, which is to say, a mystery, an ache
inside his belly and his chest that rhymes
somehow with the largeness of the night.
The stars conjuring themselves from nothing
but the dark, as if to say it's not as if
they weren't all along just where they were,
ached in the suddenly swifter darkening
and glittering and cold. He's of an age
when the thought of thinking is, at night,
a sexual thought. This morning in the crystal
of the air, dew, and the sunlight that the dew
has caught on the grass blades sparkling at his feet,
he stalks the pond. Three larger ducks,
mallards probably, burst from the reeds
and wheel and fly off south. Three redwings,
gone to their winter muteness, fly three ways
across the pond to settle on three cattails
opposite or crossways from each other,

perch and shiver into place and look around.
That's when he sees the snowy egret
in the rushes, pure white and stone still
and standing on one leg in that immobile,
perfect, almost princely way. He'd seen it
often in the summer, often in the morning
and sometimes at dusk, hunting the reeds
under the sumac shadows on the far bank.
He'd watched the slow, wide fanning
of its wings, taking off and landing,
the almost inconceivably slow way
it raised one leg and then another
when it was stalking, the quick cocking
of its head at sudden movement in the water,
and the swift, darting sureness when it stabbed
the water for a stickleback or frog. Once
he'd seen it, head up, swallowing a gopher,
its throat bulging, a bit of tail and a trickle
of blood just visible below the black beak.
Now it was still and white in the brightness
of the morning in the reeds. He liked
to practice stalking, and he raised the gun
to his shoulder and crouched in the wet grasses
and drew his bead just playfully at first.

The Red Chinese Dragon and the Shadows on Her Body in the Moonlight

L. had returned from a visit to the town
where he had lived for many years
with the wife and in the marriage he was leaving.
His task was to walk through the house
and mark things of his for the movers
(he'd taken a job in another town)
and those of their common possessions
they had agreed he would take with him
into the new life. His wife had said,
"Take what you want," and he understood
that she meant by this to say to him
that things were not the cause of her anger
or her hurt. His son, who was a senior
in high school, was also angry
and protective of his mother, who was,
after all, the one being abandoned.
L. understood that. He even thought
that his son's loyalty to his mother
was a good thing up to a point. The son,
when he'd heard the news, had acted as if
he'd been kicked in the stomach, then flared
and accused his father of selfishness,
of breaking up the family over personal feelings,
but he had also, like young men of his generation,
been raised a feminist and he had made himself
face the fact that, if his mother had a right
to her own life, like Nora in the Ibsen play
his drama class had performed the year before,
so did his father, and that he had to tell him so,
which he did, a week later, and on the phone,

a call L. would also associate with the unreal blue
of the mounded snow outside his new office
with its weather of another world. He arrived
on a Friday afternoon and stayed at a hotel
in the center of town. It was an odd sensation,
and not unpleasant, like the lightness
he had been feeling intermittently since
he'd left some months before, alongside
the heavy & incessant grief. He spent an hour
in his old gym, watching Iraqi women
in black shawls howling over their dead
on TV while he ran between two young women
on treadmills, and thought, as he often thought
those days, of the incommensurability
of kinds of suffering, and afterward,
he walked across the street to a shop
where he'd sometimes found interesting objects.
There was an old red Chinese dragon
in the window, spangled with yellow
and green, the paint chipped but unfaded,
some kind of water god, he thought,
or river god that saved you from drowning
or caused you to drown, he couldn't
remember which. On its face there was
an expression of glee, ferocious glee.
He considered buying it as a gift
for his son and decided it was not
a time to touch symbolism he didn't
understand. That night, as planned, he saw his son
in *The Tempest*. He'd sat alone near the back
of the theater and tried not to feel anything
except pleasure in the children and the play,
in which his son's girlfriend had the part of Miranda
to his Prospero. She was a gamin-faced girl,

wide-browed with ash blond hair, who more than a little
resembled L.'s wife (something they had both remarked,
amused, a year before) and who brought the house down
with Miranda's line. The audience, L. thought,
in a university town mostly knew it was coming,
but when she stood, flower-bedecked, center stage,
and lifted herself on tiptoe as she said it
in a slightly hoarse and boyish voice, the audience
howled with delight. Afterward they also murmured
audibly when his son, also center stage, adorable
and a little ludicrous in his wispy wizard's beard,
intoned his line, held out a wooden wand between his hands,
and broke it with a loud snap to abjure the magic.
L.'s wife sat in the middle of the second row.
He watched her greet many of their casual friends,
colleagues, parents of their son's friends
he'd sat in the back to avoid having to greet.
He'd brought flowers, and seeing that his wife had, too,
he decided to leave his under his seat. He waved
at his son, unbearded now and milling on stage
with the rest of the cast, gave him a thumbs up,
and drove his rental car back to the hotel.
In the morning, at ten, they'd gone through the house.
His son had answered the door, the three of them
had coffee in the kitchen and talked about the play.
His wife said not much and he concentrated
on ignoring her anger and the devastating sorrow
welling up inside him. Going through the house,
they'd had no issues except for one bowl
that they'd both remembered being the one
to spot in an antique store on the Mendocino road
twenty years before when they were quite poor
and the bowl, earthy, a luminous brown-gold,
from a famous ceramist's studio in Cornwall,

had been a plunge. (They'd made love
in the upstairs room of a bed-and-breakfast,
he involuntarily remembered, with an ocean view
and at breakfast they had heard Pachelbel's canon
for the first time with its stunned, slow, stately beauty
and went walking to look for coastal flowers,
lupine and heal-all and vetch, to fill the bowl with,
and then somehow bickered away through the afternoon
while they walked on the storm-littered beach.)
His wife looked at it a long time, arms crossed,
and then shrugged forcefully as if to say, take it
if you want it, since you've taken everything else,
and so, nettled by what he thought
was passive-aggressive in her manner, he had.
Later he found there wasn't a way to describe
to his lover or to his friends the moment
when he turned to his wife to say, again,
how sorry he was, and how she had seen it
coming and raised a palm and said, "Please, don't,"
and how his son had walked him to the door
and how, sitting in the car outside his house
of many years while his son disappeared inside,
he'd felt unable to move, stuck in some deep well
of dry sorrow, staring at the cold early blossoms
of the plum trees and at the carelessly lovely look
of the gardens his neighbors had, in the West Coast way,
labored over, until shame made him start the car
and drive it to the airport. Home again, in his new apartment
on the other side of the continent, fumbling
for his key in the humid night, he almost tripped
over the cat that came bounding out of the shadows
to greet him. It belonged to his new neighbor,
a professor of philosophy who'd written a book
about lying which he had tried to read

when he was sorting out the evasions and outright lies
his infidelity entailed. The cat was named Cat
and it was blind. It was rubbing its gray flank
against his ankles and purring, looking up at him
and purring and winking its occluded, milky eyes.
She opened the door before he did. She had put on
one of his shirts and was warm and smelled of sleep.
He scooped up the cat and tossed it in the hall
And then he hugged her. When she asked him, only half-awake,
how it had gone, he'd said, "Fine. Not easy."
and she had touched his cheek and said, "Poor baby"
and padded down the hall and back to bed.
A few nights later, after they'd made love,
he dozed and woke thinking about his son.
They had tossed off the sheets in the warm room
and when he glanced aside he was startled
to see that her body, curled naked beside him,
lustrous in the moonlight, was crisscrossed
with black shadows from the blinds. His body too.
It made them, made everything, seem vulnerable.
There was a light still on in the kitchen, and he slipped
from bed and walked down the hall to turn it off.
They'd also left the TV on, soldiers in desert camouflage
leaning against a wall. He turned that off, too,
and walked back down the hall, climbed into bed,
covered them both, lay down, and listened to the rhythm
of her breathing. After a while he entered it and slept.

Field Guide

On the Coast near Sausalito

1.

I won't say much for the sea,
except that it was, almost,
the color of sour milk.
The sun in that clear
unmenacing sky was low,
angled off the gray fissure of the cliffs,
hills dark green with manzanita.

Low tide: slimed rocks
mottled brown and thick with kelp
merged with the gray stone
of the breakwater, sliding off
to antediluvian depths.
The old story: here filthy life begins.

2.

Fish—
ing, as Melville said,
"to purge the spleen,"
to put to task my clumsy hands
my hands that bruise by
not touching
pluck the legs from a prawn,
peel the shell off,
and curl the body twice about a hook.

3.

The cabezone is not highly regarded
by fishermen, except Italians
who have the grace
to fry the pale, almost bluish flesh
in olive oil with a sprig
of fresh rosemary.

The cabezone, an ugly atavistic fish,
as old as the coastal shelf
it feeds upon
has fins of duck's-web thickness,
resembles a prehistoric toad,
and is delicately sweet.

Catching one, the fierce quiver of surprise
and the line's tension
are a recognition.

4.

But it's strange to kill
for the sudden feel of life.
The danger is
to moralize
that strangeness.
Holding the spiny monster in my hands
his bulging purple eyes
were eyes and the sun was
almost tangent to the planet
on our uneasy coast.
Creature and creature,
we stared down centuries.

FALL

Amateurs, we gathered mushrooms
near shaggy eucalyptus groves
which smelled of camphor and the fog-soaked earth.
Chanterelles, puffballs, chicken of the woods,
we cooked in wine or butter,
beaten eggs or sour cream,
half-expecting to be
killed by a mistake. "Intense perspiration,"
you said late at night,
quoting the terrifying field guide
while we lay tangled in our sheets and heavy limbs,
"is the first symptom of attack."

Friends called our aromatic fungi
liebestoads and only ate the ones
that we most certainly survived.
Death shook us more than once
those days and floating back
it felt like life. Earth-wet, slithery,
we drifted toward the names of things.
Spore prints littered our table
like nervous stars. Rotting caps
gave off a musky smell of loam.

Maps

Sourdough French bread and pinot chardonnay

✳

Apricots—
the downy buttock shape
hard black sculpture of the limbs
on Saratoga hillsides in the rain.

✳

These were the staples of the China trade:
sea otter, sandalwood, and bêche-de-mer

✳

The pointillist look of laurels
their dappled pale green body stirs
down valley in the morning wind
Daphne was supple
my wife is tan, blue-rippled
pale in the dark hollows

✳

Kit Carson in California:
it was the eyes of fish
that shivered in him the tenderness of eyes
he watched the ships come in
at Yerba Buena once, found obscene
the intelligence of crabs
their sidelong crawl, gulls
screeching for white meat,
flounders in tubs, startled

✳

Musky fall—
slime of a saffron milkcap
the mottled amanita
delicate phallic toxic

<center>✳</center>

How odd
the fruity warmth of zinfandel
geometries of "rational viticulture"

 Plucked from algae sea spray
cold sun and a low rank tide
 sea cucumbers
lolling in the crevices of rock
they traded men enough
to carve old Crocker's railway out of rock
to eat these slugs
bêche-de-mer

<center>✳</center>

The night they bombed Hanoi
we had been drinking red pinot
that was winter the walnut tree was bare
and the desert ironwood where waxwings
perched in spring drunk on pyracantha
squalls headwinds days gone
north on the infelicitous Pacific

<center>✳</center>

The bleak intricate erosion of these cliffs

 seas grown bitter
with the salt of continents

<center>✳</center>

Jerusalem artichokes
raised on sandy bluffs at San Gregorio
near reedy beaches where the steelhead ran

Coast range runoff turned salt creek
in the heat and indolence of August

*

That purple in the hills
 owl's clover stiffening the lupine
while the white flowers of the pollinated plant
 seep red

the eye owns what is familiar
 felt along the flesh
"an amethystine tinge"

*

Chants, recitations:
Olema
Tamalpais Mariposa
Mendocino Sausalito San Rafael
Emigrant Gap
Donner Pass

Of all the laws
that bind us to the past
the names of things are
stubbornest

*

Late summer—
red berries darken the hawthorns
curls of yellow in the laurels

your body and the undulant
sharp edges of the hills

 ✳

Clams, abalones, cockles, chitons, crabs

 ✳

Ishi
in San Francisco, 1911:
it was not the sea he wondered at
that inland man who saw the salmon
die to spawn and fed his dwindling people
from their rage to breed
it was the thousands of white bodies
on the beach
"Hansi saltu . . ." so many
ghosts

 ✳

The long ripple in the swamp grass
is a skunk
he shuns the day

ADHESIVE: FOR EARLENE

How often we overslept
those gray enormous mornings
in the first year of marriage
and found that rain and wind
had scattered palm nuts,
palm leaves, and sweet rotting crab apples
across our wildered lawn.

By spring your belly was immense
and your coloring a high rosy almond.

We were so broke
we debated buying thumbtacks
at the Elmwood Dime Store
knowing cellophane tape would do.
Berkeley seemed more innocent
in those flush days
when we skipped lunch
to have the price of *Les Enfants du Paradis*.

BOOKBUYING IN THE TENDERLOIN

A statuary Christ bleeds sweating grief
in the Gethsemane garden of St. Boniface Church
where empurpled Irish winos lurch
to their salvation. When incense and belief
will not suffice: ruby port in the storm
of muscatel-made images of hell
the city spews at their shuffling feet.
In the Longshoreman's Hall across the street,
three decades have unloaded since the fight
to oust the manic Trotskyite
screwballs from the brotherhood. All goes well
since the unions closed their ranks,
boosted their pensions, and hired the banks
to manage funds for the workingman's cartel.
Christ in plaster, the unions minting coin,
old hopes converge upon the Tenderloin
where Comte, Considérant, Fourier
are thick with dust in the two-bit tray
of cavernous secondhand bookstores
and the streets suffuse the ten-cent howl
of jukebox violence, just this side of blues.
Negro boy-whores in black tennis shoes
prowl in front of noisy hustler bars.
Like Samuel Gompers, they want more
on this street where every other whore
is painfully skinny, wears a bouffant,
and looks like a brown slow-blooming annual flower.
In the places that I haunt, no power
to transform the universal squalor
nor wisdom to withstand the thin wrists

of the girls who sell their bodies for a dollar
or two, the price of a Collected Maeterlinck.
The sky glowers. My God, it is a test,
this riding out the dying of the West.

Spring

We bought great ornamental oranges,
Mexican cookies, a fragrant yellow tea.
Browsed the bookstores. You
asked mildly, "Bob, who is Ugo Betti?"
A bearded birdlike man
(he looked like a Russian priest
with imperial bearing
and a black ransacked raincoat)
turned to us, cleared
his cultural throat, and
told us both interminably
who Ugo Betti was. The slow
filtering of sun through windows
glazed to gold the silky hair
along your arms. Dusk was
a huge weird phosphorescent beast
dying slowly out across the bay.
Our house waited and our books,
the skinny little soldiers on the shelves.
After dinner I read one anyway.
You chanted, "Ugo Betti has no bones,"
and when I said, "The limits of my language
are the limits of my world," you laughed.
We spoke all night in tongues,
in fingertips, in teeth.

SONG

Afternoon cooking in the fall sun—
who is more naked
 than the man
yelling, "Hey, I'm home!"
 to an empty house?
thinking because the bay is clear,
the hills in yellow heat,
& scrub oak red in gullies
that great crowds of family
should tumble from the rooms
 to throw their bodies on the Papa-body,
 I-am-loved.

Cat sleeps in the windowgleam,
 dust motes.
 On the oak table
 filets of sole
stewing in the juice of tangerines,
slices of green pepper
 on a bone-white dish.

PALO ALTO: THE MARSHES

For Mariana Richardson (1830–1891)

1.

She dreamed along the beaches of this coast.
Here where the tide rides in to desolate
the sluggish margins of the bay,
sea grass sheens copper into distances.
Walking, I recite the hard
explosive names of birds:
egret, killdeer, bittern, tern.
Dull in the wind and early morning light,
the striped shadows of the cattails
twitch like nerves.

2.

Mud, roots, old cartridges, and blood.
High overhead, the long silence of the geese.

3.

"We take no prisoners," John Frémont said
and took California for President Polk.
That was the Bear Flag War.
She watched it from the Mission San Rafael,
named for the archangel (the terrible one)
who gently laid a fish across the eyes
of saintly, miserable Tobias
that he might see.

The eyes of fish. The land
shimmers fearfully.
No archangels here, no ghosts,
and terns rise like seafoam
from the breaking surf.

4.

Kit Carson's antique .45, blue,
new as grease. The roar
flings up echoes,
row on row of shrieking avocets.
The blood of Francisco de Haro,
Ramón de Haro, José de los Reyes Berryessa
runs darkly to the old ooze.

5.

The star thistles: erect, surprised,

6.

and blooming
violet caterpillar hairs. One
of the de Haros was her lover,
the books don't say which.
They were twins.

7.

In California in the early spring
there are pale yellow mornings
when the mist burns slowly into day.
The air stings
like autumn, clarifies
like pain.

8.

Well I have dreamed this coast myself.
Dreamed Mariana, since her father owned the land
where I grew up. I saw her picture once:
a wraith encased in a high-necked black silk
dress so taut about the bones there were hardly ripples
for the light to play in. I knew her eyes
had watched the hills seep blue with lupine after rain,
seen the young peppers, heavy and intent,
first rosy drupes and then the acrid fruit,
the ache of spring. Black as her hair
the unreflecting venom of those eyes
is an aftermath I know, like these brackish,
russet pools a strange life feeds in
or the old fury of land grants, maps,
and deeds of trust. A furious dun-
colored mallard knows my kind
and skims across the edges of the marsh
where the dead bass surface
and their flaccid bellies bob.

9.

A chill tightens the skin
around my bones. The other California
and its bitter absent ghosts
dance to a stillness in the air:
the Klamath tribe was routed and they disappeared.
Even the dust seemed stunned,
tools on the ground, fishnets.
Fires crackled, smouldering.
No movement but the slow turning
of the smoke, no sounds but jays
shrill in the distance and flying further off.
The flicker of lizards, dragonflies.
And beyond the dry flag-woven lodges
a faint persistent slapping.
Carson found ten wagonloads
of fresh-caught salmon, silver
in the sun. The flat eyes stared.
Gills sucking the thin annulling air.
They flopped and shivered,
ten wagonloads. Kit Carson
burned the village to the ground.
They rode some twenty miles that day
and still they saw the black smoke
smear the sky above the pines.

10.

Here everything seems clear,
firmly etched against the pale
smoky sky: sedge, flag, owl's clover,
rotting wharves. A tanker lugs silver

bomb-shaped napalm tins toward
port at Redwood City. Again,
my eye performs
the lobotomy of description.
Again, almost with yearning,
I see the malice of her ancient eyes.
The mud flats hiss as the tide turns.
They say she died in Redwood City,
cursing "the goddammed Anglo-Yankee yoke."

II.

The otters are gone from the bay
and I have seen five horses
easy in the grassy marsh
beside three snowy egrets.

Bird cries and the unembittered sun,
wings and the white bodies of the birds,
it is morning. Citizens are rising
to murder in their moral dreams.

CONCERNING THE AFTERLIFE, THE INDIANS OF CENTRAL CALIFORNIA HAD ONLY THE DIMMEST NOTIONS

It is morning because the sun has risen.

I wake slowly in the early heat,
 pick berries from the thorny vines.
 They are deep red,
 sugar-heavy, fuzzed with dust.
The eucalyptus casts a feathered shadow
on the house, which gradually withdraws.

 After breakfast
you will swim and I am going to read
that hard man Thomas Hobbes
on the causes of the English civil wars.
There are no women in his world,
Hobbes, brothers fighting brothers
over goods.
 I see you in the later afternoon
your hair dry-yellow, plaited
from the waves, a faint salt sheen
across your belly and along your arms.
The kids bring from the sea
 intricate calcium gifts—
 black turbans, angular green whelks,
 the whorled opalescent unicorn.

We may or may not
feel some irritation at the dinner hour.
The first stars, and after dark

Vega hangs in the lyre,
the Dipper tilts above the hill.
 Traveling
in Europe Hobbes was haunted by motion.
Sailing or riding, he was suddenly aware
that all things move.
 We will lie down,
finally, in our heaviness
 and touch and drift toward morning.

THE NINETEENTH CENTURY AS A SONG

"How like a well-kept garden is your soul."
 John Gray's translation of Verlaine
& Baudelaire's butcher in 1861
shorted him four centimes
on a pound of tripe.
He thought himself a clever man
and, wiping the calves' blood from his beefy hands,
gazed briefly at what Tennyson called
"the sweet blue sky."

It was a warm day.
What clouds there were
were made of sugar tinged with blood.
They shed, faintly, amid the clatter of carriages
new settings of the songs
Moravian virgins sang on wedding days.

 The poet is a monarch of the clouds

& Swinburne on his northern coast
"trod," he actually wrote, "by no tropic foot,"
composed that lovely elegy
and then found out Baudelaire was still alive
whom he had lodged dreamily
in a "deep division of prodigious breasts."

 Surely the poet is monarch of the clouds.
 He hovers, like a lemon-colored kite,
 over spring afternoons in the nineteenth century
 while Marx in the library gloom
 studies the birth rate of the weavers of Tilsit

and that gentle man Bakunin,
home after fingerfucking the countess,
applies his numb hands
to the making of bombs.

Measure

Recurrences.
Coppery light hesitates
again in the small-leaved

Japanese plum. Summer
and sunset, the peace
of the writing desk

and the habitual peace
of writing, these things
form an order I only

belong to in the idleness
of attention. Last light
rims the blue mountain

and I almost glimpse
what I was born to,
not so much in the sunlight

or the plum tree
as in the pulse
that forms these lines.

APPLICATIONS OF THE DOCTRINE

That professor of French,
trying to start his car
among the innocent snowdrifts,
is the author of a famous book
on the self.

✳

The self is probably an illusion
and language the structure of illusions.
The self is beguiled, anyway,
by this engine of thought.

✳

The self shuffles cards
with absurd dexterity.
The deck includes
an infinite number
of one-eyed jacks.

✳

On warm days
he knows he should marry Being,
a nice girl, steady
but relentless.

✳

The self has agreed to lecture
before a psychoanalytic study group.
On the appointed day he
does not appear, thereby
meeting his obligation.

✳

The self grants an audience
to the Pope.
They talk shop.

※

The snark is writing a novel
called *The Hunting of the Self.*
The self is composing a monograph
on the frames of antique mirrors.

※

The self botanizes.
He dreams of breeding, one day,
an odorless narcissus.

※

There is a girl the self loves.
She has been trying to study him for days
but her mind keeps
wandering.

HOUSE

Quick in the April hedge
 were juncos and kinglets.
I was at the window
 just now, the bacon
sizzled under hand,
 the coffee steamed
fragrantly & fountains
 of the *Water Music*
issued from another room.
 Living in a house
we live in the body
 of our lives, last night
the odd after-dinner light
 of early spring & now
the sunlight warming or
 shadowing the morning rooms.

I am conscious of being
 myself the inhabitant
of certain premises:
 coffee & bacon & Handel
& upstairs asleep my wife.
 Very suddenly
old dusks break over me,
 the thick shagged heads
of fig trees near the fence
 & not wanting to go in
& swallows looping
 on the darkened hill
& all that terror
 in the house

& barely, only barely,
 a softball
falling toward me
 like a moon.

In Weather

What I wanted
in the pearly repetitions of February
was vision. All winter,
grieved and dull,
I hungered for it.
Sundays I looked for lightning-
stricken trees
in the slow burning of the afternoon
to cut them down, split
the dry centers,
and kindle from their death
an evening's warmth
in the uxorious amber repetitions
of the house. Dusks
weighted me, the fire,
the dim trees. I saw
the bare structure
of their hunger for light
reach to where darkness
joined them. The dark
and the limbs tangled
luxuriant as hair.
I could feel night gather them
but removed my eyes from the tug of it
and watched the fire,
a smaller thing,
contained by the hewn stone
of the dark hearth.

2.

 I can't decide
about my garbage and the creatures
who come at night to root
and scatter it. I could lock it
in the shed, but I imagine
wet noses, bodies grown alert
to the smells of warm decay
in the cold air. It seems a small thing
to share what I don't want,
but winter mornings the white yard
blossoms grapefruit peels,
tin cans, plastic bags,
the russet cores of apples.
The refuse of my life
surrounds me and the sense of waste
in the dreary gathering of it
compels me all the more
to labor for the creatures
who quiver and are quick-eyed
and bang the cans at night
and are not grateful. The other morning,
walking early in the new sun,
I was rewarded. A thaw turned up
the lobster shells from Christmas Eve.
They rotted in the yard
and standing in the muddy field I caught,
as if across great distances,
a faint rank fragrance of the sea.

3.

There are times
I wish my ignorance were
more complete. I remember
clamming inland beaches
on the January tides
along Tomales Bay. A raw world
where green crabs
which have been exposed
graze nervously on intertidal kelp
and sea anemones are clenched and colorless
in eddying pools
near dumb clinging starfish
on the sides and undersides of rock.
Among the cockles and the horseneck clams,
I turned up long, inch-thick
sea worms. Female,
phallic, ruddy brown, each one
takes twenty years to grow.
Beach people call them *innkeepers*
because the tiny male lives inside
and feeds on plankton
in the water that the worm
churns through herself to move.
I watched the brown things
that brightness bruised
writhing in the sun. Then,
carefully, I buried them.
And, eyes drifting, heart-
sick, honed to the wind's edge,
my mind became the male
drowsing in that inland sea
who lives in darkness,

drops seed twice in twenty years,
and dies. I look from my window
to the white fields
and think about the taste of clams.

4.

 A friend, the other night,
read poems full of rage
against the poor uses of desire
in mere enactment. A cruel music
lingered in my mind.
The poems made me think
I understood
why men cut women up. Hating
the source, nerved
irreducible, that music hacked
the body till the source was gone.
Then the heavy cock wields,
rises, spits seed
at random and the man
shrieks, homeless
and perfected in the empty dark.
His god is a thrust of infinite desire
beyond the tame musk
of companionable holes.
It descends to women occasionally
with contempt and languid tenderness.
I tried to hate my wife's cunt,
the sweet place where I rooted,
to imagine the satisfied disgust
of cutting her apart,
bloody and exultant

in the bad lighting and scratchy track
of butcher shops
in short experimental films.
It was easier that I might have supposed.
O spider cunt, O raw devourer.
I wondered what to make
of myself. There had been a thaw.
I looked for green shoots
in the garden, wild flowers in the woods.
I found none.

5.

 In March the owls
began to mate. Moon
on windy snow. Mournful,
liquid, the dark hummed
their cries, a soft
confusion. Hard frost
feathered the windows.
I could not sleep.
I imagined the panic
of the meadow mouse,
the star-nosed mole.
Slowly at first, I
made a solemn face
and tried the almost human wail
of owls, ecstatic
in the winter trees, *twoo*, *twoo*.
I drew long breaths.
My wife stirred in our bed.
Joy seized me.

6.

 Days return
day to me, the brittle light.
My alertness has no
issue. Deep in the woods
starburst needles of the white pine
are roof to the vacancies
in standing still. Wind
from the lake stings me.
Hemlocks grow cerebral
and firm in the dim attenuation
of the afternoon. The longer
dusks are a silence
born in pale redundancies
of silence. Walking home
I follow the pawprints of the fox.
I know that I know myself
no more than a seed
curled in the dark of a winged pod
knows flourishing.

Praise

We asked the captain what course of action he proposed to take toward a beast so large, terrifying, and unpredictable. He hesitated to answer, and then said judiciously: "I think I shall praise it."

HEROIC SIMILE

When the swordsman fell in Kurosawa's *Seven Samurai*
in the gray rain,
in Cinemascope and the Tokugawa dynasty,
he fell straight as a pine, he fell
as Ajax fell in Homer
in chanted dactyls and the tree was so huge
the woodsman returned for two days
to that lucky place before he was done with the sawing
and on the third day he brought his uncle.

They stacked logs in the resinous air,
hacking the small limbs off,
tying those bundles separately.
The slabs near the root
were quartered and still they were awkwardly large;
the logs from the midtree they halved:
ten bundles and four great piles of fragrant wood,
moons and quarter moons and half-moons
ridged by the saw's tooth.

The woodsman and the old man his uncle
are standing in midforest
on a floor of pine silt and spring mud.
They have stopped working
because they are tired and because
I have imagined no pack animal
or primitive wagon. They are too canny
to call in neighbors and come home
with a few logs after three days' work.
They are waiting for me to do something

or for the overseer of the Great Lord
to come and arrest them.

How patient they are!
The old man smokes a pipe and spits.
The young man is thinking he would be rich
if he were already rich and had a mule.
Ten days of hauling
and on the seventh day they'll probably
be caught, go home empty-handed
or worse. I don't know
whether they're Japanese or Mycenaean
and there's nothing I can do.
The path from here to that village
is not translated. A hero, dying,
gives off stillness to the air.
A man and a woman walk from the movies
to the house in the silence of separate fidelities.
There are limits to imagination.

MEDITATION AT LAGUNITAS

All the new thinking is about loss.
In this it resembles all the old thinking.
The idea, for example, that each particular erases
the luminous clarity of a general idea. That the clown-
faced woodpecker probing the dead sculpted trunk
of that black birch is, by his presence,
some tragic falling off from a first world
of undivided light. Or the other notion that,
because there is in this world no one thing
to which the bramble of *blackberry* corresponds,
a word is elegy to what it signifies.
We talked about it late last night and in the voice
of my friend, there was a thin wire of grief, a tone
almost querulous. After a while I understood that,
talking this way, everything dissolves: *justice,*
pine, hair, woman, you and *I.* There was a woman
I made love to and I remembered how, holding
her small shoulders in my hands sometimes,
I felt a violent wonder at her presence
like a thirst for salt, for my childhood river
with its island willows, silly music from the pleasure boat,
muddy places where we caught the little orange-silver fish
called *pumpkinseed.* It hardly had to with her.
Longing, we say, because desire is full
of endless distances. I must have been the same to her.
But I remember so much, the way her hands dismantled bread,
the thing her father said that hurt her, what
she dreamed. The are moments when the body is as numinous
as words, days that are the good flesh continuing.
Such tenderness, those afternoons and evenings,
saying *blackberry, blackberry, blackberry.*

SUNRISE

Ah, love, this is fear. This is fear and syllables
and the beginnings of beauty. We have walked the city,
a flayed animal signifying death, a hybrid god
who sings in the desolation of filth and money
a song the heart is heavy to receive. We mourn
otherwise. Otherwise the ranked monochromes,
the death-teeth of that horizon, survive us
as we survive pleasure. What a small hope.
What a fierce small privacy of consolation.
What a dazzle of petals for the poor meat.

Blind, with eyes like stars, like astral flowers,
from the purblind mating sickness of the beasts
we rise, trout-shaken, in the gaping air,
in terror, the scarlet sun-flash
leaping from the pond's imagination
of a deadly sea. Fish, mole,
we are the small stunned creatures
inside these human resurrections, the nights
the city praises and defiles. From there we all
walk slowly to the sea gathering scales
from the cowled whisper of the waves,
the mensural polyphony. Small stars,
and blind the hunger under sun,
we turn to each other and turn to each other
in the mother air of what we want.

That is why blind Orpheus praises love
and why love gouges out our eyes
and why all lovers smell their way to Dover.
That is why innocence has so much to account for,
why Venus appears least saintly in the attitudes of shame.

This is lost children and the deep sweetness of the pulp,
a blue thrumming at the formed bone, river,
flame, quicksilver. It is not the fire
we hunger for and not the ash. It is the still hour,
a deer come slowly to the creek at dusk,
the table set for abstinence, windows
full of flowers like summer in the provinces
vanishing when the moon's half-face pallor
rises on the dark flax line of hills.

THE YELLOW BICYCLE

The woman I love is greedy,
but she refuses greed.
She walks so straightly.
When I ask her what she wants,
she says, "A yellow bicycle."

✳

Sun, sunflower,
coltsfoot on the roadside,
a goldfinch, the sign
that says Yield, her hair,
cat's eyes, his hunger
and a yellow bicycle.

✳

Once, when they had made love in the middle of the night and it was
very sweet, they decided they were hungry, so they got up, got dressed,
and drove downtown to an all-night donut shop. Chicano kids lounged
outside, a few drunks, and one black man selling dope. Just at the
entrance there was an old woman in a thin floral print dress. She was
barefoot. Her face was covered with sores and dry peeling skin. The
sores looked like raisins and her skin was the dry yellow of a parchment
lampshade ravaged by light and tossed away. They thought she must
have been hungry and, coming out again with a white paper bag full of
hot rolls, they stopped to offer her one. She looked at them out of her
small eyes, bewildered, and shook her head for a little while, and said
very kindly, "No."

✳

Her song to the yellow bicycle:
The boats on the bay
have nothing on you,
my swan, my sleek one!

AGAINST BOTTICELLI

I.

In the life we lead together every paradise is lost.
Nothing could be easier: summer gathers new leaves
to casual darkness. So few things we need to know.
And the old wisdoms shudder in us and grow slack.
Like renunciation. Like the melancholy beauty
of giving it all up. Like walking steadfast
in the rhythms, winter light and summer dark.
And the time for cutting furrows and the dance.
Mad seed. Death waits it out. It waits us out,
the sleek incandescent saints, earthly and prayerful.
In our modesty. In our shamefast and steady attention
to the ceremony, its preparation, the formal hovering
of pleasure which falls like the rain we pray not to get
and are glad for and drown in. Or spray of that sea,
irised: otters in the tide lash, in the kelp-drench,
mammal warmth and the inhuman element. Ah, that is the secret.
That she is an otter, that Botticelli saw her so.
That we are not otters and are not in the painting
by Botticelli. We are not even in the painting by Bosch
where the people are standing around looking at the frame
of the Botticelli painting and when Love arrives, they throw up.
Or the Goya painting of the sad ones, angular and shriven,
who watch the Bosch and feel very compassionate
but hurt each other often and inefficiently. We are not in any painting.
If we do it at all, we will be like the old Russians.
We'll walk down through scrub oak to the sea
and where the seals lie preening on the beach
we will look at each other steadily
and butcher them and skin them.

2.

The myth they chose was the constant lovers.
The theme was richness over time.
It is a difficult story and the wise never choose it
because it requires a long performance
and because there is nothing, by definition, between the acts.
It is different in kind from a man and the pale woman
he fucks in the ass underneath the stars
because it is summer and they are full of longing
and sick of birth. They burn coolly
like phosphorus, and the thing need be done
only once. Like the sacking of Troy
it survives in imagination,
in the longing brought perfectly to closing,
the woman's white hands opening, opening,
and the man churning inside her, thrashing there.
And light travels as if all the stars they were under
exploded centuries ago and they are resting now, glowing.
The woman thinks what she is feeling is like the dark
and utterly complete. The man is past sadness,
though his eyes are wet. He is learning about gratitude,
how final it is, as if the grace in Botticelli's *Primavera*,
the one with sad eyes who represents pleasure,
had a canvas to herself, entirely to herself.

Like Three Fair Branches from One Root Deriv'd

I am outside a door and inside
the words do not fumble
as I fumble saying this.
It is the same in the dream
where I touch you. Notice
in this poem the thinning out
of particulars. The gate
with the three snakes is burning,
symbolically, which doesn't mean
the flames can't hurt you.
Now it is the pubic arch instead
and smells of oils and driftwood,
of our bodies working very hard
at pleasure but they are not
thinking about us. Bless them,
it is not a small thing to be
happily occupied, go by them
on tiptoe. Now the gate is marble
and the snakes are graces.
You are the figure in the center.
On the left you are going away
from yourself. On the right
you are coming back. Meanwhile
we are passing through the gate
with everything we love. We go
as fire, as flesh, as marble.
Sometimes it is good and sometimes
it is dangerous like the ignorance
of particulars, but our words are clear
and our movements give off light.

Transparent Garments

Because it is neither easy nor difficult,
because the other dark is not passport
nor is the inner dark, the horror
held in memory as talisman. Not to go in
stupidly holding out dark as some
wrong promise of fidelity, but to go in
as one can, empty or worshipping.
White, as a proposition. Not leprous
by easy association nor painfully radiant.
Or maybe that, yes, maybe painfully.
To go into that. As: I am walking in the city
and there is the whiteness of the houses,
little cubes of it bleaching in the sunlight,
luminous with attritions of light, the failure
of matter in the steadiness of light,
a purification, not burning away,
nothing so violent, something clearer
that stings and stings and is then
past pain or this slow levitation of joy.
And to emerge, where the juniper
is simply juniper and there is the smell
of new shingle, a power saw outside
and inside a woman in the bath,
a scent of lemon and a drift of song,
a heartfelt imitation of Bessie Smith.
The given, as in given up
or given out, as in testimony.

THE IMAGE

The child brought blue clay from the creek
and the woman made two figures: a lady and a deer.
At that season deer came down from the mountain
and fed quietly in the redwood canyons.
The woman and the child regarded the figure of the lady,
the crude roundness, the grace, the coloring like shadow.
They were not sure where she came from,
except the child's fetching and the woman's hands
and the lead-blue clay of the creek
where the deer sometimes showed themselves at sundown.

THE FEAST

The lovers loitered on the deck talking,
the men who were with men and the men who were with new women,
a little shrill and electric, and the wifely women
who had repose and beautifully lined faces
and coppery skin. She had taken the turkey from the oven
and her friends were talking on the deck
in the steady sunshine. She imagined them
drifting toward the food, in small groups, finishing
sentences, lifting a pickle or a sliver of turkey,
nibbling a little with unconscious pleasure. And
she imagined setting it out artfully, the white meat,
the breads, antipasti, the mushrooms and salad
arranged down the oak counter cleanly, and how they all came
as in a dance when she called them. She carved meat
and then she was crying. Then she was in darkness
crying. She didn't know what she wanted.

THE PURE ONES

Roads to the north of here are dry.
First red buds prick out the lethal spring
and corncrakes, swarming, lower in clouds
above the fields from Paris to Béziers.
This is God's harvest: the village boy
whose tongue was sliced in two,
the village crones slashing cartilage
at the knees to crawl to Carcassonne.
—If the world were not evil in itself,
the blessed one said, then every choice
would not constitute a loss.
This sickness of this age is flesh,
he said. Therefore we build with stone.
The dead with their black lips are heaped
on one another, intimate as lovers.

THE GARDEN OF DELIGHT

The floor hurts so much it whines
whichever way they step,
as if it had learned the trick
of suffering.
Poor floor.
This is the garden of delight,
a man pointing at a woman
and a bird perched
on a cylinder of crystal
watching. She has a stopper
in her mouth or the paint
has blistered, long ago, just there.
He looks worried, but not terrified,
not terrified, and he doesn't move.
It's an advantage of paintings.
You don't have to.
I used to name the flowers—
beard tongue, stonecrop,
pearly everlasting.

SANTA LUCIA

I.

Art & love: he camps outside my door,
innocent, carnivorous. As if desire
were actually a flute, as if the little song
transcend, transcend could get you anywhere.
He brings me wine; he believes in the arts
and uses them for beauty. He brings me
vinegar in small earthen pots, postcards
of the hillsides by Cézanne desire has left
alone, empty farms in August and the vague
tall chestnut trees at Jas de Bouffan, fetal
sandstone rifted with mica from the beach.
He brings his body, wolfish, frail,
all brown for summer like croissant crusts
at La Seine in the Marina, the bellies
of pelicans I watched among white dunes
under Pico Blanco on the Big Sur coast.
It sickens me, this glut & desperation.

II.

Walking the Five Springs trail, I tried to think.
Dead-nettle, thimbleberry. The fog heaved in
between the pines, violet sparrows made curves
like bodies in the ruined air. *All women
are masochists.* I was so young, believing
every word they said. *Dürer is second-rate.*
Dürer's Eve feeds her apple to the snake;

snaky tresses, cat at her feet, at Adam's foot
a mouse. Male fear, male eyes and art. The art
of love, the eyes I use to see myself
in love. Ingres, pillows. I think the erotic
is not sexual, only when you're lucky.
That's where the path forks. It's not the riddle
of desire that interests me; it is the riddle
of good hands, chervil in a windowbox,
the white pages of a book, someone says
I'm tired, someone turning on the light.

III.

Streaked in the window, the city wavers
but the sky is empty, clean. Emptiness
is strict; that pleases me. I do cry out.
Like everyone else, I thrash, am splayed.
Oh, oh, oh, oh. Eyes full of wonder.
Guernica. Ulysses on the beach. I see
my body is his prayer. I see my body.
Walking in the galleries at the Louvre,
I was, each moment, naked & possessed.
Tourists gorged on goosenecked Florentine girls
by Pollaiuolo. He sees me like a painter.
I hear his words for me: white, gold.
I'd rather walk the city in the rain.
Dog shit, traffic accidents. Whatever god
there is dismembered in his Chevy.
A different order of religious awe:
agony & meat, everything plain afterward.

IV.

Santa Lucia: eyes jellied on a plate.
The thrust of serpentine was almost green
all through the mountains where the rock cropped out.
I liked sundowns, dusks smelling of madrone,
the wildflowers, which were not beautiful,
fierce little wills rooting in the yellow
grass year after year, thirst in the roots,
mineral. They have intelligence
of hunger. Poppies lean to the morning sun,
lupine grows thick in the rockface, self-heal
at creekside. He wants to fuck. Sweet word.
All suction. I want less. Not that I fear
the huge dark of sex, the sharp sweet light,
light if it were water raveling, rancor,
tenderness like rain. What I want happens
not when the deer freezes in the shade
and looks at you and you hold very still
and meet her gaze but in the moment after
when she flicks her ears & starts to feed again.

To a Reader

I've watched memory wound you.
I felt nothing but envy.
Having slept in wet meadows,
I was not through desiring.
Imagine January and the beach,
a bleached sky, gulls. And
look seaward: what is not there
is there, isn't it, the huge
bird of the first light
arched above first waters
beyond our touching or intention
or the reasonable shore.

The Origin of Cities

She is first seen dancing which is a figure
not for art or prayer or the arousal of desire
but for action simply; her breastband is copper,
her crown imitates the city walls. Though she draws us
to her, like a harbor or a river mouth she sends us away.
A figure of the outward. So the old men grown lazy
in patrician ways lay out cash for adventures.
Imagining a rich return, they buy futures
and their slaves haunt the waterfront for news of ships.
The young come from the villages dreaming.
Pleasure and power draw them. They are employed
to make inventories and grow very clever,
multiplying in their heads, deft at the use of letters.
When they are bored, they write down old songs from the villages,
and the cleverest make new songs in the old forms
describing the pleasures of the city, their mistresses,
old shepherds and simpler times. And the temple
where the farmer grandfathers of the great merchants worshipped,
the dim temple across from the marketplace
which was once a stone altar in a clearing in the forest,
where the nightwatch pisses now against a column in the moonlight,
is holy to them; the wheat mother their goddess of sweaty sheets,
of what is left in the air when that glimpsed beauty
turns the corner, of love's punishment and the wracking
of desire. They make songs about that. They tell
stories of heroes and brilliant lust among the gods.
These are amusements. She dances, the ships go forth,
slaves and peasants labor in the fields, maimed soldiers
ape monkeys for coins outside the wineshops,
the craftsmen work in bronze and gold, accounts
are kept carefully, what goes out, what returns.

WINTER MORNING IN CHARLOTTESVILLE

Lead skies
and gothic traceries of poplar.
In the sacrament of winter
Savonarola raged against the carnal word.

Inside the prism of that eloquence
even Botticelli renounced the bestial gods
and beauty.
 Florentine vanity
gathers in the dogwood buds.
How sexual
this morning is the otherwise
quite plain
white-crowned sparrow's
plumed head!
 By a natural
selection, the word
originates its species,
 the blood flowers,
republics scrawl their hurried declarations
& small birds scavenge
 in the chaste late winter grass.

OLD DOMINION

The shadows of late afternoon and the odors
of honeysuckle are a congruent sadness.
Everything is easy but wrong. I am walking
across thick lawns under maples in borrowed tennis whites.
It is like the photographs of Randall Jarrell
I stared at on the backs of books in college.
He looked so sad and relaxed in the pictures.
He was translating Chekhov and wore tennis whites.
It puzzled me that in his art, like Chekhov's,
everyone was lost, that the main chance was never seized
because it is only there as a thing to be dreamed of
or because someone somewhere had set the old words
to the old tune: we live by habit and it doesn't hurt.
Now the *thwack* . . . *thwack* of tennis balls being hit
reaches me and it is the first sound of an ax
in the cherry orchard or the sound of machine guns
where the young terrorists are exploding
among poor people on the streets of Los Angeles.
I begin making resolutions: to take risks, not to stay
in the south, to somehow do honor to Randall Jarrell,
never to kill myself. Through the oaks I see the courts,
the nets, the painted boundaries, and the people in tennis
whites who look so graceful from this distance.

MONTICELLO

Snow is falling
on the age of reason, on Tom Jefferson's
 little hill & on the age of sensibility.

 Jane Austen isn't walking in the park,
she considers that this gray crust
 of an horizon will not do;
she is by the fire, reading William Cowper,
 and Jefferson, if he isn't dead,
has gone down to Kmart
 to browse among the gadgets:
 pulleys, levers, the separation of powers.

I try to think of history: the mammoth
 jawbone in the entry hall,
Napoléon in marble,
 Meriwether Lewis dead at Grinder's Trace.

 I don't want the powers separated,
one wing for Governor Randolph when he comes,
 the other wing for love,
 private places
 in the public weal
 that ache against the teeth like ice.

 Outside this monument, the snow
catches, star-shaped,
 in the vaginal leaves of old magnolias.

EMBLEMS OF A PRIOR ORDER

(For Louise)

Patient cultivation,
as the white petals of
the climbing rose

were to some man
a lifetime's careful work,
the mess of petals

on the lawn was bred
to fall there as a dog
is bred to stand—

gardens are a history
of art, this fin de siècle
flower & Dobermann's

pinscher, all deadly
sleekness in the neighbor's
yard, were born, *brennende*

liebe, under the lindens
that bear the morning
toward us on a silver tray.

WEED

Horse is Lorca's word, fierce as wind,
or melancholy, gorgeous, Andalusian:
 white horse grazing near the river dust;
and parsnip is hopeless,
 second cousin to the rhubarb
which is already second cousin
 to an apple pie. Marrying the words
to the coarse white umbels sprouting
 on the first of May is history
but conveys nothing; it is not the veined
 body of Queen Anne's lace
I found, bored, in a spring classroom
 from which I walked hands tingling
for the breasts that are meadows in New Jersey
 in 1933; it is thick, shaggier, and the name
is absurd. It speaks of durable
 unimaginative pleasures: reading Balzac,
fixing the window sash, rising
 to a clean kitchen, the fact
that the car starts & driving to work
 through hills where the roadside thickens
with the green ungainly stalks,
 the bracts and bright white flowerets
 of horse-parsnips.

CHILD NAMING FLOWERS

When old crones wandered in the woods,
I was the hero on the hill
in clear sunlight.

Death's hounds feared me.

Smell of wild fennel,
high loft of sweet fruit high in the branches
of the flowering plum.

Then I am cast down
into the terror of childhood,
into the mirror and the greasy knives,
the dark
woodpile under the fig trees
in the dark.
 It is only
the malice of voices, the old horror
that is nothing, parents
quarreling, somebody
drunk.

I don't know how we survive it.
On this sunny morning
in my life as an adult, I am looking
at one clear pure peach
in a painting by Georgia O'Keeffe.
It is all the fullness that there is
in light. A towhee scratches in the leaves

outside my open door.
He always does.

A moment ago I felt so sick
and so cold
I could hardly move.

PICKING BLACKBERRIES WITH A FRIEND WHO HAS BEEN READING JACQUES LACAN

August is dust here. Drought
stuns the road,
but juice gathers in the berries.

We pick them in the hot
slow-motion of midmorning.
Charlie is exclaiming:

for him it is twenty years ago
and raspberries and Vermont.
We have stopped talking

about *L'Histoire de la vérité*,
about the subject and object
and the mediation of desire.

Our ears are stoppered
in the bee-hum. And Charlie,
laughing wonderfully,

beard stained purple
by the word *juice*,
goes to get a bigger pot.

THE BEGINNING OF SEPTEMBER

I.

The child is looking in the mirror.
His head falls to one side, his shoulders slump.
He is practicing sadness.

II.

He didn't think she ought to
and she thought she should.

III.

In the summer
peaches the color of sunrise

In the fall
plums the color of dusk

IV.

Each thing moves its own way
in the wind. Bamboo flickers,
the plum tree waves, and the loquat
is shaken.

V.

The dangers are everywhere. Auxiliary verbs, fishbones, a fine careless-
ness. No one really likes the odor of geraniums, not the woman who
dreams of sunlight and is always late for work nor the man who would
be happy in altered circumstances. Words are abstract, but *words are
abstract* is a dance, car crash, heart's delight. It's the design dumb hun-
ger has upon the world. Nothing is severed on hot mornings when the
deer nibble flower heads in a simmer of bay leaves. Somewhere in the
summer dusk is the sound of children setting the table. That is mastery:
spoon, knife, folded napkin, fork; glasses all around. The place for the
plate is wholly imagined. Mother sits here and Father sits there and this
is your place and this is mine. A good story compels you like sexual
hunger but the pace is more leisurely. And there are always melons.

VI.

little mother
little dragonfly quickness of summer mornings
this is a prayer
this is the body dressed in its own warmth
at the change of seasons

VII.

There are not always melons
There are always stories

VIII.

Chester found a dozen copies of his first novel in a used bookstore and took them to the counter. The owner said, "You can't have them all," so Chester kept five. The owner said, "That'll be a hundred and twelve dollars." Chester said, "What?" and the guy said, "They're first editions, Mac, twenty bucks apiece." And so Chester said, "Why are you charging me a hundred and twelve dollars?" The guy said, "Three of them are autographed." Chester said, "Look, I wrote this book." The guy said, "All right, a hundred. I won't charge you for the autographs."

IX.

The insides of peaches
are the color of sunrise

The outsides of plums
are the color of dusk

X.

Here are some things to pray to in San Francisco: the bay, the mountain, the goddess of the city; remembering, forgetting, sudden pleasure, loss; sunrise and sunset; salt; the tutelary gods of Chinese, Japanese, Russian, Basque, French, Italian, and Mexican cooking; the solitude of coffeehouses and museums; the virgin, mother, and widow moons; hilliness, vistas; John McLaren; Saint Francis; the Mother of Sorrows; the rhythm of any life still whole through three generations; wine, especially zinfandel because from that Hungarian vine-slip came first a native wine not resinous and sugar-heavy; the sourdough mother, yeast and beginning; all fish and fisherman at the turning of the tide; the turning of the tide; eelgrass, oldest inhabitant; fog; seagulls; Joseph Worcester; plum blossoms; warm days in January . . .

XI.

She thought it was a good idea.
He had his doubts.

XII.

ripe blackberries

XIII.

She said: reside, reside
and he said, gored heart
She said: sunlight, cypress
he said, idiot children
nibbling arsenic in flaking paint
she said: a small pool of semen
translucent on my belly
he said maybe he said
maybe

XIV.

the sayings of my grandmother:
they're the kind of people
who let blackberries rot on the vine

XV.

The child approaches the mirror very fast
then stops

and watches himself
gravely.

XVI.

So summer gives over—
white to the color of straw
dove gray to slate blue
 burnishings
a little rain
a little light on the water

NOT GOING TO NEW YORK: A LETTER

Dear Dan—
 This is a letter of apology, unrhymed.
Rhyme belongs to the dazzling couplets of arrival.
Survival is the art around here. It rhymes by accident
with the rhythm of days which arrive like crows in a field
of stubble corn in upstate New York in February.
In upstate New York in February thaws hardened the heart
against the wish for spring. There was not one thing
in the barren meadows not muddy and raw-fleshed.
At night I dreamed of small black snakes with orange markings
disappearing down their holes, of being lost in the hemlocks
and coming to a clearing of wild strawberry, sunlight,
abandoned apple trees. At night it was mild noon in a clearing.
Nothing arrived. This was a place left to flower
in the plain cruelty of light. Mornings the sky was opal.
The windows faced east and a furred snow reassumed the pines
but arrived only mottled in the fields so that its flesh
was my grandmother's in the kitchen of the house
on Jackson Street, and she was crying. I was a good boy.
She held me so tight when she said that, smelling like sleep
rotting if sleep rots, that I always knew how death would come
to get me and the soft folds of her quivery white neck
were what I saw, so that sometimes on an airplane I look down
to snow covering the arroyos on the east side of the Sierra
and it's grandmother's flesh and I look away. In the house
on Jackson Street, I am the figure against the wall
in Bonnard's *The Breakfast Room*. The light is terrible. It is
wishes that are fat dogs, already sated, snuffling
at the heart in dreams. The table linen is so crisp
it puts an end to fantasies of rectitude, clean hands, high art,
and the blue beside the white in the striping is the color

of the river Loire when you read about it in old books
and dreamed of provincial breakfasts, the sun the color
of bread crust and the fruit icy cold and there was no
terrified figure dwarflike and correct, disappearing
off the edge of Bonnard's *The Breakfast Room*. It was not
grandmother weeping in the breakfast room or the first thaw
dream of beautiful small snakes slithering down holes.
In this life that is not dreams but my life
the clouds above the bay are massing toward December
and gulls hover in the storm-pearled air and the last
of last season's cedar spits and kindles on the fire.
Summer dries us out with golden light, so winter
is a kind of spring here—wet trees, a reptile odor
in the earth, mild greening—and the seasonal myths
lie across one another in the quick darkening of days.
Kristin and Luke are bent to a puzzle, some allegory
of the quattrocento cut in a thousand small uneven pieces
which, on the floor, they recompose with rapt,
leisurely attention. Kristin asks, searching
for a piece round at one end, fluted at the other,
"Do you know what a shepherd is?" and Luke, looking for
a square edge with a sprig of Italian olive in it,
makes a guess. "Somebody who hurts sheep."
My grandmother was not so old. She was my mother's mother;
I think, the night before, my father must have told her
we were going to move. She held me weeping, probably,
because she felt she was about to lose her daughter.
We only buried her this year. In the genteel hotel
on Leavenworth that looked across a mile of human misery
to the bay, she smoked regally, complained about her teeth.
Luke watched her wide-eyed, with a mingled look of wonder
and religious dread she seemed so old. And once,
when he reached up involuntarily to touch her withered cheek,
she looked at him awhile and patted his cheek back and winked

and said to me, askance: "Old age ain't for sissies."
This has nothing to do with the odd terror in my memory.
It only explains it—the way this early winter weather
makes life seem more commonplace and—at a certain angle—
more intense. It is not poetry, where decay and a created
radiance lie hidden inside words the way that memory
folds them into living. "O Westmoreland thou art a summer bird
that ever in the haunch of winter sings the lifting up of day."
Pasternak translated those lines. I imagine Russian summer,
the smell of jasmine drifting toward the porch. I would like
to get on a plane, but I would also like to sit on the porch
and watch one shrink to the hovering of gulls and glint
in the distance, circle east toward snow and disappear.
He would have noticed the articles as a native speaker wouldn't:
a bird, *the* haunch; and understood a little what persists
when, eyes half-closed, lattice-shadow on his face,
he murmured the phrase in the dark vowels of his mother tongue.

Songs to Survive the Summer

It's funny, isn't it, Karamazov,
all this grief and pancakes afterwards . . .

These are the dog days,
unvaried
except by accident,

mist rising from soaked lawns,
gone world, everything
rises and dissolves in air,

whatever it is would
clear the air
dissolves in air and the knot

of day unties
invisibly like a shoelace.
The gray-eyed child

who said to my child: "Let's play
in my yard. It's OK,
my mother's dead."

*

Under the loquat tree.
It's almost a song,
the echo of a song:

on the bat's back I fly
merrily toward summer
or at high noon

in the outfield clover
guzzling Orange Crush,
time endless, examining

a wooden coin I'd carried
all through summer
without knowing it.

The coin was grandpa's joke,
carved from live oak,
Indian side and buffalo side.

His eyes lustered with a mirth
so deep and rich he never
laughed, as if it were a cosmic

secret that we shared.
I never understood; it married
in my mind with summer. Don't

take any wooden nickels,
kid, and gave me one
under the loquat tree.

✳

The squalor of mind
is formlessness,
informis,

the Romans said of ugliness,
it has no form,
a man's misery, bleached skies,

the war between desire
and dailiness. I thought
this morning of Wallace Stevens

walking equably to work
and of a morning two Julys ago
on Chestnut Ridge, wandering

down the hill when one
rusty elm leaf, earth-
skin peeling, wafted

by me on the wind.
My body groaned toward fall
and preternaturally

a heron lifted from the pond.
I even thought I heard
the ruffle of the wings

three hundred yards below me
rising from the reeds.
Death is the mother of beauty

and that clean-shaven man
smelling of lotion,
lint-free, walking

toward his work, a
pure exclusive music
in his mind.

✳

The mother of the neighbor
child was thirty-one,
died, at Sunday breakfast,

of a swelling in the throat.
On a toy loom
she taught my daughter

how to weave. My daughter
was her friend
and now she cannot sleep

for nighttime sirens,
sure that every wail
is someone dead.

Should I whisper in her ear,
death is the mother
of beauty? Wooden

nickels, kid? It's all in
shapeliness, give your
fears a shape?

＊

In fact, we hide together
in her books.
Prairie farms, the heron

knows the way, old
country songs, herbal magic,
recipes for soup,

tales of spindly orphan
girls who find
the golden key, the
darkness at the center
of the leafy wood.
And when she finally sleeps

I try out Chekhov's
tenderness to see
what it can save.

⁕

Maryushka the beekeeper's
widow,
though three years mad,

writes daily letters
to her son. Semyon tran-
scribes them. The pages

are smudged by his hands,
stained with
the dregs of tea:

"My dearest Vanushka,
Sofia Agrippina's ill
again. The master

asks for you. Wood
is dear. The cold
is early. Poor

Sofia Agrippina!
The foreign doctor
gave her salts

but Semyon says her icon
candle guttered
St. John's Eve. I am afraid,

Vanya. When she's ill,
the master likes to have
your sister flogged.

She means no harm.
The rye is gray
this time of year.

When it is bad, Vanya,
I go into the night
and the night eats me."

✳

The haiku comes
in threes
with the virtues of brevity:

What a strange thing!
To be alive
beneath plum blossoms.

The black-headed
Steller's jay is squawking
in our plum.

Thief! Thief!
A hard, indifferent bird,
he'd snatch your life.

✳

The love of books
is for children
who glimpse in them

a life to come, but
I have come
to that life and

feel uneasy
with the love of books.
This is my life,

time islanded
in poems of dwindled time.
There is no other world.

*

But I have seen it twice.
In the Palo Alto marsh
sea birds rose in early light

and took me with them.
Another time, dreaming,
river birds lifted me,

swans, small angelic terns,
and an old woman in a shawl
dying by a dying lake

whose life raised men
from the dead
in another country.

*

Thick nights, and nothing
lets us rest. In the heat
of mid-July our lust

is nothing. We swell
and thicken. Slippery,
purgatorial, our sexes

will not give us up.
Exhausted after hours
and not undone,

we crave cold marrow
from the tiny bones that
moonlight scatters

on our skin. Always
morning arrives,
the stunned days,

faceless, droning
in the juice of rotten quince,
the flies, the heat.

*

Tears, silence.
The edified generations
eat me, Maryushka.

I tell them
pain is form and
almost persuade

myself. They are not
listening. Why
should they? Who

cannot save me anymore
than I, weeping
over *Great Russian Short*

Stories in summer,
under the fattened figs,
saved you. Besides,

it is winter there.
They are trying out
a new recipe for onion soup.

*

Use a heavy-bottomed
three- or four-quart pan.
Thinly slice six large

yellow onions and sauté
in olive oil and butter
until limp. Pour in

beef broth. Simmer
thirty minutes,
add red port and bake

for half an hour. Then
sprinkle half a cup
of diced Gruyère and cover

with an even layer
of toasted bread and
shredded Samsoe. Dribble

melted butter on the top
and bake until the cheese
has bubbled gold.

Surround yourself with friends.
Huddle in a warm place.
Ladle. Eat.

＊

Weave and cry.
Child, every other siren
is a death;

the rest are for speeding.
Look how comically the jay's
black head emerges

from a swath of copper leaves.
Half the terror
is the fact that,

in our time, speed saves us,
a whine we've traded
for the hopeless patience

of the village bell
which tolled in threes:
weave and cry and weave.

＊

Wilhelm Steller, form's
hero, made
a healing broth.

He sailed with Bering
and the crew despised him,
a mean impatient man

born low enough
to hate the lower class.
For two years

he'd connived to join
the expedition and put
his name to all the beasts

and flowers of the north.
Now, Bering sick,
the crew half-mad with scurvy,

no one would let him
go ashore. Panic,
the maps were useless,

the summer weather almost gone.
He said, there are herbs
that can cure you,

I can save you all. He didn't
give a damn about them
and they knew it. For two years

he'd prepared. Bering listened.
Asleep in his bunk, he'd
seen death writing in the log.

On the island while
the sailors searched for water
Steller gathered herbs

and looking up
he saw the blue, black-crested
bird, shrilling in a pine.

His mind flipped to
Berlin, the library, a glimpse
he'd had at Audubon,

a blue-gray crested bird
exactly like the one
that squawked at him, a

Carolina jay, unlike
any European bird; he knew
then where they were,

America, we're saved.
No one believed him or,
sick for home, they didn't care

what wilderness
it was. They set sail
west. Bering died.

Steller's jay, by which
I found Alaska.
He wrote it in his book.

⁂

Saved no one. Still
walking in the redwoods
I hear the cry

thief, thief, and
think of Wilhelm Steller;
in my dream we

are all saved. Camping
on a clement shore
in early fall, a strange land.

We feast most delicately.
The swans are stuffed with grapes,
the turkey with walnut

and chestnut and wild plum.
The river is our music: *unalaska*
(to make bread from acorns

we leach the tannic acid out—
this music, child,
and more, much more!).

⁂

When I was just
your age, the war was over
and we moved.

An Okie family lived
next door to our new
country house. That summer

Quincy Phipps was saved.
The next his house became
an unofficial Pentecostal church.

Summer nights: hidden
in the garden I ate figs,
watched where the knobby limbs

rose up and flicked
against the windows where
they were. *O Je-sus.*

Kissed and put to bed,
I slipped from the window
to the eaves and nestled

by the loquat tree.
The fruit was yellow-brown
in daylight; under the moon

pale clusters hung
like other moons, *O*
Je-sus, and I picked them;

the fat juices
dribbling down my chin,
I sucked and listened.

Men groaned. The women
sobbed and moaned, a
long unsteady belly-deep

bewildering sound, half
pleasure and half pain
that ended sometimes

in a croon, a broken song:
O Je-sus,
Je-sus.

 ✳

That is what I have
to give you, child, stories,
songs, loquat seeds,

curiously shaped; they
are the frailest stay against
our fears. Death

in the sweetness, in the bitter
and the sour, death
in the salt, your tears,

this summer ripe and overripe.
It is a taste in the mouth,
child. We are the song

death takes its own time
singing. It calls us
as I call you *child*

to calm myself. It is every
thing touched casually,
lovers, the images

of saviors, books, the coin
I carried in my pocket
till it shone, it is

all things lustered
by the steady thoughtlessness
of human use.

Human Wishes

SPRING DRAWING

A man thinks *lilacs against white houses*, having seen them in the farm country south of Tacoma in April, and can't find his way to a sentence, a brushstroke carrying the energy of *brush* and *stroke*

—as if he were stranded on the aureole of the memory of a woman's breast,

and she, after the drive from the airport and a chat with her mother and a shower, which is ritual cleansing and a passage through water to mark transition,

had walked up the mountain on a summer evening.

Away from, not toward. As if the garden roses were a little hobby of the dead. As if the deer pellets in the pale grass and the wavering moon and the rondure—as they used to say, upping the ante—of heaven

were admirable completely, but only as common nouns of a plainer intention, *moon, shit, sky,*

as if spirit attended to plainness only, the more complicated forms exhausting it, tossed-off grape stems becoming crystal chandeliers,

as if radiance were the meaning of meaning, and justice responsible to daydream not only for the strict beauty of denial,

but as a need to reinvent the inner form of wishing.

Only the force of the brushstroke keeps the lilacs from pathos—the hes and shes of the comedy may or may not get together, but if they are to get at all,

then the interval created by *if*, to which mind and breath attend, nervous as the grazing animals the first brushes painted,

has become habitable space, lived in beyond wishing.

VINTAGE

They had agreed, walking into the delicatessen on Sixth Avenue, that
their friends' affairs were focused and saddened by massive projection;

movie screens in their childhood were immense, and someone had pro-
posed that need was unlovable.

The delicatessen had a chicken salad with chunks of cooked chicken
in a creamy basil mayonnaise a shade lighter than the Coast Range in
August; it was gray outside, February.

Eating with plastic forks, walking and talking in the sleety afternoon,
they passed a house where Djuna Barnes was still, reportedly, making
sentences.

Bashō said: avoid adjectives of scale, you will love the world more and
desire it less.

And there were other propositions to consider: childhood, VistaVision,
a pair of wet, mobile lips on the screen at least eight feet long.

On the corner a blind man with one leg was selling pencils. He must
have received a disability check,

but it didn't feed his hunger for public agony, and he sat on the sidewalk
slack-jawed, with a tin cup, his face and opaque eyes turned upward in a
look of blind, questing pathos—

half Job, half mole.

Would the good Christ of Manhattan have restored his sight and two thirds of his left leg? Or would he have healed his heart and left him there in a mutilated body? And what would that peace feel like?

It makes you want, at this point, a quick cut, or a reaction shot. "The taxis rivered up Sixth Avenue." "A little sunlight touched the steeple of the First Magyar Reform Church."

In fact, the clerk in the liquor store was appalled. "No, no," he said, "that cabernet can't be drunk for another five years."

Spring Rain

Now the rain is falling, freshly, in the intervals between sunlight,

a Pacific squall started no one knows where, drawn east as the drifts of warm air make a channel;

it moves its own way, like water or the mind,

and spills this rain passing over. The Sierras will catch it as last snow flurries before summer, observed only by the wakened marmots at ten thousand feet,

and we will come across it again as larkspur and penstemon sprouting along a creek above Sonora Pass next August,

where the snowmelt will have trickled into Deadman Creek and the creek spilled into the Stanislaus and the Stanislaus into the San Joaquin and the San Joaquin into the slow salt marshes of the bay.

That's not the end of it: the gray jays of the mountains eat larkspur seeds, which cannot propagate otherwise.

To simulate the process, you have to soak gathered seeds all night in the acids of coffee

and then score them gently with a very sharp knife before you plant them in the garden.

You might use what was left of the coffee we drank in Lisa's kitchen visiting.

There were orange poppies on the table in a clear glass vase, stained near the bottom to the color of sunrise;

the unstated theme was the blessedness of gathering and the blessing of dispersal—

it made you glad for beauty like that, casual and intense, lasting as long as the poppies last.

LATE SPRING

And then in mid-May the first morning of steady heat,

the morning, Leif says, when you wake up, put on shorts, and that's it
for the day,

when you pour coffee and walk outside, blinking in the sun.

Strawberries have appeared in the markets, and peaches will soon;

squid is so cheap in the fish stores you begin to consult Japanese and
Italian cookbooks for the various and ingenious ways of preparing *ika*
and *calamari*;

and because the light will enlarge your days, your dreams at night will
be as strange as the jars of octopus you saw once in a fisherman's boat
under the summer moon;

and after swimming, white wine; and the sharing of stories before din-
ner is prolonged because the relations of the children in the neighbor-
hood have acquired village intensity and the stories take longer telling;

and there are the nights when the fog rolls in that nobody likes—hey,
fog, the Miwok sang, who lived here first, you better go home, pelican
is beating your wife—

and after dark in the first cool hour, your children sleep so heavily in
their beds exhausted from play, it is a pleasure to watch them,

Leif does not move a muscle as he lies there; no, wait; it is Luke who
lies there in his eight-year-old body,

Leif is taller than you are and he isn't home; when he is, his feet will extend past the end of the mattress, and Kristin is at the corner in the dark, talking to neighborhood boys;

things change; there is no need for this dream-compelled narration; the rhythm will keep me awake, changing.

The archbishop of San Salvador is dead, murdered by no one knows
who. The left says the right, the right says provocateurs.

But the families in the barrios sleep with their children beside them and
a pitchfork, or a rifle if they have one.

And posterity is grubbing in the footnotes to find out who the bishop is,

or waiting for the poet to get back to his business. Well, there's this:

her breasts are the color of brown stones in moonlight, and paler in
moonlight.

And that should hold them for a while. The bishop is dead. Poetry
proposes no solutions: it says justice is the well water of the city of
Novgorod, black and sweet.

César Vallejo died on a Thursday. It might have been malaria, no one
is sure; it burned through the small town of Santiago de Chuco in an
Andean valley in his childhood; it may very well have flared in his veins
in Paris on a rainy day;

and nine months later Osip Mandelstam was last seen feeding off the
garbage heap of a transit camp near Vladivostok.

They might have met in Leningrad in 1931, on a corner; two men about
forty; they could have compared gray hair at the temples, or compared
reviews of *Trilce* and *Tristia* in 1922.

What French they would have spoken! And what the one thought
would save Spain killed the other.

"I am no wolf by blood," Mandelstam wrote that year. "Only an equal could break me."

And Vallejo: "Think of the unemployed. Think of the forty million families of the hungry. . . ."

Spring Drawing 2

A man says *lilacs against white houses, two sparrows, one streaked, in a thinning birch,* and can't find his way to a sentence.

In order to be respectable, Thorstein Veblen said, desperate in Palo Alto, a thing must be wasteful, i.e., "a selective adaptation of forms to the end of conspicuous waste."

So we try to throw nothing away, as Keith, making dinner for us as his grandmother had done in Jamaica, left nothing; the kitchen was as clean at the end as when he started; even the shrimp shells and carrot fronds were part of the process,

and he said, when we tried to admire him, "Listen, I should send you into the chicken yard to look for a rusty nail to add to the soup for iron."

The first temptation of Sakyamuni was desire, but he saw that it led to fulfillment and then to desire, so that one was easy.

Because I have pruned it badly in successive years, the climbing rose has sent out, among the pale pink floribunda, a few wild white roses from the rootstalk.

Suppose, before they said *silver* or *moonlight* or *wet grass,* each poet had to agree to be responsible for the innocence of all the suffering on earth,

because they learned in arithmetic, during the long school days, that if there was anything left over,

you had to carry it. The wild rose looks weightless, the floribunda are heavy with the richness and sadness of Europe

as they imitate the dying, petal by petal, of the people who bred them.

You hear pain singing in the nerves of things; it is not a song.

The gazelle's head turned; three jackals are eating his entrails and he is watching.

CALM

1.

September sun, a little fog in the mornings. No sanctified terror. At
night Luke says, "How do you connect a *b* to an *a* in cursive?" He is
bent to the task with such absorption that he doesn't notice the Scarlatti
on the stereo, which he would in other circumstances turn off. He has
said that chamber music sounds to him worried. I go out and look at
the early stars. They glow faintly; faintly the mountain is washed in
the color of sunset, at that season a faded scarlet like the petals of the
bougainvillea which is also fading. A power saw, somewhere in the
neighborhood, is enacting someone's idea of more pleasure, an extra
room or a redwood tub. It hums and stops, hums and stops.

2.

In the dream there was a face saying no. Not with words. Brow furrow,
crow's-feet, lip curl: no, it is forbidden to you, no. But it was featureless,
you could put your hand through it and feel cold on the other side. It
was not the father-face saying no among the torsos and pillars of alu-
minum nor the mother-face weeping no, no, no at the gate that guards
rage; it was not even the idiot face of the obedient brother tacking his
list of a hundred and seventy-five reasons why not on the greenhouse
door. This face spits on archetypes, spits on caves, rainbows, the little
human luxury of historical explanation. The meadow, you remember
the meadow? And the air in June which held the scent of it as the
woman in religious iconography holds the broken son? You can go into
that meadow, the light routed by a brilliant tenderness of green, a cool
V carved by a muskrat in the blue-gray distance of the pond, black-
eyed Susans everywhere. You can go there.

MUSEUM

On the morning of the Käthe Kollwitz exhibit, a young man and
woman come into the museum restaurant. She is carrying a baby; he
carries the air-freight edition of the Sunday *New York Times*. She sits
in a high-backed wicker chair, cradling the infant in her arms. He fills
a tray with fresh fruit, rolls, and coffee in white cups and brings it to
the table. His hair is tousled, her eyes are puffy. They look like they
were thrown down into sleep and then yanked out of it like divers
coming up for air. He holds the baby. She drinks coffee, scans the front
page, butters a roll, and eats it in their little corner in the sun. After
a while, she holds the baby. He reads the *Book Review* and eats some
fruit. Then he holds the baby while she finds the section of the paper
she wants and eats fruit and smokes. They've hardly exchanged a look.
Meanwhile, I have fallen in love with this equitable arrangement, and
with the baby who cooperates by sleeping. All around them are faces
Käthe Kollwitz carved in wood of people with no talent or capacity for
suffering who are suffering the numbest kinds of pain: hunger, helpless
terror. But this young couple is reading the Sunday paper in the sun,
the baby is sleeping, the green has begun to emerge from the rind of the
cantaloupe, and everything seems possible.

NOVELLA

A woman who, as a thirteen-year-old girl, develops a friendship with
a blind painter, a painter who is going blind. She is Catholic, lives in
the country. He rents a cabin from her father, and she walks through
the woods—redwood, sword fern, sorrel—to visit him. He speaks to
her as an equal and shows her his work. He has begun to sculpt but still
paints, relying on color and the memory of line. He also keeps English
biscuits in a tin and gives her one each visit. She would like more but he
never gives her more. When he undresses her, she sometimes watches
him, watches his hands which are thick and square, or his left eye with a
small cloud like gray phlegm on the retina. But usually not. Usually she
thinks of the path to his house, whether deer had eaten the tops of the
fiddleheads, why they don't eat the peppermint saprophytes sprouting
along the creek; or she visualizes the approach to the cabin, its large
windows, the fuchsias in front of it where Anna's hummingbirds always
hover with dirty green plumage and jeweled throats. Sometimes she
thinks about her dream, the one in which her mother wakes up with
no hands. The cabin smells of oil paint, but also of pine. The painter's
touch is sexual and not sexual, as she herself is. From time to time
she remembers this interval in the fall and winter of ninth grade. By
spring the painter had moved. By summer her period had started. And
after that her memory blurred, speeding up. One of her girlfriends
French-kissed a boy on a Friday night in the third row from the back
at the Tamalpais theater. The other betrayed her and the universe by
beginning to hang out with the popular girls whose fathers bought
them cars. When the memory of that time came to her, it was touched
by strangeness because it formed no pattern with the other events in her
life. It lay in her memory like one piece of broken tile, salmon-colored
or the deep green of wet leaves, beautiful in itself but unusable in the
design she was making. Just the other day she remembered it. Her
friends were coming up from the beach with a bucket full of something,

smiling and waving to her, shouting something funny she couldn't make out, and suddenly she was there—the light flooding through the big windows, the litter of canvases, a white half-finished torso on the worktable, the sweet, wheaty odor of biscuits rising from the just-opened tin.

CHURCHYARD

Somerset Maugham said a professional was someone who could do his best work when he didn't particularly feel like it. There was a picture of him in the paper, a face lined deeply and morally like Auden's, an old embittered tortoise, the corners of the mouth turned down resolutely to express the idea that everything in life is small change. And what he said when he died: I'm all through, the clever young men don't write essays about me. In the fleshly world, the red tulip in the garden sunlight is almost touched by shadow and begins to close up. Someone asked me yesterday: are deer monogamous? I thought of something I had read. When deer in the British Isles were forced to live in the open because of heavy foresting, it stunted them. The red deer who lived in the Scottish highlands a thousand years ago were a third larger than the present animal. This morning, walking into the village to pick up the car, I thought of a roof where I have slept in the summer in New York, pigeons in the early morning sailing up Fifth Avenue and silence in which you imagine the empty canyons the light hasn't reached yet. I was standing on the high street in Shelford, outside the fussy little teashop, and I thought a poem with the quick, lice-ridden pigeons in it might end: this is a dawn song in Manhattan. I hurried home to write it and, as I passed the churchyard, school was letting out. Luke was walking toward me smiling. He thought I had come to meet him. That was when I remembered the car, when he was walking toward me through the spring flowers and the eighteenth-century gravestones, his arms full of school drawings he hoped not to drop in the mud.

CONVERSION

Walking down the stairs this morning in the bitter cold, in the old house's
salt smell of decay, past the Mansergh family coat of arms on the landing,
I longed for California and thought I smelled laurel leaves: riding an
acacia limb in the spring, rivers of yellow pollen, wild fennel we broke
into six-inch lengths and threw at each other in the neighborhood wars
or crouched in thickets of broom, shooting blue jays with BB guns.
Oiseaux, I read last week when I picked up a volume of Ponge in the
bookshop on rue Racine and thought of blue jays and so bought the
Ponge, thinking I would write grave, luminous, meditative poems. And
walking across the bridge later past Notre Dame, I remembered Jack
Kjellen who lived with his mother the telephone operator and who
always wanted to pretend that we were the children of Fatima having a
vision of the Virgin, and I would have to go along for a while, hoping
to lure him back to playing pirates. Vision of Jack kneeling under the
fig tree, palms prayerfully touching, looking up awed and reverent
into the branches where the fat green figs hung like so many scrotums
among the leaves. Scrota? But they were less differentiated than that:
breasts, bottoms. The sexual ambiguity of flowers and fruits in French
botanical drawings. Oh yes, sweet hermaphrodite peaches and the
glister of plums!

Human Wishes

This morning the sun rose over the garden wall and a rare blue sky leaped from east to west. Man is altogether desire, say the Upanishads. Worth anything, a blue sky, says Mr. Acker, the Shelford gardener. Not altogether. In the end. Last night on television the ethnologist and the cameraman watched with hushed wonder while the chimpanzee carefully stripped a willow branch and inserted it into the anthill. He desired red ants. When they crawled slowly up the branch, he ate them, pinched between long fingers as the zoom lens enlarged his face. Sometimes he stopped to examine one, as if he were a judge at an ant beauty contest or God puzzled suddenly by the idea of suffering. There was an empty place in the universe where that branch wasn't and the chimp filled it, as Earlene, finding no back on an old Welsh cupboard she had bought in Saffron Walden, imagined one there and imagined both the cupboard and the imagined back against a kitchen wall in Berkeley, and went into town looking for a few boards of eighteenth-century tongue-and-groove pine to fill that empty space. I stayed home to write, or rather stayed home and stared at a blank piece of paper, waiting for her to come back, thinking tongue-and-groove, tongue-and-groove, as if language were a kind of moral cloud chamber through which the world passed and from which it emerged charged with desire. The man in the shop in Cambridge said he didn't have any old pine, but when Earlene went back after thinking about it to say she was sure she had seen some, the man found it. Right under his feet, which was puzzling. Mr. Acker, hearing the story, explained. You know, he said, a lot of fiddling goes on in those places. The first time you went in, the governor was there, the second time he wasn't, so the chap sold you some scrap and he's four quid in pocket. No doubt he's having a good time now with his mates in the pub. Or he might have put it on the horses at Newmarket. He might parlay it into a fortune.

TALL WINDOWS

All day you didn't cry or cry out and you felt like sleeping. The desire to sleep was lightbulbs dimming as a powerful appliance kicks on. You recognized that. As in school it was explained to you that pus was a brave army of white corpuscles hurling themselves at the virulent invader and dying. Riding through the Netherlands on a train, you noticed that even the junk was neatly stacked in the junkyards. There were magpies in the fields beside the watery canals, neat little houses, tall windows. In Leiden, on the street outside the university, the house where Descartes lived was mirrored in the canal. There was a pair of swans and a sense that, without haste or anxiety, all the people on the street were going to arrive at their appointments punctually. Swans and mirrors. And Descartes. It was easy to see how this European tranquillity would produce a poet like Mallarmé, a middle-class art like symbolism. And you did not despise the collective orderliness, the way the clerks in the stores were careful to put bills in the cash register with the Queen's face facing upward. In the house next to the house where Descartes lived, a Jewish professor died in 1937. His wife was a Dutch woman of strict Calvinist principles and she was left with two sons. When the Nazis came in 1940, she went to court and perjured herself by testifying that her children were conceived during an illicit affair with a Gentile, and when she developed tuberculosis in 1943, she traded passports with a Jewish friend, since she was going to die anyway, and took her place on the train to the camps. Her sons kissed her good-bye on the platform. Eyes open. What kept you awake was a feeling that everything in the world has its own size, that if you found its size among the swellings and diminishings it would be calm and shine.

THE HARBOR AT SEATTLE

They used to meet one night a week at a place on top of Telegraph Hill
to explicate Pound's *Cantos*—Peter who was a scholar; and Linda who
could recite many of the parts of the poem that envisioned paradise;
and Bob who wanted to understand the energy and surprise of its
music; and Bill who knew Greek and could tell them that "Dioce,
whose terraces were the color of stars," was a city in Asia Minor
mentioned by Herodotus.

And that winter when Bill locked his front door and shot himself in the
heart with one barrel of a twelve-gauge Browning over-and-under, the
others remembered the summer nights, after a long session of work,
when they would climb down the steep stairs that negotiated the cliff
where the hill faced the waterfront to go somewhere to get a drink and
talk. The city was all lights at that hour and the air smelled of coffee
and the bay.

In San Francisco coffee is a family business, and a profitable one, so that
members of the families are often on the society page of the newspaper,
which is why Linda remembered the wife of one of the great coffee
merchants, who had also killed herself; it was a memory from childhood,
from those first glimpses a newspaper gives of the shape of the adult
world, and it mixed now with the memory of the odor of coffee and the
salt air.

And Peter recalled that the museum had a photograph of that woman by
Minor White. They had all seen it. She had bobbed hair and a smart suit
on with sharp lapels and padded shoulders, and her skin was perfectly
clear. Looking directly into the camera, she does not seem happy but
she seems confident; and it is as if Minor White understood that her
elegance, because it was a matter of style, was historical, because
behind her is an old barn which is the real subject of the picture—the

grain of its wood planking so sharply focused that it seems alive, grays and blacks in a rivery and complex pattern of venation.

The back of Telegraph Hill was not always so steep. At the time of the earthquake, building materials were scarce, so coastal ships made a good thing of hauling lumber down from the northwest. But the economy was paralyzed, there were no goods to take back north, so they dynamited the side of the hill and used the blasted rock for ballast, and then, in port again, they dumped the rock in the water to take on more lumber, and that was how they built the harbor in Seattle.

Paschal Lamb

Well, David had said—it was snowing outside and his voice contained many registers of anger, disgust, and wounded justice, I think it's crazy. I'm not going to be a sacrificial lamb.

In Greece sometimes, a friend told me, when she walked on the high road above the sea back to her house from the village in the dark, and the sky seemed immense, the moon terribly bright, she wondered if her life would be a fit gift.

And there is that poor heifer in the poem by Keats, all decked out in ribbons and flowers, no terror in the eyes, no uncontrollable slobber of mucus at the muzzle, since she didn't understand the festivities.

And years later, after David had quit academic life, he actually bought a ranch in Kentucky near a town called Pleasureville, and began to raise sheep.

When we visited that summer and the nights were shrill with crickets and the heat did not let up, we traded stories after dinner and he told us again the story about his first teaching job and the vice president.

When he bought the place, he had continued his subscriptions to *The Guardian* and *Workers Vanguard*, but they piled up in a corner un-read. He had a mortgage to pay. He didn't know a thing about raising animals for slaughter, and so he read *The American Sheepman* with an intensity of concentration he had never even approximated when he was reading political theory for his Ph.D. orals.

The vice president of the United States, after his term in office, accepted a position as lecturer in political science at a small college in his home district, where David had just taken his first job. The dean

brought Hubert Humphrey around to introduce him to the faculty. When they came to David's office, the vice president, expensively dressed, immensely hearty, extended his hand and David did not feel he could take it because he believed the man was a war criminal; and not knowing any way to avoid the awkwardness, he said so, which was the beginning of his losing the job at that college.

But that was the dean's doing. The vice president started to cry. He had the hurt look, David said, of a kicked dog with a long, unblemished record of loyalty and affection, this man who had publicly defended, had *praised* the terror bombing of villages full of peasants. He seemed to David unimaginably empty of inner life if he could be hurt rather than affronted by a callow young man making a stiffly moral gesture in front of two men his father's age. David said that he had never looked at another human being with such icy, wondering detachment, and that he hadn't liked the sensation.

And so in the high-ceilinged kitchen, in the cricket-riddled air drenched with the odor of clover, we remembered Vic Doyno in the snow in Buffalo, in the days when the war went on continuously like a nightmare in our waking and sleeping hours.

Vic had come to work flushed with excitement at an idea he had had in the middle of the night. He had figured out how to end the war. It was a simple plan. Everyone in the country—in the world, certainly a lot of Swedish and English students would go along—who was opposed to the war would simply cut off the little finger on the left hand and send it to the president. Imagine! They would arrive slowly at first, the act of one or two maniacs, but the news would hit the newspapers and the next day there would be a few more. And the day after that more. And on the fourth day there would be thousands. And on the fifth day, clinics would be set up—organized by medical students in Madison, San Francisco, Stockholm, Paris—to deal with the surgical procedure safely and on a massive scale. And on the sixth day, the war would stop.

It would stop. The helicopters at Bien Hoa would sit on the airfields in silence like squads of disciplined mosquitoes. Peasants, worried and curious because peasants are always worried and curious, would stare up curiously into the unfamiliar quiet of a blue, cirrus-drifted sky. And years later we would know each other by those missing fingers. An aging Japanese businessman minus a little finger on his left hand would notice the similarly mutilated hand of his cab driver in Chicago, and they would exchange a fleeting unspoken nod of fellowship.

And it could happen. All we had to do to make it happen—Vic had said, while the water for tea hissed on the hot plate in David's chilly office and the snow came down thick as cotton batting, was cut off our little fingers right now, take them down to the department secretary, and have her put them in the mail.

DUCK BLIND

He was a judge in Louisiana—this is a story told by his daughter over dinner—and duck hunting was the one passion in his life. Every year during the season when the birds migrate, green-headed mallards and pintails and canvasbacks, blue-winged teal and cinnamon teal, gadwall and widgeon and scaup carried by some inward reckoning down wide migration routes in orderly flocks from Canada to Yucatán, he rose at three in the morning and hunted them. Now, at seventy-five, he still goes every day to the blind; he belongs to a club with other white men who, every morning, fathers and sons, draw lots before sunup and row quietly in skiffs to their positions. When he misses a shot, he shakes his head and says, "To shoot a duck"—it is what hunters often say—"you have to be a duck." And many mornings now he falls asleep. When five sprig circle, making a perfect pass above his blind, and all the men hold their breath and hear the silky sound of wind in the oiled feathers of the birds, and nothing happens, only silence, one of his companions will whisper to his son, "Goddammit, I think the judge is asleep again." And if it happens twice, he says, "Lennie, you better row over there and see if the judge is asleep or dead." And the son, a middle-aged man, balding, with thick, inarticulate hands, rows toward the judge's blind in the ground mist, and watches the birds veer off into the first light of the south sky.

QUARTET

The two couples having dinner on Saturday night—it is late fall—are
in their late thirties and stylish, but not slavishly so. The main course is
French, loin of pork probably, with a North African accent, and very
good. The dessert will be sweet and fresh, having to do with cream and
berries (it is early fall), and it feels like a course, it is that substantial.
They are interestingly employed: a professor of French, let's say, the
assistant curator of film at a museum, a research director for a labor
union, a psychologist (a journalist, a sculptor, an astronomer, etc.). One
of them believes that after death there is nothing, that our knowledge
of this is a fluke, or a joke like knocking on doors as children sometimes
do, and then disappearing so that the pleasure has to be in imagining
the dismay of the person who finds the entryway empty. Another believes
dimly and from time to time not in heaven exactly, but in a place where
the dead can meet and talk quietly, where losses are made good. Another
believes in the transmigration of souls, not the cosmic reform school of
Indian religion, but an unplanned passage rather like life in its mixture
of randomness and affinity. The fourth believes in ghosts, or has felt
that consciousness might take longer to perish than the body and linger
sometimes as spectral and unfinished grief, or unfinished happiness, if it
doesn't come to the same thing. They are not talking about this. They are
talking about high school (children, travel, politics—they know more
or less who is paying for their meal). Four people, the women with soft
breasts, the men with soft, ropy external genitals. In chairs, talking. It is
probably the third Saturday in September. Maybe they have had melon or
a poached pear. The hostess, a solid, placid woman with unusually large
knuckles and a good amateur soprano voice, has begun to pour coffee
into cream-colored cups.

A Story About the Body

The young composer, working that summer at an artist's colony, had watched her for a week. She was Japanese, a painter, almost sixty, and he thought he was in love with her. He loved her work, and her work was like the way she moved her body, used her hands, looked at him directly when she made amused and considered answers to his questions. One night, walking back from a concert, they came to her door and she turned to him and said, "I think you would like to have me. I would like that too, but I must tell you that I have had a double mastectomy," and when he didn't understand, "I've lost both my breasts." The radiance that he had carried around in his belly and chest cavity—like music—withered very quickly, and he made himself look at her when he said, "I'm sorry. I don't think I could." He walked back to his own cabin through the pines, and in the morning he found a small blue bowl on the porch outside his door. It looked to be full of rose petals, but he found when he picked it up that the rose petals were on top; the rest of the bowl—she must have swept them from the corners of her studio—was full of dead bees.

In the Bahamas

The doctor looked at her stitches thoughtfully. A tall lean white man
with an English manner. "Have you ever watched your mum sew?"
he asked. "The fellow who did this hadn't. I like to take a tuck on
the last stitch. That way the skin doesn't bunch up on the ends. Of
course, you can't see the difference, but you can feel it." Later she
asked him about all the one-armed and one-legged black men she kept
seeing in the street. "Diabetic gangrene, mostly. There really isn't
more of it here than in your country, but there's less prosthesis. It's
expensive, of course. And stumps are rather less of a shock when you
come right down to it. Well, as we say, there's nothing colorful about
the Caribbean." He tapped each black thread into a silver basin as he
plucked it out. "Have you ever been to Haiti? Now there is a truly
appalling place."

January

> Three clear days
> and then a sudden storm—
> the waxwings, having
> feasted on the pyracantha,
> perch in the yard
> on an upended pine, and face
> into the slanting rain.
> I think they are a little drunk.

I was making this gathering—which pleased me, the waxwings that
always pass through at this time of year, the discarded Christmas tree
they perched in, and the first January storm, as if I had finally defined
a California season—when Rachel came down the walk and went into
the house. I typed out the poem—the birds giddy with Janus, the two-
faced god—and then went in to say hello.

> Two women sitting at a kitchen table
> Muted light on a rainy morning
> One has car keys in her hand

I was surprised by two feelings at once; one was a memory, the other a
memory trace. The memory, called up, I think, by a glimpse of Rachel's
sculpted profile against the cypresses outside the kitchen window just
before she turned to greet me: I thought of a day twelve years ago in
early summer. Rachel had just had an abortion and we all went for a
walk in San Francisco near the bay. Everything was in bloom and we
were being conscientiously cheerful, young really, not knowing what
form there might be for such an occasion or, in fact, what occasion it
was. And Rachel, in profile, talking casually, the bay behind her, looked
radiant with grief. The memory trace had to do with car keys and two
women in a kitchen. Someone was visiting my mother. It was a rainy
day so I was inside. Her friend, as adults will, to signal that they are not

going to take too much of your time, had car keys in her hand. Between
Earlene and Rachel, there were three oranges in a basket on a table and
I had the sweet, dizzying sensation that the color was circulating among
them in a dance.

> Sing the hymeneal slow.
> Lovers have a way to go,
> their lightest bones will have to grow
> more heavy in uneasy heat.
> The heart is what we eat
> with almond blossoms bitter to the tongue,
> the hair of tulips
> in the softening spring.

Rachel is looking for a house. A realtor had just shown her one. Looking
at the new house, she loved the old one, especially the green of the
garden, looking out on the garden. The old house has drawbacks, long
rehearsed, and the new one, with its cedar shingle, exposed beams,
view, doesn't feel right, it is so anonymous and perfect; it doesn't have
the green secrecy of the garden or the apple tree to tie Lucia's swing to.
Earlene is asking questions, trying to help. A few minutes later, when I
pass through again, they are laughing. At the comedy in the business of
trying to sort through mutually exclusive alternatives in which figures
some tacit imagination of contentment, some invisible symbolizing
need from which life wants to flower. "I hate that old house," Rachel is
saying, laughing, tears in her eyes. But that is not mainly what I notice;
I find myself looking at the women's skin, the coloring and the first
relaxation of the tautness of the sleeker skin of the young, the casual
beauty and formality of that first softening.

> Back at my desk: no birds, no rain,
> but light—the white of Shasta daisies,
> and two red geraniums against the fence,
> and the dark brown of wet wood,
> glistening a little as it dries.

The Apple Trees at Olema

They are walking in the woods along the coast
and in a grassy meadow, wasting, they come upon
two old neglected apple trees. Moss thickened
every bough and the wood of the limbs looked rotten
but the trees were wild with blossom and a green fire
of small new leaves flickered even on the deadest branches.
Blue-eyes, poppies, a scattering of lupine
flecked the meadow, and an intricate, leopard-spotted
leaf-green flower whose name they didn't know.
Trout lily, he said; she said, adder's-tongue.
She is shaken by the raw, white, backlit flaring
of the apple blossoms. He is exultant,
as if something he felt were verified,
and looks to her to mirror his response.
If it is afternoon, a thin moon of my own dismay
fades like a scar in the sky to the east of them.
He could be knocking wildly at a closed door
in a dream. She thinks, meanwhile, that moss
resembles seaweed drying lightly on a dock.
Torn flesh, it was the repetitive torn flesh
of appetite in the cold white blossoms
that had startled her. Now they seem tender
and where she was repelled she takes the measure
of the trees and lets them in. But he no longer
has the apple trees. This is as sad or happy
as the tide, going out or coming in, at sunset.
The light catching in the spray that spumes up
on the reef is the color of the lesser finch
they notice now flashing dull gold in the light
above the field. They admire the bird together,
it draws them closer, and they start to walk again.

A small boy wanders corridors of a hotel that way.
Behind one door, a maid. Behind another one, a man
in striped pajamas shaving. He holds the number
of his room close to the center of his mind
gravely and delicately, as if it were the key,
and then he wanders among strangers all he wants.

MISERY AND SPLENDOR

Summoned by conscious recollection, she
would be smiling, they might be in a kitchen talking,
before or after dinner. But they are in this other room,
the window has many small panes, and they are on a couch
embracing. He holds her as tightly
as he can, she buries herself in his body.
Morning, maybe it is evening, light
is flowing through the room. Outside,
the day is slowly succeeded by night,
succeeded by day, The process wobbles wildly
and accelerates: weeks, months, years. The light in the room
does not change, so it is plain what is happening.
They are trying to become one creature,
and something will not have it. They are tender
with each other, afraid
their brief, sharp cries will reconcile them to the moment
when they fall away again. So they rub against each other,
their mouths dry, then wet, then dry.
They feel themselves at the center of a powerful
and baffled will. They feel
they are an almost animal,
washed up on the shore of a world—
or huddled against the gate of a garden—
to which they can't admit they can never be admitted.

Santa Lucia II

Pleasure is so hard to remember. It goes
so quick from the mind. That day in third grade,
I thought I heard the teacher say the ones
who finished the assignment could go home.
I had a new yellow rubber raincoat
with a hat, blue galoshes; I put them on,
took my lunch pail and my books and started
for the door. The whole class giggled. Somehow
I had misheard. "Where are *you* going?"
the teacher said. The kids all roared. I froze.
In yellow rubber like a bathtub toy.
That memory comes when I call, vivid,
large and embarrassing like the helpless
doglike fidelity of my affections,
and I flush each time. But the famous night
we first made love, I think I remember
stars, that the moon was watery and pale.

It always circles back to being seen.
Psyche in the dark, Psyche in the daylight
counting seed. We go to the place where words
aren't and we die, suffer resurrection
two by two. Some men sleep, some read, some
want chocolate in the middle of the night.
They look at you adoring and you wonder
what it is they think they see. Themselves
transformed, adored. Oh, it makes me tired
and it doesn't work. On the floor in the sunlight
he looked sweet. Laughing, hair tangled, he said
I was all he wanted. If he were all I
wanted, he'd be life. I saw from the window

Mrs. Piombo in the backyard, planting phlox
in her immaculate parable of a garden.
She wears her black sweater under the cypress
in the sun. Life fits her like a glove,
she doesn't seem to think it's very much.

Near Point Sur Lighthouse, morning, dunes
of white sand the eelgrass holds in place.
I saw at a distance what looked like feet
lifted in the air. I was on the reef,
I thought I was alone in all the silence,
poking anemones, watching turban snails
slide across the brown kelp in tidal pools.
And then I saw them. It was all I saw—
a pair of ankles; lifted, tentative.
They twitched like eyelids, like a nerve jumping
in the soft flesh of the arm. My crotch throbbed
and my throat went dry. Absurd. Pico Blanco
in the distance and the summer heat steady
as a hand. I wanted to be touched
and didn't want to want it. And by whom?
The sea foamed easily around the rocks
like the pathos of every summer. In the pools
anemones, cream-colored, little womb-mouths,
oldest animal with its one job to do
I carry as a mystery inside
or else it carries me around it, petals
to its stamen. And then I heard her cry.
Sharp, brief, a gull's hunger bleeding off the wind.
A sound like anguish. Driving up the coast—
succulents ablaze on the embankments,
morning glory on the freeway roadcuts
where the rifles crackled at the army base—
I thought that life was hunger moving and

that hunger was a form of suffering.
The drive from the country to the city
was the distance from solitude to wanting,
or to union, or to something else—the city
with its hills and ill-lit streets, a vast
dull throb of light, dimming the night sky.

What a funny place to center longing,
in a stranger. All I have to do is reach
down once and touch his cheek and the long fall
from paradise begins. The dream in which
I'm stuck and Father comes to help but then
takes off his mask, the one in which shit, oozing
from a wound, forms delicate rosettes, the dream
in which my book is finished and my shoulders
start to sprout a pelt of hair, or the woman
in the sari, prone, covered with menstrual
blood, her arms raised in supplication.
We take that into the dark. Sex is peace
because it's so specific. And metaphors:
live milk, blond hills, blood singing,
hilarity that comes and goes like rain,
you got me coffee, I'll get you your book,
something to sleep beside, with, against.

The morning light comes up, and their voices
through the wall, the matter-of-fact chatter
of the child dawdling at breakfast, a clink
of spoons. It's in small tasks the mirrors
disappear, the old woman already
gone shopping. Her apricot, pruned yesterday,
is bare. To be used up like that. Psyche
punished for her candle in the dark.
Oil painting is a form of ownership.

The essay writer who was here last year,
at someone's party, a heavy man with glasses,
Persian cat. Art since the Renaissance
is ownership. I should get down to work.
You and the task—the third that makes a circle
is the imagined end. You notice rhythms
washing over you, opening and closing,
they are the world, inside you, and you work.

CUTTINGS

Body Through Which the Dream Flows

You count up everything you have
or have let go.
What's left is the lost and the possible.
To the lost, the irretrievable
or just out of reach, you say:
light loved the pier, the seedy
string quartet of the sun going down over water
that gilds ants and beach fleas
ecstatic and communal on the stiffened body
of a dead grebe washed ashore
by last night's storm. Idiot sorrow,
an irregular splendor, is the half sister
of these considerations.
To the possible you say nothing.
October on the planet.
Huge moon, bright stars.

The Lovers Undressing

They put on rising, and they rose.
They put on falling, and they fell.
They were the long grass on the hillside
that shudders in the wind. They sleep.
Days, kitchens. Cut flowers,
shed petals, smell of lemon, smell of toast
or soap. Are you upset about something,
one says. No, the other says.
Are you sure, the one says.
Yes, the other says, I'm sure.

Sad

Often we are sad animals.
Bored dogs, monkeys getting rained on.

Migration

A small brown wren in the tangle
of the climbing rose. April:
last rain, the first dazzle
and reluctance of the light.

Dark

Desire lies down with the day
and the night birds wake
to their fast heartbeats
in the trees. The woman beside you
is breathing evenly. All day
you were in a body. Now
you are in a skull. Wind,
streetlights, trees flicker
on the ceiling in the dark.

Things Change

Small song,
two beat:
the robin on the lawn
hops from sun
into shadow, shadow
into sun.

Stories in Bed

In the field behind her house, she said,
fennel grew high and green
in early summer, and the air
smelled like little anise-scented loaves
in the Italian restaurants her father
used to take them to on Sunday nights.
She had to sit up straight:
it was the idea of family
they failed at. She lights a cigarette,
remembering the taut veins
in her mother's neck, how she had studied them,
repelled. He has begun to drowse:
backyards, her voice, dusty fennel,
the festering sweetness of the plums.

Monday Morning, Late Summer

On the fence
in the sunlight,
beach towels.

No wind.

The apricots have ripened
and been picked.
The blackberries have ripened
and been picked.

So

They walked along the dry gully.
Cottonwoods, so the river must be underground.

Plus Which

She turned to him. Or, alternatively,
she turned away. Doves let loose
above the sea, or the sea at night
beating on the pylons of a bridge.
Off-season: the candles were Mediterranean,
opaque, and the cat cried *olor,*
olor, olor in the blue susurrations
of heather by the outhouse door.

SANTA BARBARA ROAD

Mornings on the south side of the house
just outside the kitchen door
arrived early in summer—
when Luke was four or five
he would go out there, still in his dandelion-
yellow pajamas on May mornings
and lie down on the first warm stone.

For years, when the green nubs of apricots
first sprouted on the backyard tree,
I thought about a bench in that spot,
a redwood screen behind green brushstrokes
of bamboo, and one April, walking into the kitchen,
I felt like a stranger to my life
and it scared me, so when the gray doves returned
to the telephone wires
and the lemons were yellowing
and no other task presented itself,
I finally went into the garden and started
digging, trying to marry myself
and my hands to that place.

*

Household verses: "Who are you?"
the rubber duck in my hand asked Kristin
once, while she was bathing, three years old.
"Kristin," she said, laughing, her delicious
name, delicious self. "That's just your name,"
the duck said. "Who are you?" "Kristin,"
she said. "Kristin's a name. Who are you?"
the duck asked. She said, shrugging,
"Mommy, Daddy, Leif."

*

The valley behind the hills heats up,
vultures, red-tailed hawks floating in the bubbles
of warm air that pull the fog right in
from the ocean. You have to rise at sunup
to see it steaming through the Gate
in ghostly June. Later, on street corners,
you can hardly see the children, chirping
and shivering, each shrill voice climbing over
the next in an ascending chorus. "Wait, you guys,"
one little girl says, trying to be heard.
"Wait, wait, wait, wait, wait."
Bright clothes: the last buses of the term.

*

Richard arrives to read poems, the final guest
of a long spring. I thought of Little Shelford,
where we had seen him last. In the worked gold
of an English October, Kristin watched the neighbor's
horses wading in the meadow grass, while Leif
and I spiraled a football by the chalk-green,
moss-mortared ruin of the garden wall.
Mr. Acker, who had worked in the village
since he was a boy, touched his tweed cap
mournfully. "Reminds me of the war," he said.
"Lots of Yanks here then." Richard rolled a ball
to Luke, who had an old alphabet book
in which cherubic animals disported.
Richard was a *rabbit* with a *roller*.
Luke evidently thought that it was droll
or magical that Richard, commanded
by the power of the word, was crouching
under the horse chestnut, dangling

a hand-rolled cigarette and rolling him a ball.
He gave me secret, signifying winks, though
he could not quite close one eye at a time.
So many prisms to construct a moment!
Spiderwebs set at all angles on a hedge:
what Luke thought was going on, what Mr. Acker
saw, and Richard, who had recently divorced,
idly rolling a ball with someone else's child,
healing slowly, as the neighbor's silky mare
who had had a hard birth in the early spring,
stood quiet in the field as May grew sweet,
her torn vagina healing. So many visions
intersecting at what we call the crystal
of a common world, all the growing and shearing,
all the violent breaks. On Richard's last night
in Berkeley, we drank late and drove home
through the city gardens in the hills. Light
glimmered on the bay. Night-blooming jasmine
gave a heavy fragrance to the air. Richard
studied the moonlit azaleas in silence.
I knew he had a flat in East London.
I wondered if he was envying my life.
"How did you ever get stuck in this nest
of gentlefolk?" he said. "Christ! It's lovely.
I shouldn't want to live in America.
I'd miss the despair of European men."

※

Luke comes running into the house excited
to say that an Iceland poppy has "bloomed up."
His parents, who are not getting along
especially well, exchange wry looks.
They had both forgotten, since small children
were supposed to love flowers, that they actually

do. And there is the pathos of the metaphor
or myth: irresistible flowering.

※

Everything rises from the dead in June.
There is some treasure hidden in the heart of summer
everyone remembers now, and they can't be sure
the lives they live in will discover it.
They remember the smells of childhood vacations.
The men buy maps, raffish hats. Some women
pray to it by wearing blouses
with small buttons you have to button patiently,
as if to say, this is not winter, not
the cold shudder of dressing in the dark.

※

Howard, one child on his shoulder,
another trotting beside him, small hand
in his hand, is going to write a book—
"Miranda, stop pulling Daddy's hair"—about
the invention of the family in medieval France.
The ritual hikes of Memorial Day: adults
chatting in constantly re-forming groups,
men with men, women with women, couples,
children cozened along with orange sections
and with raisins, running ahead, and back,
and interrupting. Long views through mist
of the scaly brightness of the ocean,
the massive palisade of Point Reyes cliffs.
"I would have thought," a woman friend says,
peeling a tangerine for Howard whose hands
are otherwise employed, cautioning a child
to spit out all the seeds, "that biology
invented the family." A sudden upward turn

of the trail, islands just on the horizon,
blue. "Well," he says, "I think it's useful
to see it as a set of conventions."

*

Someone's great-aunt dies. Someone's sister's
getting married in a week. The details are comic.
But we dress, play flutes, twine flowers,
and read long swatches from the Song of Songs
to celebrate some subtle alteration
in a cohabitation that has, probably, reached a crisis
and solved it with the old idea of these vows.
To vow, and tear down time: one of the lovers gives up
an apartment, returned to and stripped piecemeal
over months or years, until one maidenhair fern
left by the kitchen window as a symbol, dwindling,
of the resilience of a solitary life
required watering. Now it too is moved.

*

Summer solstice: parents, if their children
are young enough, put them to bed before dark,
then sit to watch the sun set on the bay.
A woman brings her coffee to the view.
Dinner done. What was she thinking
before her mother called, before the neighbor
called about the car pool? Something,
something interesting. The fog flares
and smolders, salmon first, then rose,
and in the twilight the sound comes up
across the neighborhood backyards of a table
being set. Other lives with other schedules.
Then dark, and, veering eerily, a bat.

Body half-emerged from the bright blue cocoon
of the sleeping bag, he wakes, curled hand
curling toward the waves of his sister's
cut-short, slept-on and matted, cornfield-
colored hair. She stirs a little in her sleep.
Her mother, whose curved brow her brow exactly
echoes, stirs. What if the gnostics had it backward?
What if eternity is pure destruction? The child,
rubbing his eyes, stares drowsily at the sea,
squints at his father who is sitting up,
shivers from his bag, plods up the beach
to pee against the cliff, runs back, climbs in
with his mother, wriggles close. In a minute
he'll be up again, fetching driftwood for a fire.

*

Leif comes home from the last day of his sophomore year.
I am sitting on the stoop by our half-dug,
still-imagined kitchen porch, reading
Han dynasty rhyme-prose. He puts a hand on my shoulder,
grown to exactly my height and still growing.
"Dad," he says, "I'm not taking any more
of this tyrannical bullshit." I read to him
from Chia Ya: *The great man is without bent,*
a million changes are as one to him.
He says, "And another thing, don't lay
your Buddhist trips on me." *The span of life is fated;*
man cannot guess its ending.
In stillness like the stillness of deep springs. . . .
In the kitchen he flips the lid
of the blueberry yogurt. I am thinking
this project is more work than I want.

Joining, scattering, ebbing and flowing,
where is there persistence, where is there rule?
"Bullshit," he mutters, "what is the existential reality"—
he has just read *Nausea* in advanced English—
"of all this bullshit, Todo?"
Todo is the dog. It occurs to me
that I am not a very satisfying parent
to rebel against. *Like an unmoored boat*
drifting aimlessly, not even valuing
the breath of life, the wise man
embraces nothing, and drifts with it.

I look at his long body in a chair
and wonder if I'd tell him to embrace the void.
I think he will embrace a lover soon.
I want the stars to terrify him once. I want him
to weep bitterly when his grandfather dies,
hating the floral carpet, hating it that his old aunts
have become expert at this event.
I would ward off, if I could, the thicket
of grief on grief in which Chia Ya
came to entire relinquishment as to a clearing.
Digging again, I say, "You know, I started this job
and I hate it already, and now I have to finish."
He leans against the doorpost with a spoon.
Takes a mouthful. "Well, Pop," he says, "that's life."

 *

Children stroll down to the lakeside
on a path already hot from the morning sun
and known well by them in its three turnings—
one by the sugar pine gouged with rusty nails
where summers past they put a hammock or a swing,
one by the thimbleberry where the walk seems driest,

dust heaviest on the broad soft leaves, and bees—
you have to be careful—are nuzzling in the flowers,
one by the aspens where the smell of water
starts and the path opens onto sand, the wide blue lake,
mountains on the farther shore. The smaller boy
has line, a can for crawfish, and an inner tube.
He's nursing a summer cold. His older brother's
carrying a book, a towel, a paper on *Medea*
his girlfriend has mailed to him from summer school.
The girl has several books, some magazines.
She loves her family, but she's bored. She'd rather
be in town where her friends are, where her real life
has begun. They settle on the beach.
Cold water, hot sun, the whole of an afternoon.

Berkeley Eclogue

1.

Sunlight on the streets in afternoon
and shadows on the faces in the open-air cafés.
What for? Wrong question. You knock
without knowing that you knocked. The door
opens on a century of clouds and centuries
of centuries of clouds. The bird sings
among the toyons in the spring's diligence
of rain. *And then what? Hand on your heart.*
Would you die for spring? What would you die for?
Anything?
 Anything. It may be I can't find it
and they can, the spooners of whipped cream
and espresso at the sunny tables, the women
with their children in the stores. *You want to sing?*
Tra-la. Empty and he wants to sing.
A pretty river, but there were no fish.
Smart fish. They will be feeding for a while.
He wants to sing. Yes, poverty or death.
Piety or death, you meant, you dope. You fool,
"bloody little fool." She slammed the door.
He was, of course, forlorn. And lorn and afterlorn.
It made a busy afternoon. The nights were difficult.
No doors, no drama. The moon ached aimlessly.
Dogs in the morning had their dog masks on.
It did not seem good, the moths, the apples?
The gold meander in her long brown hair
cast one vote then, sinuous as wrists. He attended
to her earnestness as well—and the child liked breakfast.
He believed in that. Every day was a present

he pretended that he brought. The sun came up.
Nothing to it. I'll do it again tomorrow,
and it did. Sundays he fetched croissants,
the frank nipples of brioche that say it's day,
eat up, the phone will ring, the mail arrive.
Someone who heard you sing the moths, the apples
and they were—for sure they were, and good
though over there. Gold hair. A lucky guy
with a head on his shoulders, and all heart.
You can skip this part. The moths, the apples,
and the morning news. Apartheid, terror,
boys in a jungle swagging guns. *Injustice*
in tropical climates is appalling,
and it does do you credit to think so.
I knew that I had my own work to do.
The ones who wear the boots decide all that.
He wants to sing one thing so true that it is true.
I cast a vote across the river, skipped another
on the pond. It skittered for a while triumphantly,
then sank. And we were naked on the riverbank.
I believed a little in her breasts, the color
of the aureoles that afternoon, and something
she said about her sister that seemed shrewd.
Afterward we watched a woman making masks,
mostly with feathers and a plaster cast of face
she glued them to. The mouths formed cries.
They were the parts that weren't there—implied
by what surrounded them. They were a cunning
emptiness. *I think you ought to start again.*
The fish were smart. They mouthed the salmon eggs,
or so you felt. The boys kept reeling in.
Casting and reeling in. You'll never catch a fish
that way, you said. One caught a fish that way.
One perched in a chair abandoned on the sand.

Drank orange soda, watched his rod twitter
in the fork of a willow twig. "I'm getting a bite, Dad."
It was the river current or the wind. In every
language in the world, I bet. *Do you believe
in that?* Not especially. It means the race is old.
And full of hope? *He wants to sing.*
You bastard, she said, and slammed the door.
You've been in this part already. Say "before."
"Before." She shut the door. It couldn't have been
otherwise. How sick you were. The mouths, the apples,
the buttons on a blouse. The bone was like pearl,
and small, and very shiny. The fat child's face
was flecked with Santa Rosa plum. She cried.
Her mother hit her. Then it seemed like blood.
A flood of tears, then. You remembered
never to interfere. It humiliates them.
They beat the child again when they get home.
It's only your feeling you assuage.
You didn't interfere. Her gold wandering of hair,
she told you that another time. The father
at the county fair was whaling on the boy
with fists. There was music in the background
and a clown walked by and looked and looked away.
She told you then, gold and practical advice.
You wanted one and craved the other.
Say "mother." No. *Say it.* No. *She shut the door?*
I wish she had. I saw the shadow cast there
on the floor. *What did you think?* I asked her,
actually. She said she hurt her lip. And
took a drink? Or the shadow did. I didn't think.
I knew she was lying. A child could see that.
You were a child. *Ah, this is the part
where he parades his wound. He was a child.*
It is the law of things: the little billy goat

goes first. Happily, he's not a morsel
for the troll. *Say "Dad, I've got a bite."*
That's different. Then you say, "Reel it in."
They're feeling fear and wonder, then.
That's when you teach them they can take the world
in hand. *You do?* Sometimes I do. Carefully.
They beat the child again when they get home.
All right. Assume the children are all right.
They're singing in the kibbutzim. The sun is rising.
Let's get past this part. The kindergarten
is a garden and they face their fears in stories
your voice makes musical and then they sleep.
They hear the sirens? *Yes, they hear the sirens.*
That part can't be helped. No one beats them, though.
And there are no lies they recognize. They know
you're with them and they fall asleep. What then?
Get past this part. It is a garden. Then they're grown.
What then? Say "groan." *I say what to say,*
you don't. They're all OK, and grown. What then?

2.

Then? Then, the truth is, then they fall in love.
Oh no. *Oh yes.* Big subject. *Big shadow.*
I saw it slant across the floor, linoleum
in fact, and very dirty. Sad and dirty.
Because it lacked intention? Well, it did lack art.
Let's leave the shadow part alone. They fall in love.
What then? I want to leave this too.
It has its songs. Too many. I know them all.
It doesn't seem appropriate somehow. It was summer.
He saw her wandering through a field of grass.
It was the sweetest fire. Later, in the fall, it rained.

You loved her then? In rain? and gold October?
I would have died for her. *Tra-la.* Oh yes,
tra-la. We took long walks. You gather sadness
from a childhood to make a gift of it.
I gave her mine. *Some gift.* Is it so bad?
Sadness is a pretty word. Shadow's
shadow. And once there was a flood. Heavy rains,
and then the tide came in. I left her house
at midnight. It was pouring. I hitched a ride,
which stalled. The car in front of us had stopped.
The water rose across the road and ran downhill.
You'd forgotten this. I remember now. My knee
was in a cast. I hopped to the car in front,
the one that stalled. The driver's tongue stuck out,
a pale fat plum. His eyes bulged. An old man
in a gray felt hat. And the red lids flickered,
so he wasn't dead. *What did you do?* Got in,
shoved him aside, and tried to start the car.
What did you feel then? Wonderful. Like cleaning fish.
Your hands are bloody and you do the job.
It reminds you of a poem now? Yes,
the one about the fall that Bashō liked.
"The maple leaf becomes a midwife's hand."
The engine skipped and sank, twice. Then it started.
And I drove. The hospital was just a mile away
but near the creek. I thought the water
would be even higher. *Interesting, of course.*
This is the part about falling in love?
I left her house. We were necking, remember,
on a soft green velvet couch. *What then?*
I took the downhill road and floored it.
A gush spewed up and blurred the windshield.
I couldn't see a thing. The car sputtered,
surged, sputtered, surged, and died. And

he was dead. *Who was he?* Some old man.
That was the winter that you fell in love?
It was. *Did you feel bad?* No, I tried.
Do you believe in that? Now? I'm not sure.
He looked like a baby when they got him out
and raindrops bounced off raindrops on his face.
It didn't cost me anything.

 Anything?

PRIVILEGE OF BEING

Many are making love. Up above, the angels
in the unshaken ether and crystal of human longing
are braiding one another's hair, which is strawberry blond
and the texture of cold rivers. They glance
down from time to time at the awkward ecstasy—
it must look to them like featherless birds
splashing in the spring puddle of a bed—
and then one woman, she is about to come,
peels back the man's shut eyelids and says,
look at me, and he does. Or is it the man
tugging the curtain rope in that dark theater?
Anyway, they do, they look at each other;
two beings with evolved eyes, rapacious,
startled, connected at the belly in an unbelievably sweet
lubricious glue, stare at each other,
and the angels are desolate. They hate it. They shudder pathetically
like lithographs of Victorian beggars
with perfect features and alabaster skin hawking rags
in the lewd alleys of the novel.
All of creation is offended by this distress.
It is like the keening sound the moon makes sometimes,
rising. The lovers especially cannot bear it,
it fills them with unspeakable sadness, so that
they close their eyes again and hold each other, each
feeling the mortal singularity of the body
they have enchanted out of death for an hour or so,
and one day, running at sunset, the woman says to the man,
I woke up feeling so sad this morning because I realized
that you could not, as much as I love you,
dear heart, cure my loneliness,
wherewith she touched his cheek to reassure him

that she did not mean to hurt him with this truth.
And the man is not hurt exactly,
he understands that life has limits, that people
die young, fail at love,
fail of their ambitions. He runs beside her, he thinks
of the sadness they have gasped and crooned their way out of
coming, clutching each other with old, invented
forms of grace and clumsy gratitude, ready
to be alone again, or dissatisfied, or merely
companionable like the couples on the summer beach
reading magazine articles about intimacy between the sexes
to themselves, and to each other,
and to the immense, illiterate, consoling angels.

Natural Theology

White daisies against the burnt orange of the windowframe,
lusterless redwood in the nickel gray of winter,
in the distance turbulence of water—the green regions
of the morning reflect whatever can be gained, normally,
by light, then give way to the blue regions of the afternoon
which do not reflect so much as they remember,
as if the light, one will all morning, yielded to a doubleness
in things—plucked skins of turkeys in an ill-lit butchershop
in the pitch-dark forenoon of a dreary day, or a stone bridge
in a small town, a cool café, tables with a violin-back sheen,
ferns like private places of the body distanced and made cool—
images not quite left behind rising as an undertow
of endless transformation against the blurring world
outside the window where, after the morning clarities,
the faint reflection of a face appears; among the images
a road, repetitively, with meadow rue and yarrow
whitening its edges, and pines shadowing the cranberry brush,
and the fluting of one bird where the road curves and disappears,
becoming that gap or lack which is the oldest imagination
of need, defined more sharply by the silver-gray region
just before the sun goes down and the clouds fade
through rose to bruise to the city-pigeon color of a sky
going dark and the wind comes up in brushstroke silhouettes
of trees and to your surprise the window mirrors back to you
a face open, curious, and tender; as dance is defined
by the body's possibilities arranged, this dance
belongs to the composures and the running down of things
in the used sugars of five thirty: a woman straightening
a desk turns her calendar to another day, signaling
that it is another day where the desk is concerned
and that there is in her days what doesn't belong to the desk;

a kid turns on TV, flops on the couch to the tinny sound
of little cartoon parents quarreling; a man in a bar
orders a drink, watches ice bob in the blond fluid,
he sighs and looks around; sad at the corners, nagged by wind,
others with packages; others dreaming, picking their noses
dreamily while they listen to the radio describe configurations
of the traffic they are stuck in as the last light
like held breath flickers among mud hens on the bay,
the black bodies elapsing as the dark comes on, and the face
in the window seems harder and more clear. The religion
or the region of the dark makes soup and lights a fire,
plays backgammon with children on the teeth or the stilettos
of the board, reads books, does dishes, listens
to the wind, listens to the stars imagined to be singing
invisibly, goes out to be regarded by the moon, walks
dogs, feeds cats, makes love in postures so various,
with such varying attention and intensity and hope,
it enacts the dispersion of tongues among the people
of the earth—*compris? Versteh'*—and sleeps with sticky genitals
the erasures and the peace of sleep: exactly the half-moon
holds, and the city twinkles in particular windows, throbs
in its accumulated glow which is also and more blindingly
the imagination of need from which the sun keeps rising into morning light,
because desires do not split themselves up, there is one desire
touching the many things, and it is continuous.

TAHOE IN AUGUST

What summer proposes is simply happiness:
heat early in the morning, jays
raucous in the pines. Frank and Ellen have a tennis game
at nine, Bill and Cheryl sleep on the deck
to watch a shower of summer stars. Nick and Sharon
stayed in, sat and talked the dark on,
drinking tea, and Jeanne walked into the meadow
in a white smock to write in her journal
by a grazing horse who seemed to want the company.
Some of them will swim in the afternoon.
Someone will drive to the hardware store to fetch
new latches for the kitchen door. Four o'clock;
the joggers jogging—it is one of them who sees
down the flowering slope the woman with her notebook
in her hand beside the white horse, gesturing, her hair
from a distance the copper color of the hummingbirds
the slant light catches on the slope; the hikers
switchback down the canyon from the waterfall;
the readers are reading, Anna is about to meet Vronsky,
that nice M. Swann is dining in Combray
with the aunts, and Carrie has come to Chicago.
What they want is happiness: someone to love them,
children, a summer by the lake. The woman who sets aside
her book blinks against the fuzzy dark,
reentering the house. Her daughter drifts downstairs;
out late the night before, she has been napping,
and she's cross. Her mother tells her David telephoned.
"He's such a dear," the mother says, "I think
I make him nervous." The girl tosses her head as the horse
had done in the meadow while Jeanne read it her dream.
"You can call him now, if you want," the mother says,

"I've got to get the chicken started,
I won't listen." "Did I say you would?"
the girl says quickly. The mother who has been slapped
this way before and done the same herself another summer
on a different lake says, "Ouch." The girl shrugs
sulkily. "I'm sorry." Looking down: "Something
about the way you said that pissed me off."
"Hannibal has wandered off," the mother says,
wryness in her voice, she is thinking it is August,
"why don't you see if he's at the Finleys' house
again." The girl says, "God." The mother: "He loves
small children. It's livelier for him there."
The daughter, awake now, flounces out the door,
which slams. It is for all of them the sound of summer.
The mother she looks like stands at the counter snapping beans.

THIN AIR

What if I did not mention death to get started
or how love fails in our well-meaning hands
or what my parents in the innocence of their malice
toward each other did to me. What if I let the light
pour down on the mountain meadow, mule ears
dry already in the August heat, and the sweet
heavy scent of sage rising into it, marrying
what light it can, a wartime marriage,
summer is brief in these mountains, the
ticker-tape parade of snow will bury it
in no time, in the excess the world gives
up there, and down here, you want snow? you think
you have seen infinity watching the sky shuffle
the pink cards of thirty thousand flamingoes
on the Serengeti Plain? this is my blush,
she said, turning toward you, eyes downcast
demurely, a small smile playing at her mouth,
playing what? house, playing I am the sister
and author of your sorrow, playing the Lord
God loves the green earth and I am a nun
of his Visitations, you want snow, I'll give you
snow, she said, this is my flamingoes-in-migration
blush. Winter will bury it. You had better
sleep through that cold, or sleep in a solitary bed
in a city where the stone glistens darkly
in the morning rain, you are allowed a comforter,
silky in texture though it must be blue,
and you can listen to music in the morning,
the notes nervous as light reflected in a fountain,
and you can drink your one cup of fragrant tea
and rinse the cup and sweep your room and

the sadness you are fighting off while the gulls'
calls beat about the church towers out the window
and you smell the salt smell of the sea
is the dream you don't remember of the meadow
sleeping under fifteen feet of snow though you half
recall the tracks of some midsized animal,
a small fox or a large hare, and the deadly
silence, and the blinded-eye gray of the winter sky:
it is sleeping, the meadow, don't wake it.
You have to go to the bottom of the raveling.
The surgical pan, and the pump, and the bits
of life that didn't take floating in the smell
of alcohol, or the old man in the bed spitting up
black blood like milk of the other world, or the way
middle-aged women from poorer countries are the ones
who clean up after and throw the underwear away.
Hang on to the luxury of the way she used
to turn to you, don't abandon it, summer
is short, no one ever told you differently,
this is a good parade, this is the small hotel,
the boathouse on the dock, and the moon thin,
just silvering above the pines, and you are starting
to sweat now, having turned north out of the meadow
and begun the ascent up granite and through buckthorn
to the falls. There is a fine film on your warm skin
that you notice. You are water, light and water and thin air,
and you're breathing deeply now—a little dead marmot
like a rag of auburn hair swarms with ants beside the trail—
and you can hear the rush of water in the distance
as it takes its leap into the air and falls. In the winter
city she is walking toward you or away from you,
the fog condensing and dripping from the parapets
of old apartments and from the memory of intimate garments
that dried on the balcony in summer, even in the spring.

Do you understand? You can brew your one cup of tea
and you can drink it, the leaves were grown in Ceylon,
the plump young man who packed them was impatient,
he is waiting for news of a scholarship to Utrecht,
he is pretty sure he will rot in this lousy place
if he doesn't get it, and you can savor the last sip,
rinse the cup, and put it on the shelf,
and then you go outside or you sit down at the desk.
You go into yourself, the sage scent rising in the heat.

Between the Wars

When I ran, it rained. Late in the afternoon—
midsummer, upstate New York, mornings I wrote,
read Polish history, and there was a woman
whom I thought about; outside the moody, humid
American sublime—late in the afternoon,
toward sundown, just as the sky was darkening,
the light came up and redwings settled in the cattails.
They were death's idea of twilight, the whole notes
of a requiem the massed clouds croaked
above the somber fields. *Lady of eyelashes,*
do you hear me? Whiteness, otter's body,
coolness of the morning, rubbed amber
and the skin's salt, do you hear me? This is Poland speaking,
"era of the dawn of freedom," nineteen twenty-two.
When I ran, it rained. The blackbirds settled
their clannish squabbles in the reeds, and light came up.
First darkening, then light. And then pure fire.
Where does it come from? out of the impure
shining that rises from the soaked odor of the grass,
the levitating, Congregational, meadow-light-at-twilight
light that darkens the heavy-headed blossoms
of wild carrot, out of that, out of nothing
it boils up, pools on the horizon, fissures up,
igniting the undersides of clouds: pink flame,
red flame, vermilion, purple, deeper purple, dark.
You could wring the sourness of the sumac from the air,
the fescue sweetness from the grass, the slightly
maniacal cicadas tuning up to tear the fabric
of the silence into tatters, so that night,
if it wants to, comes as a beggar to the door
at which, if you do not offer milk and barley

to the maimed figure of the god, your well will foul,
your crops will wither in the fields. In the eastern marches
children know the story that the aspen quivers
because it failed to hide the Virgin and the Child
when Herod's hunters were abroad. Think: night is the god
dressed as the beggar drinking the sweet milk.
Gray beard, thin shanks, the look in the eyes
idiot, unbearable, the wizened mouth agape,
like an infant's that has cried and sucked and cried
and paused to catch its breath. The pink nubbin
of the nipple glistens. I'll suckle at that breast,
the one in the song of the muttering illumination
of the fields before the sun goes down, before
the black train crosses the frontier from Prussia
into Poland in the age of the dawn of freedom.
Fifty freight cars from America, full of medicine
and the latest miracle, canned food.
The war is over. There are unburied bones
in the fields at sunup, skylarks singing,
starved children begging chocolate on the tracks.

ON SQUAW PEAK

I don't even know which sadness
it was came up
in me when we were walking down the road to Shirley Lake,
the sun gleaming in snowpatches,
the sky so blue it seemed the light's dove
of some pentecost of blue,
the mimulus, yellow, delicate of petal,
and the pale yellow cinquefoil trembling in the damp
air above the creek,—
and fields of lupine,
that blue blaze of lupine, a swath of paintbrush
sheening it, and so much of it, long meadows
of it gathered out of the mountain air and spilling
down ridge toward the lake it almost looked like
in the wind. I think I must have thought
the usual things: that the flowering season
in these high mountain meadows is so brief, that
the feeling, something like hilarity, of sudden
pleasure when you first come across some tough little plant
you knew you'd see comes because it seems—I mean
by *it* the larkspur or penstemon curling
and arching the reach of its sexual being
up out of a little crack in granite—to say
that human hunger has a niche up here in the light-cathedral
of the dazzled air. I wanted to tell you
that when the ghost-child died, the three-month dreamer
she and I would never know, I kept feeling that
the heaven it went to was like the inside of a store window
on a rainy day from which you watch the blurred forms
passing in the street. Or to tell you, more terrible,
that when she and I walked off the restlessness

of our misery afterward in the Coast Range hills,
we saw come out of the thicket shyly
a pure white doe. I wanted to tell you I knew
it was a freak of beauty like the law of averages
that killed our child and made us know, as you had said
that things between lovers, even of longest standing,
can be botched in their bodies, though their wills don't fail.
Still later, on the beach, we watched the waves.
No two the same size. No two in the same arch
of rising up and pouring. But it is the same law.
You shell a pea, there are three plump seeds and one
that's shriveled. You shell a bushelful and you begin
to feel the rhythms of the waves at Limantour,
glittering, jagged, that last bright October afternoon.
It killed something in me, I thought, or froze it,
to have to see where beauty comes from. I imagined
for a long time that the baby, since
it would have liked to smell our clothes to know
what a mother and father would have been,
hovered sometimes in our closet and I half-expected
to see it there, half-fish spirit, form of tenderness,
a little dead dreamer with open eyes. That was
private sorrow. I tried not to hate my life,
to fear the frame of things. I knew what two people
couldn't say
on a cold November morning in the fog—
you remember the feel of Berkeley winter mornings—
what they couldn't say to each other
was the white deer not seen. It meant to me
that beauty and terror were intertwined so powerfully
and went so deep that any kind of love
can fail. I didn't say it. I think the mountain startled
my small grief. Maybe there wasn't time.
We may have been sprinting to catch the tram

because we had to teach poetry
in that valley two thousand feet below us.
You were running—Steven's mother, Michael's lover,
mother and lover, grieving, of a girl
about to leave for school and die to you a little
(or die into you, or simply turn away)—
and you ran like a gazelle,
in purple underpants, royal purple,
and I laughed out loud. It was the abundance
the world gives, the more-than-you-bargained-for
surprise of it, waves breaking,
the sudden fragrance of the mimulus at creekside
sharpened by the summer dust.
Things bloom up there. They are
for their season alive in those bright vanishings
of the air we ran through.

Sun Under Wood

Now goth sonne under wode—
Me reweth, Marie, thi faire rode.
Now goth sonne under tre—
Me reweth, Marie, thy sonne and thee.

—ANONYMOUS, TWELFTH CENTURY

HAPPINESS

Because yesterday morning from the steamy window
we saw a pair of red foxes across the creek
eating the last windfall apples in the rain—
they looked up at us with their green eyes
long enough to symbolize the wakefulness of living things
and then went back to eating—
and because this morning
when she went into the gazebo with her black pen and yellow pad
to coax an inquisitive soul
from what she thinks of as the reluctance of matter,
I drove into town to drink tea in the café
and write notes in a journal—mist rose from the bay
like the luminous and indefinite aspect of intention,
and a small flock of tundra swans
for the second winter in a row was feeding on new grass
in the soaked fields; they symbolize mystery, I suppose,
they are also called whistling swans, are very white,
and their eyes are black—

and because the tea steamed in front of me,
and the notebook, turned to a new page,
was blank except for a faint blue idea of order,
I wrote: *happiness! it is December, very cold,*
we woke early this morning,
and lay in bed kissing,
our eyes squinched up like bats.

Our Lady of the Snows

In white,
the unpainted statue of the young girl
on the side altar
made the quality of mercy seem scrupulous and calm.

When my mother was in a hospital drying out,
or drinking at a pace that would put her there soon,
I would slip in the side door,
light an aromatic candle,
and bargain for us both.
Or else I'd stare into the day-moon of that face
and, if I concentrated, fly.

Come down! come down!
she'd call, because I was so high.

Though mostly when I think of myself
at that age, I am standing at my older brother's closet
studying the shirts,
convinced that I could be absolutely transformed
by something I could borrow.
And the days churned by,
navigable sorrow.

DRAGONFLIES MATING

1.

The people who lived here before us
also loved these high mountain meadows on summer mornings.
They made their way up here in easy stages
when heat began to dry the valleys out,
following the berry harvest probably and the pine buds:
climbing and making camp and gathering,
then breaking camp and climbing and making camp and gathering.
A few miles a day. They sent out the children
to dig up bulbs of the mariposa lilies that they liked to roast
at night by the fire where they sat talking about how this year
was different from last year. Told stories,
knew where they were on earth from the names,
owl moon, bear moon, gooseberry moon.

2.

Jaime de Angulo (1934) was talking to a Channel Island Indian
in a Santa Barbara bar. You tell me how your people said
the world was made. Well, the guy said, Coyote was on the mountain
and he had to pee. Wait a minute, Jaime said,
I was talking to a Pomo the other day and he said
Red Fox made the world. They say Red Fox, the guy shrugged,
we say Coyote. So, he had to pee
and he didn't want to drown anybody, so he turned toward the place
where the ocean would be. Wait a minute, Jaime said,
if there were no people yet, how could he drown anybody?
The Channelleño got a funny look on his face. You know,
he said, when I was a kid, I wondered about that,

and I asked my father. We were living up toward Santa Ynez.
He was sitting on a bench in the yard shaving down fence posts
with an ax, and I said, how come Coyote was worried about people
when he had to pee and there were no people? The guy laughed.
And my old man looked up at me with this funny smile
and said, You know, when I was a kid, I wondered about that.

3.

Thinking about that story just now, early morning heat,
first day in the mountains, I remembered stories about sick Indians
and—in the same thought—standing on the free throw line.

St. Raphael's parish, where the northernmost of the missions
had been, was founded as a hospital, was named for the angel
in the scriptures who healed the blind man with a fish
he laid across his eyes.— I wouldn't mind being that age again,
hearing those stories, eyes turned upward toward the young nun
in her white, fresh-smelling, immaculately laundered robes.—

The Franciscan priests who brought their faith in God
across the Atlantic, brought with the baroque statues and metalwork
crosses
and elaborately embroidered cloaks, influenza and syphilis and the
coughing disease.

Which is why we settled an almost empty California.
There were drawings in the mission museum of the long, dark wards
full of small brown people, wasted, coughing into blankets,

the saintly Franciscan fathers moving patiently among them.
It would, Sister Marietta said, have broken your hearts to see it.
They meant so well, she said, and such a terrible thing

came here with their love. And I remembered how I hated it
after school—because I loved basketball practice more than anything
on earth—that I never knew if my mother was going to show up

well into one of those weeks of drinking she disappeared into,
and humiliate me in front of my classmates with her bright, confident eyes,
and slurred, though carefully pronounced words, and the appalling

impromptu sets of mismatched clothes she was given to
when she had the dim idea of making a good impression in that state.
Sometimes from the gym floor with its sweet, heady smell of varnish

I'd see her in the entryway looking for me, and I'd bounce
the ball two or three times, study the orange rim as if it were,
which it was, the true level of the world, the one sure thing

the power in my hands could summon. I'd bounce the ball
once more, feel the grain of the leather in my fingertips and shoot.
It was a perfect thing; it was almost like killing her.

4.

When we say "mother" in poems,
we usually mean some woman in her late twenties
or early thirties trying to raise a child.

We use this particular noun
to secure the pathos of the child's point of view
and to hold her responsible.

5.

If you're afraid now?
Fear is a teacher.
Sometimes you thought that
nothing could reach her,
nothing can reach you.
Wouldn't you rather
sit by the river, sit
on the dead bank,
deader than winter,
where all the roots gape?

6.

This morning in the early sun,
steam rising from the pond the color of smoky topaz,
a pair of delicate, copper-red, needle-fine insects
are mating in the unopened crown of a Shasta daisy
just outside your door. The green flower heads look like wombs
or the upright, supplicant bulbs of a vegetal pre-erection.
The insect lovers seem to be transferring the cosmos into each other
by attaching at the tail, holding utterly still, and quivering intently.

I think (on what evidence?) that they are different from us.
That they mate and are done with mating.
They don't carry all this half-mated longing up out of childhood
and then go looking for it everywhere.
And so, I think, they can't wound each other the way we do.
They don't go through life dizzy or groggy with their hunger,
kill with it, smear it on everything, though it is perhaps also true
that nothing happens to them quite like what happens to us
when the blue-backed swallow dips swiftly toward the green pond

and the pond's green-and-blue reflected swallow marries it a moment
in the reflected sky and the heart goes out to the end of the rope
it has been throwing into abyss after abyss, and a singing shimmers
from every color the morning has risen into.

My insect instructors have stilled, they are probably stuck together
in some bliss and minute pulse of after-longing
evolution worked out to suck that last juice of the world
into the receiver body. They can't separate probably
until it is done.

MY MOTHER'S NIPPLES

They're where all displacement begins.
They bulldozed the upper meadow at Squaw Valley,
where horses from the stable, two chestnuts, one white,
grazed in the mist and the scent of wet grass on summer mornings
and moonrise threw the owl's shadow on voles and wood rats
crouched in the sage smell the earth gave back after dark
with the day's heat to the night air.
And after the framers began to pound nails
and the electricians and plumbers came around to talk specs
with the general contractor, someone put up a green sign
with alpine daises on it that said Squaw Valley Meadows.
They had gouged up the deep-rooted bunchgrass
and the wet alkali-scented earth had been pushed aside
or trucked someplace out of the way, and they poured concrete
and laid road—pleasant scent of tar in the spring sun—

<div align="center">*</div>

"He wanted to get out of his head," she said,
"so I told him to write about his mother's nipples."

<div align="center">*</div>

The cosmopolitan's song on this subject:
Alors! les nipples de ma mère!

The romantic's song

What could be more fair
than les nipples de ma mère?

The utopian's song

I will freely share
les nipples de ma mère.

The philosopher's song

Here was always there
with les nipples de ma mère

The capitalist's song

Fifty cents a share

The saint's song

Lift your eyes in prayer

The misanthrope's song

I can scarcely bear

The melancholic's song

They were never there,
les nipples de ma mère.
They are not anywhere.

The indigenist's song

And so the boy they called Loves His Mother's Tits
Went into the mountains and fasted for three days.
On the fourth he saw a red-tailed hawk with broken wings,
On the fifth a gored doe in a ravine, entrails
Spilled onto the rocks, eye looking up at him
From the twisted neck. All the sixth day he was dizzy

And his stomach hurt. On the seventh he made three deep cuts
In the meat of his palm. He entered the pain at noon
And an eagle came to him crying three times like the mewling
A doe makes planting her hooves in the soft duff for mating
And he went home and they called him Eagle Three Times after that.

The regionalist's song

Los Pechos.
Rolling oak woodland between Sierra pines
and the simmering valley.

✳

Pink, of course, soft; a girl's—
she wore white muslin tennis outfits
in the style Helen Wills made fashionable.
Trim athletic swimsuits.
A small person, compact body. In the photographs
she's on the beach, standing straight,
hands on hips, grinning,
eyes desperate even then.

✳

Mothers in the nineteen forties didn't nurse.
I never saw her naked. Oh! yes, I did,
once, but I can't remember. I remember
not wanting to.

✳

Two memories. My mother had been drinking for several days, and I
had thought dinner would be cancelled, so I wouldn't get to watch *The
Lone Ranger* on my aunt's and uncle's television set. But we went to
dinner and my aunt with her high-pitched voice took the high-minded
tone that she took in my mother's presence. She had put out hard

candies in little cut glass dishes as she always did, and we ate dinner, at which water was served to the grown-ups, and no one spoke except my uncle who teased us in his English accent. A tall man. He used to pat me on the head too hard and say, "Robert of Sicily, brother of the Pope Urbane." And after dinner when the television was turned on in the immaculate living room and Silver was running across the snowy screen, his mane shuddering from the speed, the doorbell rang. It was two men in white coats and my mother bolted from the table into the kitchen and out the back door. The men went in after her. The back stairs led into a sort of well between the houses, and when I went into the kitchen I could hear her screaming, "No! no!," the sound echoing and reechoing among the houses.

Some years later. I am perhaps ten, eleven. We are visiting my mother on the parklike grounds of the State Hospital in the Napa Valley. It is Sunday again. Green lawns, the heavy sweet scent of mock orange. Many of the patients are walking, alone or with their families, on the paths. One man seemed to be giving speeches to a tree. I had asked my grandmother why, if my mother had a drinking problem, that's the phrase I had been taught to use, why she was locked up with crazy people. It was a question I could have asked my father, but I understood that his answer would not be dependable. My grandmother said, with force, she had small red curls on her forehead, dressed with great style, you had better ask your father that. Then she thought better of it, and said, They have a treatment program, dear, maybe it will help. I tried out that phrase, treatment program. My mother was sitting on a bench. She looked immensely sad, seemed to have shrunk. Her hair was pulled across her forehead and secured with a white barrette, like Teresa Wright in the movies. At first my brother and I just sat next to her on the bench and cried. My father held my sister's hand. My grandmother and grandfather stood to one side, a separate group, and watched.

Later, while they talked I studied a middle-aged woman sitting on the next bench talking to herself in a foreign language. She was wearing

a floral print dress and she spoke almost in a whisper but with passion,
looking around from time to time, quick little furtive resentful glances.
She was so careless of herself that I could see her breast, the brown
nipple, when she leaned forward. I didn't want to look, and looked, and
looked away.

<center>✳</center>

Hot Sierra morning.
Brenda working in another room.
Rumble of heavy equipment in the meadow,
bird squall, Steller's jay, and then
the piercing three-note whistle of a robin.
They're mating now. Otherwise they're mute.
Mother-ing. Or Mother-song.
Mother-song-song-song.

<center>✳</center>

We used to laugh, my brother and I in college,
about the chocolate cake. Tears in our eyes laughing.
In grammar school, whenever she'd start to drink,
she panicked and made amends by baking chocolate cake.
And, of course, when we got home, we'd smell the strong, sweet smell
of the absolute darkness of chocolate,
and be too sick to eat it.

<center>✳</center>

The first girl's breasts I saw
were the Chevy dealer's daughter Linda Wren's.
Pale in the moonlight. Little nubbins, pink-nosed.
I can still hear the slow sound of the surf
of my breath drawing in. I think I almost fainted.

<center>✳</center>

Twin fonts of mercy, they used to say of the Virgin's breasts
in the old liturgy the Irish priests

could never quite handle, it being a form of bodily reference,
springs of grace, freshets
of loving-kindness. If I remember correctly,
there are baroque poems in this spirit
in which each of Christ's wounds is a nipple.
Drink and live: this is the son's blood.

❊

Dried figs, candied roses.

What is one to say of the nipples of old women
who would, after all, find the subject
unseemly.

Yesterday I ran along the edge of the meadow in the heat
of late afternoon. So many wildflowers
tangled in the grass. So many grasses—
reedgrass, the bentgrass and timothy, little quaking grass,
dogtail, ripgut brome—the seeds flaring from the stalks
in tight chevrons of green and purple-green
but loosening.

I said to myself:
some things do not blossom in this life.

I said: what we've lost is a story
and what we've never had
a song.

When my father died, I was curious to see in what ratio she would feel
relieved and lost. All during the days of his dying, she stood by his bed
talking to whichever of her children were present about the food in
the cafeteria or the native state of the nurses—"She's from Portland,
isn't that interesting? Your Aunt Nell lived in Portland when Owen
was working for the Fisheries."— and turn occasionally to my father

who was half-conscious, his eyes a morphine cloud, and say, in a sort
of baby talk, "It's all right, dear. It's all right." And after he died, she
was dazed, and clearly did not know herself whether she felt relieved
or lost, and I felt sorry for her that she had no habit and no means of
self-knowing. She was waiting for us to leave so she could start drinking.
Only once was she suddenly alert. When the young man from the
undertaker's came and explained that she would need a copy of her
marriage license in order to do something about the insurance and
pensions, she looked briefly alive, anxious, and I realized that, though
she rarely told the truth, she was a very poor dissembler. Now her eyes
were a young girl's. What, she asked, if someone just couldn't turn up
a marriage license; it seemed such a detail, there must be cases. I could
see that she was trying out avenues of escape, and I was thinking, now
what? They were never married? I told her not to worry. I'd locate it.
She considered this and said it would be fine. I could see she had made
some decision, and then she grew indefinite again.

So, back in California, it was with some interest that I retraced the
drive from San Francisco to Santa Rosa which my parents made in 1939,
when according to my mother's story—it was the first account of it
I'd ever heard—she and my father had eloped. The Sonoma County
Office of Records was in a pink cinder-block building landscaped
with reptilian pink oleanders which were still blooming in the Indian
summer heat. It would have been raining when my parents drove that
road in an old (I imagined) cream-colored Packard convertible I had
seen one photo of. I asked the woman at the desk for the marriage
certificate for February 1939. I wondered what the surprise was going
to be, and it was a small one. No problem, Mrs. Minh said. But you
had the date wrong, so it took me a while to find it. It was October,
not February. Driving back to San Francisco, I had time to review this
information. My brother was born in December 1939. Hard to see that
it meant anything except that my father had tried very hard to avoid his
fate. I felt so sorry for them. That they thought it was worth keeping
a secret. Or, more likely, that their life together began in a negotiation
too painful to be referred to again. That my mother had, with a certain

fatality, let me pick up the license, so her first son would not know the circumstance of his conception. I felt sorry for her shame, for my father's panic. It finished off my dim wish that there had been an early romantic or ecstatic time in their lives, a blossoming, brief as a northern summer maybe, but a blossoming.

What we've never had is a song
and what we've really had is a song.
Sweet smell of timothy in the meadow.
Clouds massing east above the ridge in a sky
as blue as the mountain lakes,
so there are places on this earth clear all the way up
and all the way down
and in between a various blossoming,
the many seed shapes of the many things
finding their way into flower or not,
that the wind scatters.

There are all kinds of emptiness and fullness
that sing and do not sing.

I said: you are her singing.

I came home from school and she was gone. I don't know what instinct sent me to the park. I suppose it was the only place I could think of where someone might hide: she had passed out under an orange tree, curled up. Her face, flushed, eyelids swollen, was a ruin. Though I needed urgently to know whatever was in it, I could hardly bear to look. When I couldn't wake her, I decided to sit with her until she woke up. I must have been ten years old: I suppose I wanted for us to look like a son and mother who had been picnicking, like a mother who had fallen asleep in the warm light and scent of orange blossoms and a boy who was sitting beside her daydreaming, not thinking about anything in particular.

You are not her singing, though she is what's
broken in a song.
She is its silences.

She may be its silences.

Hawk drifting in the blue air,
gray of the granite ridges,
incense cedars, pines.

I tried to think of some place on earth she loved.

I remember she only ever spoke happily
of high school.

The Gardens of Warsaw

The rain loves the afternoon and the tall lime trees
just where the broad Avenue of Third of May
crosses Jerozolimska Street (it is 1922)
have carved green channels deep into the summer.
Above the dusty pavements, darkening only faintly
when the clouds pass over, above clanging trolleys
and the glistening Vistula flinging the broken forms
of trees and clouds and bridges back into the sky,
above the Virgin's statue on the Street of Honey Cakes,
above the Church of the Holy Cross where Chopin's heart,
in a glimmering silver box, is turning to fine dust,
above the kiosks with their posters of Clara Bow and Chaplin
and Valentino as The Sheik, above the crowded tenements
huddled around courtyards, above new apartment houses
with mansard roofs, Viennese grilles, King Tut carvings,
sylphlike women frosted into glass, it is raining a light rain.
It rains on the Saxon Gardens, lilacs and apple trees
on the grassy slopes, and on the Ujazdowski Gardens
with their chain of ponds where the black-billed swans
paddle calmly under the archways of miniature bridges
and a Zionist boy is reading a book on a wooden bench.
It rains on the Botanical Gardens where the magnolias,
blooming, toss off grails of pure white idly.
It rains also on the Lazienki Gardens lightly
and the small palace with its cream-colored walls
and columned porticoes shimmering in the bull's-eye
circles-within-circles the rain makes lightly
on the face of the lagoon and on the feathers of nightingales
furtive in the elms and on the bronze statue of Stanislaus
in the sweet scent of the orangery where water laps
against the mottled marble stairs of the amphitheater

where Paderewski once conducted Brahms, and even the children,
chasing each other on the grass across the way,
or turning in fast circles, arms out, till they fall down
into their dizziness, stopped at a sudden yearning lift
of the violins, and listened. It is summer as I write,
Northern California. Clear air, a blazing sky in August,
bright shy Audubon's warblers in the pines.
I have been reading an old travel guide I found,
bound in dark blue cloth with gilded scrollwork titles,
in a used bookstore in this little mountain town.
It is inscribed, "From Cazimir to Hilda,
with patient hope and deep respect. Come back,
my dear. Be sure to see the bell of Krakow."
The children clear the table, fetch fleecy towels
for the beach. Congress in recess, guards sleeping
at the embassies. Even the murderers are on vacation.

LAYOVER

Thin snow falling on the runway at Anchorage,
bundled bodies of men, gray padded jackets, outsized gloves,
heads bent against the wind. They lunge, weaving
among the scattering of luggage carts, hard at what must be
half the world's work, loading and unloading.

Mounded snow faintly gray and sculpted into what seems
the entire vocabulary of resignation. It shines
in the one patch of sun, is lustered with the precipitate
of the exhaust of turbine engines, the burnt carbons
of Precambrian forests, life feeding life
feeding life in the usual, mindless way. The colonizer's
usual prefab, low-roofed storage sheds in the distance
pale beige and curiously hopeful in their upright verticals
like boys in an army, or like the spruce and hemlock forest
on low hillsides beyond them. And beyond those, half-seen
in the haze, range after range of snowy mountains
in the valleys of which—moose feeding along the frozen streams,
snow foxes hunting ptarmigan in the brilliant whiteness—
no human could survive for very long, and which it is the imagination's
intensest, least possible longing to inhabit.

This is a day of diplomatic lull. Iraq seems to have agreed
to withdraw from Kuwait with Russian assurances
that the government of Hussein will be protected. It won't happen,
thousands of young men will be killed, shot, blown up,
buried in the sand, an ancient city bombed,
but one speaks this way of countries, as if they were entities
with wills. Iraq has agreed. Russia has promised. A bleak thing,

dry snow melting on the grizzled, salted tarmac.
One of the men on the airstrip is waving his black,
monstrously gloved hands at someone. Almost dancing:
strong body, rhythmic, efficient stride. He knows
what he's supposed to do. He's getting our clothes to us
at the next stop. Flower burst ties, silky underwear.
There are three young Indians, thin faces, high cheekbones,
skin the color of old brass, chatting quietly across from me
in what must be an Athabascan dialect. A small child crying
mildly, sleepily, down the way, a mother murmuring in English.
Soft hums of motors stirring through the plane's low, dim fuselage
the stale air, breathed and breathed, we have been sharing.

Notes on "Layover"

I could have said that I am a listless eye gazing through watery glass on a Friday afternoon in February. A raven flies by. If he cries out sharply, I can't hear him. Strong wingbeats. Very black against gray sky, white snow.

I could have said that Alaska—*where the sea breaks its back*, in one of the languages of the people who looked for centuries at water lashing and lashing against jagged rock, mists of spray blown toward them by Aleutian winds—still feels like a military colony, which is the way a wilderness is settled, and is, ultimately, why I happen to be here.

And that the woman with the baby is the wife of some technician whose rank she knows well from filling out forms to do with the delivery of her child and an ovarian cyst she had removed and discount airfares for the relatives of ALASCOM personnel, and also because it is a form of hope, grade seven, soon to be grade six.

And that, watching the men unload the luggage, I was thinking of her body, and then of her underwear. Pretty, not very expensive, neatly folded for the journey.

A way of locating itself that even the idle mind works at. Airports: people dressed well and not well, hope and exhaustion, reunions, separations. Families with banners and flowers, WELCOME HOME SUSIE, and the beaming unsexual smiles of family loyalty, and floral sprays in cellophane. Men with clean shirts in rayon bags smoking in the limbo between sales presentations—"I just admit flat out" overheard on the flight in "that we've had a little problem with distribution and that the home office knows it has to get its act together, so we're pricing real competitively, and if they place an order right now" words that can stare down any hopelessness "they got a good chance of getting theirselves a hell of a deal." Nursing slim glasses of beer in the lounges—each sip stranding a little line of foam—to the

sound of daytime talk shows on men who sleep with their mothers-in-law, transvestites, filmed three thousand miles away, transmitted to the heavens and bounced back in little waves and dots and flurries of ionized air carrying the peculiar contents of human curiosity. The sweet bleating of the baby, part whimper, part croon now, to take its place in this vast, deeply strange net of contingencies. An old poem by an old poet composed on islands to the southwest of here; he must have been on a fishing boat: The whitebait / opens its black eye / in the net of the law.

I could have said a translation of the Athabascan idiom for "good-bye" is "make prayers to the raven." Anyone who has walked in a northern forest knows what sense it makes. Sharp echoing cry in the pinewood and the snow. Swift black flash of its flight, and the powerful wings. Ruthless and playful spirit of creation. World's truth in the black bead of its eye.

That all crossings over are a way of knowing, and of knowing we don't know, where we have been: a man leaves one woman for another and wakes up in a room with morning light and a vase he doesn't recognize, full of hydrangeas, mauve petals of hydrangeas.

THE WOODS IN NEW JERSEY

Where there was only gray, and brownish gray,
And grayish brown against the white
Of fallen snow at twilight in the winter woods,

Now an uncanny flamelike thing, black
and sulphur-yellow, as if it were dreamed by Audubon,
Is turned upside down in a delicate cascade

Of new green leaves, feeding on whatever mites
Or small white spiders haunt underleafs at stem end.
A magnolia warbler, to give the thing a name.

The other name we give this overmuch of appetite
And beauty unconscious of itself is life.
And that that kept the mind becalmed all winter? —

The more austere and abstract rhythm of the trunks,
Vertical music the cold makes visible,
That holds the whole thing up and gives it form,

or strength—call that the law. It's made,
whatever we like to think, more of interests
than of reasons, trees reaching each their own way

for the light, to make the sort of order that there is.
And what of those deer threading through the woods
In a late snowfall and silent as the snow?

Look: they move among the winter trees, so much
the color of the trees, they hardly seem to move.

for Justice William J. Brennan, Jr.

Iowa City: Early April

This morning a cat—bright orange—pawing at the one patch of new
 grass in the sand- and tanbark-colored leaves.

And last night the sapphire of the raccoon's eyes in the beam of the
 flashlight.
He was climbing a tree beside the house, trying to get onto the porch, I
 think, for a wad of oatmeal
Simmered in cider from the bottom of the pan we'd left out for the birds.

And earlier a burnished, somewhat dazed woodchuck, his coat
 gleaming with spring,
Loping toward his burrow in the roots of a tree among the drying
 winter's litter
Of old leaves on the floor of the woods, when I went out to get the
 New York Times.

And male cardinals whistling back and forth—sireeep, sreeep, sreeep—
Sets of three sweet full notes, weaving into and out of each other like
 the triplet rhymes in medieval poetry,
And the higher, purer notes of the tufted titmice among them,
High in the trees where they were catching what they could of the early sun.

And a doe and two yearlings, picking their way along the worrying path
 they'd made through the gully, their coats the color of the forest floor,
Stopped just at the roots of the great chestnut where the woodchuck's
 burrow was,
Froze, and the doe looked back over her shoulder at me for a long
 moment and leaped forward,
Her young following, and bounded with that almost mincing precision
 in the landing of each hoof
Up the gully, over it, and out of sight. So that I remembered

Dreaming last night that a deer walked into the house while I was
 writing at the kitchen table,
Came in the glass door from the garden, looked at me with a stilled
 defiant terror, like a thing with no choices,
And, neck bobbing in that fragile-seeming, almost mechanical mix of
 arrest and liquid motion, came to the table
And snatched a slice of apple, and stood, and then quietened, and to my
 surprise did not leave again.

And those little captains, the chickadees, swift to the feeder and swift away.

And the squirrels with their smoke-plume tails trailing digging in the
 leaves to bury or find buried—
I'm told they don't remember where they put things, that it's an activity
 of incessant discovery—
Nuts, tree-fall proteins, whatever they forage from around the house of
 our leavings,

And the flame-headed woodpecker at the suet with his black-and-white
 ladderback elegant fierceness—

They take sunflower seeds and stash them in the rough ridges of the
 tree's bark
Where the beaks of the smoke-and-steel blue nuthatches can't quite get
 at them—
Though the nuthatches sometimes seem to get them as they con the
 trees methodically for spider's eggs or some other overwintering
 insect's intricately packaged lump of futurity
Got from its body before the cold came on.

And the little bat in the kitchen lightwell—
When I climbed on a chair to remove the sheet of wimpled plastic and
 let it loose,
It flew straight into my face and I toppled to the floor, chair under me,

And it flared down the hall and did what seemed a frantic reconnoiter
 of the windowed, high-walled living room.
And lit on a brass firelog where it looked like a brown and ash gray
 teenaged suede glove with Mephistophelean dreams,
And then, spurt of black sperm, up, out the window, and into the
 twilight woods.
All this life going on about my life, or living a life about all this life
 going on,
Being a creature, whatever my drama of the moment at the edge of the
 raccoon's world—
He froze in my flashlight beam and looked down, no affect, just looked,
The ringtailed curled and flared to make him look bigger and not to be
 messed with—
I was thinking he couldn't know how charming his comic-book
 robber's mask was to me,
That his experience of his being and mine of his and his of mine were
 things entirely apart,
Though there were between us, probably, energies of shrewd and
 respectful tact, based on curiosity and fear—
I knew about his talons whatever he knew about me—
And as for my experience of myself, it comes and goes, I'm not sure it's
 any one thing, as my experience of these creatures is not,
And I know I am often too far from it or too near, glad to be rid of it
 which is why it was such a happiness,
The bright orange of the cat, and the first pool of green grass-leaves
 in early April, and the birdsong—that orange and that green not
 colors you'd set next to one another in the human scheme.

And the crows' calls, even before you open your eyes, at sunup.

A Note on "Iowa City: Early April"

The raccoon stared down from the crotch of a tree.
A dark night, icy in the early spring.

"This naturalist I admire," I said, "says that every species lives in its
 own sensory world."

The raccoon stared down; he was silent.

"He also said that we may come to know enough about the human
 brain to diagnose and correct for the deformations
imposed by evolution on the human senses and arrive at something like
 objective truth."

The raccoon was silent.

"Maybe," I volunteered, "they can do something about raccoon
 deformation."

He might have been thinking "deformed from what?" but I don't think
 so; he was silent.

He might have been trying to discern under the odor of garlic and
 rosemary on my fingers,
and under the smell of oatmeal soap under that, the smell of sex from a
 sweet hour when we lay down and the snow fell in quick flurries
in the early afternoon; he may have been smelling toward some distant
 cousin to the smell that is pistil and stamen
from which flowers the raccoon-universe.

Maybe that, but I don't know. The raccoon was silent.

He might have been studying an enemy,
 he might simply have been curious
but I don't know.

So I entered the silence, and was glad to be in it for a while, knowing I
 couldn't stay.

It smelled like snow and pine and the winter dark, though it was my
 silence, not his, and there was nothing there.

for E. O. Wilson

Sonnet

A man talking to his ex-wife on the phone.
He has loved her voice and listens with attention
to every modulation of its tone. Knowing
it intimately. Not knowing what he wants
from the sound of it, from the tendered civility.
He studies, out of the window, the seed shapes
of the broken pods of ornamental trees.
The kind that grow in everyone's garden, that no one
but horticulturists can name. Four arched chambers
of pale green, tiny vegetal proscenium arches,
a pair of black tapering seeds bedded in each chamber.
A wish geometry, miniature, Indian or Persian,
lovers or gods in their apartments. Outside, white,
patient animals, and tangled vines, and rain.

FAINT MUSIC

Maybe you need to write a poem about grace.

When everything broken is broken,
and everything dead is dead,
and the hero has looked into the mirror with complete contempt,
and the heroine has studied her face and its defects
remorselessly, and the pain they thought might,
as a token of their earnestness, release them from themselves
has lost its novelty and not released them,
and they have begun to think, kindly and distantly,
watching the others go about their days—
likes and dislikes, reasons, habits, fears—
that self-love is the one weedy stalk
of every human blossoming, and understood,
therefore, why they had been, all their lives,
in such a fury to defend it, and that no one—
except some almost inconceivable saint in his pool
of poverty and silence—can escape this violent, automatic
life's companion ever, maybe then, ordinary light,
faint music under things, a hovering like grace appears.

As in the story a friend told once about the time
he tried to kill himself. His girl had left him.
Bees in the heart, then scorpions, maggots, and then ash.
He climbed onto the jumping girder of the bridge,
the bay side, a blue, lucid afternoon.
And in the salt air he thought about the word *seafood*,
that there was something faintly ridiculous about it.
No one said *landfood*. He thought it was degrading to the rainbow perch
he'd reeled in gleaming from the cliffs, the black rock bass,

scales like polished carbon, in beds of kelp
along the coast—and he realized that the reason for the word
was crabs, or mussels, clams. Otherwise
the restaurants could just put *fish* up on their signs,
and when he woke—he'd slept for hours, curled up
on the girder like a child—the sun was going down
and he felt a little better, and afraid. He put on the jacket
he'd used for a pillow, climbed over the railing
carefully, and drove home to an empty house.

There was a pair of her lemon yellow panties
hanging on a doorknob. He studied them. Much-washed.
A faint russet in the crotch that made him sick
with rage and grief. He knew more or less
where she was. A flat somewhere on Russian Hill.
They'd have just finished making love. She'd have tears
in her eyes and touch his jawbone gratefully. "God,"
she'd say, "you are so good for me." Winking lights,
a foggy view downhill toward the harbor and the bay.
"You're sad," he'd say. "Yes." "Thinking about Nick?"
"Yes," she'd say and cry. "I tried so hard," sobbing now,
"I really tried so hard." And then he'd hold her for a while—
Guatemalan weavings from his fieldwork on the wall—
and they'd fuck again, and she would cry some more,
and go to sleep.
 And he, he would play that scene
once only, once and a half, and tell himself
that he was going to carry it for a very long time
and that there was nothing he could do
but carry it. He went out onto the porch, and listened
to the forest in the summer dark, madrone bark
cracking and curling as the cold came up.

It's not the story though, not the friend
leaning toward you, saying "And then I realized—,"
which is the part of stories one never quite believes.
I had the idea that the world's so full of pain
it must sometimes make a kind of singing.
And that the sequence helps, as much as order helps—
First an ego, and then pain, and then the singing.

FORTY SOMETHING

She says to him, musing, "If you ever leave me,
and marry a younger woman and have another baby,
I'll put a knife in your heart." They are in bed,
so she climbs onto his chest, and looks directly
down into his eyes. "You understand? Your heart."

SHAME: AN ARIA

You think you've grown up in various ways
and then the elevator door opens and you're standing inside
reaming out your nose—something about the dry air
in the mountains—and find yourself facing two spruce elderly couples
dressed like improbable wildflowers in their primary color,
definitely on vacation sports outfits, a wormy curl of one of the body's
shameful and congealed lubricants gleaming on your fingertip
under the fluorescent lights, and there really isn't too much to say
as you descend the remaining two flights with them in silence,
all five of you staring straight ahead in the commodious
aluminium group coffin toward the ground floor. You are,
of course, trying to think of something witty to say. Your hand
is, of course, in your pocket discreetly transferring the offending article
into its accumulation of lint. One man clears his throat
and you admit to yourself that there are kinds of people—if not
people in particular—you hate, that these are they,
and that your mind is nevertheless, is nevertheless working
like a demented cicada drying its wings after rain to find some way
to save yourself in your craven, small child's large ego's idea
of their eyes. You even crank it up a notch, getting more high-minded
and lugubrious in the seconds it takes for the almost silent
gears and oiled hydraulic or pneumatic plungers and cables
of the machine to set you down. "Nose picking," you imagine explaining
to the upturned, reverential faces, "is in a way the ground floor
of being. The body's fluids and solids, its various despised disjecta,
toenail pairings left absently on the bedside table that your lover
the next night notices there, skid marks in underwear or little, faint,
odorous pee-blossoms of the palest polleny color; the stiffened
small droplets in the sheets of the body's shuddering late-night loneliness
and self-love, russets of menstrual blood, toejam, earwax,
phlegm, the little dead militias of white corpuscles

we call pus, what are they after all but the twins of the juices
of mortal glory: sap, wine, breast milk, sperm, and blood. The most
 intimate hygienes,
those deepest tribal rules that teach a child
trying to struggle up out of the fear of loss of love
from anger, hatred, fear, they get taught to us, don't they,
as boundaries, terrible thresholds, what can be said (or thought, or done)
inside the house but not out, what can be said (or thought, or done)
only by oneself, which must therefore best not be done at all,
so that the core of the self, we learn early is where shame lives
and where we also learn doubleness, and a certain practical cunning,
and what a theater is, and the ability to lie—"
the elevator has opened and closed, the silver-haired columbines
of the mountain are murmuring over breakfast menus in a room full of
 bright plastics
somewhere, and you, grown up in various ways, are at the typewriter,
thinking of all the slimes and jellies of decay, thinking
that the zombie passages, ghoul corridors, radiant death's-head
entries to that realm of terror claim us in the sick, middle-of-the-night
sessions of self-hatred and remorse, in the day's most hidden,
watchful self, the man not farting in line at the bank,
no trace of discomfort on his mild, neighbor-loving face, the woman
calculating the distance to the next person she can borrow a tampon from
while she smiles attentively into this new man's explanation
of his theory about deforestation, claims us also, by seepage, in our lies,
small malices, razor nicks on the skin of others of our meannesses,
deprivations, rage, and what to do but face that way
and praise the kingdom of the dead, praise the power which we have
 all kinds
of phrases to elide, that none of us can worm our way out of—
"which all must kneel to in the end," "that no man can evade—"
praise it by calling it time, say it is master of the seasons,
mistress of the moment of the hunting hawk's sudden sheen of
 grape-brown

gleaming in the morning sun, the characteristic slow gesture,
two fingers across the cheekbone deliberately, of the lover dreamily
oiling her skin, in this moment, no other, before she turns to you
the face she wants you to see and the rest
that she hopes, when she can't keep it hidden, you can somehow love
and which, if you could love yourself, you would.

REGALIA FOR A BLACK HAT DANCER

In the morning, after running along the river:
"Creekstones practice the mild yoga of becoming smooth."
By afternoon I was thinking: once you're smooth, you're dead.
"It is good sometimes that poetry should disenchant us,"
I wrote, and something about the "the heart's huge vacancy,"
which seemed contemptible. After dinner—sudden cooling
of the summer air—I sat down to it. Where.

*

Walking down to Heart's Desire beach in the summer evenings
of the year my marriage ended—

though I was hollowed out by pain,
honeycombed with the emptiness of it,
like the bird bones on the beach
the salt of the bay water had worked on for a season—
such surprising lightness in the hand—
I don't think I could have told the pain of loss
from the pain of possibility,
though I knew they weren't the same thing.

When I think of that time, I think mainly of the osprey's cry,
a startled yelp,
the cry more a color than a sound, and as if
it ripped the sky, was white,
as if it were scar tissue and fresh hurt at once.

Toyon, old oak, and coffeeberry: always about halfway,
but especially if the day had been hot, the scent of vanilla grass—
my throat so swollen with some unsortable mix
of sorrow and desire I couldn't swallow—

salt smell, gray water, sometimes the fog came in,
pouring down the dragonback of pines,
often there was one blue heron in the tidal pond—

and I'd present my emptiness, which was huge, baffled
(Rilke writing in French because there was no German equivalent
for *l'absence* in "the great positive sense"
with which it appeared in Valéry:
one of my minor occupations was raging against Rilke),
and most of the time I felt nothing,
when the moment came that was supposed to embody presence,
nothing really. There were a few buffleheads,
as usual, a few gulls rocking in the surf.
Sometimes a Western grebe diving and swimming
with its crazed red eye.

So there were these two emptinesses: one made of pain and desire
and one made of vacancy.

(Paused for a moment in this writing and went out.
Dark, first the dark. Wind in the trees.
Everybody's private pain: in Korea once, in a mountain pass,
a carved placatory shrine, a figure of a couple copulating,
and underneath in hangul: we beget joy, we beget suffering.

It made you want to say a prayer, to conjure prayer.

Lost everything: this is the night; it doesn't love me
or not. Shadow of a hawk, then shadow of a hawk.
Going down at about the speed of a second hand.)

I thought of my mother ending her days in a hotel room,
scarcely able to breathe. "I'm doing fine
except for the asthma." "It's emphysema, Mom."

"We used to call it asthma. Anyway, I'm just lucky
I have my health." Of my brother in the psych ward
at San Francisco General, his ward mate an eight-months-pregnant
girl, coming down, like him, from crack.
When they were let out to smoke in a courtyard,
some guy from another ward four stories up
was pounding on the window. She thought he was trying
to get her attention. A shy, pleased smile (gap in her bad front teeth).
And said to me, coyly, "Fatal attraction."
When he got the window open, it turned out
he wanted the orderly, also smoking. He needed insulin.
My brother on crack, spoken with a stutter: "The really crazy jones
lasts about two hours and when you come down,
you really (r-r-r-really) come down. You got nothing left
but the lint in your pockets."
 Emptinesses—
one is desire, another is the object that it doesn't have.
Everything real nourished in the space between these things.

There ought to be some single word for the misery of divorce.
(What is the rhythm of that line? Oh, I see. Four and three,
Emily's line!—

 There ought to be some single word
 For the misery of divorce.
 It dines upon you casually
 duh-dduh-duh-dduh-fierce/remorse/pierce)

In Berkeley over dinner in a restaurant on a Friday night,
I noticed that it was full of fathers with daughters,
mothers with sons. Some of them people I knew or recognized.
The manager of the bookstore, the woman who sold antiques.
These were the stunned, out-of-the-house, noncooking parents
in their new apartments who had the children weekends,

while their mates, resuming the unaccustomed ritual of dating,
were out with the new lover. Children, I guess, make of this
what they have to. I looked around. Kids staring at their plates,
parents studying them anxiously, saying, "So, how was school?"
The whole theater of the real: sadness, which seems infinite,
cruelty, which seems infinite, the cheerful one-armed guy
in the bakery mornings— he puts his croissant between his teeth
and pours himself some coffee; someone on the phone
trying to get me to pay my brother's rent, "I got too big a heart,
I try to run a clean place"—the first floor reserved
for transvestite hookers wobbling on spiked heels—
and who would deny their clients the secret exhaustion
of their dreams?; the whole botched world—that funny phrase
I'd heard yesterday, someone talking about a failing baseball team:
"they really screw the pooch." And the pelicans
that settled in the cove in the late midsummer dusk,
preposterous creatures, they seem companionable,
finding each other as the dark came on. I would go home,
make tea, call my children, some piece of writing
that I'd started would seem possible.

 Odd how families
live in houses. At first a lot marked out with string.
Then levels, rooms, that lift it off the ground,
arrange it, and then inside that intricate dance
of need and habit and routine. Children's crayon drawings
on the wall. Messages on the refrigerator. Or altars
for the household gods. At night the dreaming bodies,
little gene pool echoes passing back and forth among them,
earlobe, the lap of an eyelid, and the dreams.

Under sorrow, what? I'd think. Under
the animal sense of loss?

Climbing in Korea,
months later, coming to the cave of the Sokkaram Buddha—
a view down a forested ravine to the Sea of Japan—
perhaps a glimpse: the closed eyelids—you'd have to make a gesture
with your hand to get the fineness of the gesture in the stone—
the stone hands resting on the thighs, open, utterly composed.

Cool inside. Dark. The stone, though there was no lighting,
seemed to glow. It seemed I could leave every internal fury there
and walk away. In the calm I felt like a wind-up monkey.
Like I had always been a wind-up monkey, and that,
if I knew the gesture (going outside? picking the petals
of the wildflowers—there was something like a thimbleberry bush—
everything was "like" something I knew—on the path
from the monastery— so I seemed to be walking
in a parallel universe, peopled by unfamiliar birdsong,
and ancient trail dust, and the forest's dappled light—
papery flowers, very plain ancestor of the garden rose—
another elaboration of desire—of a startling magenta-blue;
I thought I might pick them, bring them in,
and drop before the—what—the Buddha—
the carved, massive stone, the—)

Also thought I could leave my wedding ring. And didn't do it.
In the months we were apart, I had endless fantasies
about when I'd finally take it off and how. And then one day,
I was moving, lugging cardboard boxes, I looked down
and it wasn't there. I looked in the grass of the driveway strip.
Sow bugs, an earwig. So strange. This was a time when,
in the universities, everyone was reading Derrida.
Who'd set out to write a dissertation about time;
he read Heidegger, Husserl, Kant, Augustine, and found
that there was no place to stand from which to talk about it.
There was no ground. It was language. The scandal

of nothingness! Put cheerfully to work by my colleagues
to dismantle regnant ideologies. It was a time when,
a few miles away, kids were starting to kill each other
in wars over turf for selling drugs, schizophrenics
with matted hair, dazed eyes, festering feet, always engaged
in some furious volleying inner dialogue they neglected,
unlike the rest of us, to hide, were beginning to fill the streets,
"de-institutionalized," in someone's idea of reform,
and I was searching in the rosebed of a rented house
inch by inch, looking under the car seat where the paper clips
and Roosevelt dimes and unresolved scum-shapes of once
vegetal stuff accumulate in abject little villages
where matter hides while it transforms itself. Nothing there.
I never found it.

 Looking at old frescoes
from the medieval churches in The Cloisters once, I wondered if,
all over Europe, there were not corresponding vacancies,
sheer blanks where pietàs and martyrdoms of Santa Lucia
and crowing cocks rising to announce the dawn in which
St. Peter had betrayed his lord in sandstone and basalt
and carnelian marble once had been. This emptiness
felt like that. Under the hosannahs and the terror of the plague
and the crowning of the Virgin in the spring.
I didn't leave my ring. Apparently I was supposed to wait
until it disappeared. I didn't know what else, exactly,
I could leave.

 In Seoul, in Myongdong, in a teeming alley,
there was a restaurant where the fish was so fresh
they let you know it by beginning each meal
with a small serving of the tips of the tentacles
of octopus, just cut, writhing on a plate.
In the latticed entrance, perch glowing like pearls
in the lamplight thrown from doorways
as they circulate, wide-eyed and moony, in the tanks,

coppery lobsters scuttling over lobsters,
squid like the looseness in a dream. Had been at a meeting
all day on the conditions of imprisoned writers.
This one without paper and pen for several years.
This one with blood in his urine.

 In small cells
all over the world, I found myself thinking,
walking through the marketplace—apple-pears
and nectarines in great piles, wavery under swinging lamps,
as if you could sell the sunrise—torturers upholding
the order of the state. Under screams order, and under that—
it must be the torturer's nightmare—nothing.

 Smoothness
of the stone at Sokkaram. The way the contours, flowing,
were weightless and massive at once. I said to myself
there was kindness in the Buddha's hands, but there wasn't kindness
in the hands. They made the idea of kindness
seem—not a delusion exactly, or a joke. They smoothed
the idea away the way you'd stroke a nervous or a frightened dog.

(Outside again. Rubbing my eyes. Deep night, brilliant stars.
I never thought I'd write about this subject. Was tired of "subjects."
Mallarmé on music: the great thing is that it can resolve an argument
without ever stating the terms. But thought I'd ride this rhythm out,
this somewhat tired, subdued voice—like Landor's "Carlino," perhaps—
a poet-guide!—and see where it was going.)

 Around that time—
find the neutral distance in which to say this—
a woman came into my life. What I felt was delight.
When she came into the room, I smiled. The gift was
that there didn't need to be passionate yearning across distances.
One night—before or after Sokkaram?—when we had made love
and made love, desperate kissings, wells of laughter,
in a monkish apartment on the wooden floor, we went outside,

naked in the middle of the night. There must have been a full moon.
There was a thick old shadowy deodar cedar by my door
and the cones were glowing, lustrously glowing,
and we thought, both of us, our happiness had lit the tree up.

The word that occurs to me is *droll*. It seemed sublimely droll.
The way we were as free as children playing hide-and-seek.
Her talk—raffish, funny, unexpected, sometimes wise, darkened—
the way a black thing is scintillant in light—by irony.
The way neither of us needed to hold back, think
before we spoke, lie, tiptoe carefully around a given subject,
or brace ourselves to say hard truths. It felt to me hilarious,
and hilarity, springwater gushing up from some muse's font
of crystal in old poems, seemed a form of emptiness. Look!
(Rilke in the sonnets) I last but a minute. I walk on nothing.
Coming and going I do this dance in air. At night
when we had got too tired to talk, were touching all along our bodies,
nodding off, I'd fall asleep smiling. Mornings—for how long—
I'd wake in pain. Physical pain, fluid; it moved
through my body like a grassfire spreading on a hill.
(Opposite of touching.) I'd think of my wife, her lover,
some moment in our children's lives, the gleam of old wood
on a Welsh cabinet we'd agonized over buying,
put against one wall, then another till it founds its place.
This—old word!—riding that we made, its customs, villages, demesnes,
would torture me awhile. If she were there, rare mornings
that she was—we did a lot of car keys, hurried dressing, last kisses
on swollen lips at 2 am—I'd turn to her, stare at her sleeping face
and want to laugh from happiness. I'd even think: ten years
from now we could be screaming at each other in a kitchen,
and want to laugh. My legs and chest still felt as if
someone had been beating them with sticks. I could hardly move.
I'd quote Vallejo to myself: "*Golpes como del odio de Dios*";
I'd stare at the ceiling, bewildered, and feel a grief

so old it could have been some beggar woman in a fairy tale.
I didn't know you could lie down in such swift, opposing currents.

 Also, two emptinesses, I suppose, the one
joy comes from, the one regret, disfigured intention, the longing
to be safe or whole flows into when it's disappearing.

I'd gone out of the cave. Looked at the scaled brightness
of the sea ten miles away; looked at unfamiliar plants.
During the war, a botanist in Pusan had told me,
a number of native species had become extinct. People
in the countryside boiled anything that grew to make a soup.
We had "spring hunger," he said, like medieval peasants.
There's even a word for it in ancient Korean. Back inside,
in the cool darkness carved with boddhisattvas,
I presented myself once more for some revelation.
Nothing. Great calm, flowing stone. No sorrow, no not-sorrow.
Lotuses, carved in the pediment, simple, fleshy, open.

Private pain is easy, in a way. It doesn't go away,
but you can teach yourself to see its size. Invent a ritual.
Walk up a mountain in the afternoon, gather up pine twigs.
Light a fire, thin smoke, not an ambitious fire,
and sit before it and watch it till it burns to ash
and the last gleam is gone from it, and dark falls.
Then you get up, brush yourself off, and walk back to the world.
If you're lucky, you're hungry.
 In the town center
of Kwangju, there was a late October market fair.
Some guy was barbecuing halfs of baby chicks on a long, sooty contraption
of a grill, slathering them with soy sauce. Baby chicks.
Corn pancakes stuffed with leeks and garlic. Some milky,
violent, sweet Korean barley wine or beer. Families strolling.
Booths hawking calculators, sox, dolls to ward off evil,

and computer games. Everywhere, of course, it was Korea,
people arguing politics, red-faced, women serving men.
I thought in this flesh-and-charcoal-scented heavy air
of the Buddha in his cave. Tired as if from making love
or writing through the night. Was I going to eat a baby chick?
Two pancakes. A clay mug of the beer. Sat down
under an umbrella and looked to see, among the diners
feasting, quarreling about their riven country,
if you were supposed to eat the bones. You were. I did.

JATUN SACHA

First she was singing. Then it was a gold thing, her singing.
And her bending. She was singing and a gold thing.
A selving. It was a ringing before there was a bell.

Before there was a bell there was a bell. Notwithstanding.
Standing or sitting, sometimes at night or in the day,
when they worked, they hummed. And made their voices high
and made sounds. It was the ringing they hadn't heard yet
singing, though they heard it, ringing.

When Casamiro's daughter went to the river and picked arum leaves,
and wet them, and rubbed them together,
they made the one sweet note that was the ringing.
It was the one-note cry of a bee-eating bird
with a pale blue crest, and when the first one
made the ringing with the arum leaves, and the others
heard that the arum leaves were the bee-eating bird,
they laughed. Their laughter rang.

And the young guy who worked metal—they liked it best at night,
when the iron glowed and the sparks showered down
and he struck metal against metal in the glowing.
He fashioned what he fashioned for adornment
or for praying or for killing. And he knew the made things
from the ringing. Which was the arum leaves and the sounds
made in love and the bee-eating bird and the humming.

She sang like that, something of keening and something of laughing,
birth cries, and a gold thing, ringing.

Frida Kahlo: In the Saliva

In the saliva
In the paper
in the eclipse
In all the lines
in all the colors
in all the clay jars
in my breast
outside inside—
in the inkwell—in the difficulties of writing
in the wonder of my eyes—in the ultimate
limits of the sun (the sun has no limits) in
everything. To speak it all is imbecile, magnificent
DIEGO in my urine—DIEGO in my mouth—in my
heart. In my madness. In my dream—in
the blotter—in the point of my pen—
in the pencils—in the landscapes—in the
food—in the metal—in imagination
in the sicknesses—in the glass cupboards—
in his lapels—in his eyes—DIEGO—
in his mouth—DIEGO—in his lies.

Transcribed and translated from a manuscript in her hand, at Diego
Rivera's studio near the Hacienda San Angel in Mexico City

English: An Ode

1.

¿De quien son las piedras del rio
que ven tus ojos, habitante?

Tiene un espejo la mañana.

2.

Jodhpurs: from a state in northeast India,
for the riding breeches of the polo-playing English.

Dhoti: once the dress of the despised,
it is practically a symbol of folk India.
One thinks of blood flowering in Gandhi's
after the zealot shot him.

Were one, therefore, to come across a child's primer
a rainy late winter afternoon in a used bookshop
in Hyde Park and notice, in fine script,
fading, on the title page,
"Susanna Mansergh, The Lodge, Little Shelford, Cmbs."
and underneath it, a fairly recent ballpoint
in an adult hand: *Anna Sepulveda Garcia—sua libra*
and flip through pages which asseverate,
in captions enhanced by lively illustrations,
that *Jane wears jodhpurs*, while *Derek wears a dhoti*,
it wouldn't be unreasonable to assume a political implication,

lost, perhaps, on the children of Salvadoran refugees
studying English in a housing project in Chicago.

3.

Ode: not connected, historically, to *odor* or to *odd*.

To *mad*, though obsolete, meant "to behave insanely"
and is quite another thing than to *madden*,
meaning, of course, "to irritate."
So that the melancholy Oxford cleric who wished to live
"Far from the madding crowd's ignoble strife"
and gave Thomas Hardy the title for that novel
was merely observing that people in large numbers
living at close quarters act crazy
and are best given a wide berth.

Not an option, perhaps,
for a former high school math teacher
from San Salvador whose sister, a secretary in the diocesan office
of the Christian Labor Movement, was found
in an alley with her neck broken, and who therefore
followed her elder brother to Chicago and, perhaps,
bought a child's alphabet book in a used bookstore
near the lake where it had languished for thirty years
since the wife, perhaps, of an Irish professor of Commonwealth History
at the university had sold it in 1959—maybe the child died
of some childhood cancer—maybe she outgrew the primer
and when her bookshelf began to fill with more grown-up books,
The Wind in the Willows, Winnie-the-Pooh—
what privilege those titles suddenly call up!—
her father, famous for his groundbreaking *Cold War and Commonwealth*
of 1948, looking antique now on the miscellaneous shelf

beside row on row of James T. Farrell, sold it. Or perhaps his wife
did and found it painful to let her daughter's childhood go,
was depressed after. Probably she hated Chicago anyway.
And, browsing, embittered, among the volumes on American history
she somehow felt she should be reading,
thought *Wisconsin, Chicago*: they killed them
and took their language and then they used it
to name the places that they've taken.
Perhaps the marriage survived. Back in London
she may have started graduate school in German Lit.
"Be ahead of all partings," Rilke said in the Spender translation.
Perhaps she was one of those lives—if the child did die
of the sickness I chose to imagine—in which death
inscribes a permanent before and after. Perhaps
she was one of those whose story is innocence
and a private wound and aftermath.

4.

-*Math*, as it turned out,
when she looked up the etymology
comes from an Anglo-Saxon word for mowing.
Maeth. It would have been the era
of "hot skirts" and The Rolling Stones.
And she a little old to enjoy it. Standing on Chelsea Embankment
after the Duncan Grant retrospective at the Tate,
thinking about the use of *du* in the *Duino Elegies*
or about the photo in the *Times* that morning
of the Buddhist monk in Saigon, wearing something
like a dhoti, immobile, sheathed in flames.

5.

There are those who think it's in fairly bad taste
to make habitual reference to social and political problems
in poems. To these people it seems a form of melodrama
or self-aggrandizement, which it no doubt partly is.
And there's no doubt either that these same people also tend
to feel that it ruins a perfectly good party
to be constantly making reference to the poor or oppressed
and their misfortunes in poems which don't,
after all, lift a finger to help them. Please
help yourself to the curried chicken.
What is the etymology of *curry?* Of *chicken?*
Wouldn't you like just another splash of chardonnay?
There's far less objection, generally speaking,
you will find yourself less *at loggerheads*
with the critics, by making mention of accidental death,
which might happen to any of us, which does not,
therefore, seem like moral nagging, and which is also,
in our way of seeing things, possibly tragic
and possibly absurd—"Helen Mansergh was thinking about Rilke's
pronouns
which may be why she never saw the taxi"—and thus
a subject much easier to ironize.

She—the mother from Salvador—may have bought several books.
Mother Goose, Goodnight Moon. All
relatively cheap. And that night her brother might have come
with a bag of groceries. And—a gesture against sleet and ice—
flowers in January!
And the Salvadoran paper from Miami.

6.

Disaster: something wrong with the stars.
Loggerheads: heavy brass balls attached to long sticks;
they were heated on shipboard and plunged into buckets of tar
to soften it for use. By synecdoche were sailors tars.
And from the rage of living together in brutish conditions
on a ship the tars were often at loggerheads. You could crush
a man's knees with them easily. One swing. Claim
it was an accident. If the buggers didn't believe you,
the punishment was some number of lashes with a whip. Not death.
That was the punishment for sodomy, or striking an officer.

7.

 "As when the Sun
in dim eclipse disastrous twilight sheds . . ."
Mount Diablo foothills, green in the early spring.
Creeks running, scent of bay leaves in the air.

And we heard a high two-note whistle: once,
twice, and then again with a high vibrato tailing.
"What's that?" "Loggerhead shrike."

(Years later one of the young poets at Iowa, impatient
with her ornithologist boyfriend, his naming
everything to death, her thinking *bird, bird!*)

8.

Imagine (from the Latin, *imago,* a likeness)
a language (also from Latin, *lingua,* the tongue)

purged (*purgo*, to cleanse) of history (not the Greek *hist*
for tissue, but the Greek *historia*,
to learn by inquiry). Not this net of circumstance
(*circum*, etc.) that we are caught in,
ill-starred, quarried with veins of cruelty,
stupidity, bad luck,
which rhymes with *fuck*,
not the sweet act, the exclamation
of disgust, or maybe both
a little singing ode-like rhyme
because we live our lives in language and in time,
craving some pure idiomorphic dialect of the thing itself,
Adamic, electrified by clear tension
like the distance between a sparrow and a cat,
self and thing and eros as a god of wonder:
it sat upon a branch and sang: the bird.

9.

In one of Hardy's poems, a man named "Drummer Hodge,"
born in Lincolnshire where the country word
for twilight was *dimpsy* two centuries ago,
was a soldier buried in South Africa.
Some war that had nothing to do with him.
Face up according to the custom of his people
so that Hardy could imagine him gazing forever
into foreign constellations. *Cyn* was the Danish word
for farm. Hence Hodge's cyn.
And someone of that stock studied medicine.
Hence Hodgkin's lymphoma. *Lymph* from the Latin
meant once "a pure clear spring of water."
Hence *limpid*. But it came to mean
the white cells of the blood.

"His homely Northern breast and brain
 Grow to some Southern tree
And strange-eyed constellations reign
 His stars eternally."

10.

I have been hearing it all morning
As if it were a Spanish nonsense rhyme.
Like the poem of José Martí the woman in Chicago
might have sung to her children as they fell asleep:

 Yo soy un hombre sincero
 De donde crece la palma,
 Y antes de morime quiero
 Echar mis versos del alma.

Do you hear it? She has (strong beat)
a Hodg (strong beat) kin's lym-phom (strong beat)-a.

This impure spring of language, strange-eyed,
"To scatter the verses of the soul."

11.

So—what are the river stones
that come swimming to your eyes, *habitante?*

They hold the hope of morning.

The Seventh Night

It was the seventh night and he walked out to look at stars.
Chill in the air, sharp, not of summer, and he wondered
if the geese on the lake felt it and grew restless
and if that was why, in the later afternoon, they had gathered
at the bay's mouth and flown abruptly back and forth,
back and forth on the easy, swift veering of their wings.
It was high summer and he was thinking of autumn,
under a shadowy tall pine, and of geese overhead on cold mornings
and high clouds drifting. He regarded the stars in the cold dark.
They were a long way off, and he decided, watching them blink,
that compared to the distance between him and them,
the outside-looking-in feeling was dancing cheek-to-cheek.
And noticed then that she was there, a shadow between parked cars,
looking out across the valley where the half-moon poured thin light
down the pine ridge. She started when he approached her,
and then recognized him, and smiled, and said, "Hi, night light."
And he said, "Hi, dreamer." And she said, "Hi, moonshine,"
and he said, "Hi, mortal splendor." And she said, "That's good."
She thought for a while. Scent of sage or yerba buena
and the singing in the house. She took a new tack and said,
"My father is a sad chair and I am the blind thumb's yearning."
He said, "Who threw the jade swan in the chicken soup?"
Some of the others were coming out of the house, saying good-bye,
hugging each other. She said, "The lion of grief paws
what meat she is given." Cars starting up, one of the stagehands
struggling to uproot the pine. He said, "Rifling the purse
of possible regrets." She said, "Staggering tarts, a narcoleptic moon."
Most of the others were gone. A few gathered to listen.
The stagehands were lugging off the understory plants.
Two others were rolling up the mountain. It was clear that,
though polite, they were impatient. He said, "Good-bye, last thing."

She said, "So long, apocalypse." Someone else said, "Time,"
but she said, "The last boat left Xania in late afternoon."
He said, "Good-bye, Moscow, nights like sable,
mornings like the word *persimmon*." She said,
"Day's mailman drinks from a black well of reheated coffee
in a café called Mom's on the outskirts of Durango." He said,
"That's good." And one of the stagehands stubbed
his cigarette and said, "OK, would the last of you folks to leave,
if you can remember it, just put out the stars?" which they did,
and the white light everywhere in that silence was white paper.

INTERRUPTED MEDITATION

Little green involute fronds of fern at creekside.
And the sinewy clear water rushing over creekstone
of the palest amber, veined with a darker gold,
thinnest lines of gold rivering through the amber
like—ah, now we come to it. *We were not put on earth,*
the old man said, he was hacking into the crust
of a sourdough half loaf in his vehement, impatient way
with an old horn-handled knife, *to express ourselves.*
I knew he had seen whole cities leveled: also
that there had been a time of shame for him, outskirts
of a ruined town, half Baroque, half Greek Revival,
pediments of Flora and Hygeia from a brief eighteenth-century
health spa boom lying on the streets in broken chunks
and dogs scavenging among them. His one act of courage
then had been to drop pieces of bread or chocolate,
as others did, where a fugitive family of Jews
was rumored to be hiding. *I never raised my voice,*
of course, none of us did. He sliced wedges of cheese
after the bread, spooned out dollops of sour jam
from some Hungarian plum, purple and faintly gingered.
Every day the bits of half-mildewed, dry, hard—
this is my invention—whitened chocolate, dropped furtively
into rubble by the abandoned outbuilding of some suburban
mechanic's shop—but I am sure he said chocolate—
and it comforted no one. *We talked in whispers.*
"Someone is taking them." "Yes," Janos said,
"But it might just be the dogs." He set the table.
Shrugged. Janos was a friend from the university,
who fled east to join a people's liberation army,
died in Siberia somewhere. *Some of us whispered "art,"*
he said. *Some of us "truth."* A debate with cut vocal chords.

You have to understand that, for all we knew, the Germans
would be there forever. And if not the Germans, the Russians.
Well, you don't "have to" understand anything, naturally.
No one knew which way to jump. What we had was language,
you see. Some said art, some said truth. Truth, of course,
was death. Clattered the plates down on the table. *No one,*
no one said "self-expression." Well, you had your own forms
of indulgence. Didn't people in the forties say "man"
instead of "the self?" I think I said. *I thought "the self"*
came in in 1949. He laughed. *It's true. Man,*
we said, is the creature who is able to watch himself
eat his own shit from fear. You know what that is?
Melodrama. I tell you, there is no bottom to self-pity.

This comes back to me on the mountainside. Butterflies—
tiny blues with their two-dot wings like quotation marks
or an abandoned pencil sketch of a face. They hover lightly
over lupine blooms, whirr of insects in the three o'clock sun.
What about being? I had asked him. *Isn't language responsible*
to it, all of it, the texture of bread, the hairstyles
of the girls you knew in high school, shoelaces, sunsets,
the smell of tea? Ah, he said, *you've been talking to Miłosz.*
To Czesław I say this: silence precedes us. We are catching up.
I think he was quoting Jabès whom he liked to read.
Of course, here, gesturing out the window, pines, ragged green
of a winter lawn, the bay, *you can express what you like,*
enumerate the vegetation. And you! you have to, I'm afraid,
since you don't excel at metaphor. A shrewd, quick glance
to see how I have taken this thrust. *You write well, clearly.*
You are an intelligent man. But—finger in the air—
silence is waiting. Miłosz believes there is a Word
at the end that explains. There is silence at the end,
and it doesn't explain, it doesn't even ask. He spread chutney
on his bread, meticulously, out to the corners. Something

angry always in his unexpected fits of thoroughness
I liked. Then cheese. Then a lunging, wolfish bite.
Put it this way, I give you, here, now, a magic key.
What does it open? This key I give you, what exactly
does it open? Anything, anything! But what? I found
that what I thought about was the failure of my marriage,
the three or four lost years just at the end and after.
For me there is no key, not even the sum total of our acts.
But you are a poet. You pretend to make poems. And?

She sat on the couch sobbing, her rib cage shaking
from its accumulated abysses of grief and thick sorrow.
I don't love you, she said. The terrible thing is
that I don't think I ever loved you. He thought to himself
fast, to numb it, that she didn't mean it, thought
what he had done to provoke it. It was May.
Also pines, lawn, the bay, a blossoming apricot.
Everyone their own devastation. Each on its own scale.
I don't know what the key opens. I know we die,
and don't know what is at the end. We don't behave well.
And there are monsters out there, and millions of others
to carry out their orders. We live half our lives
in fantasy, and words. This morning I am pretending
to be walking down the mountain in the heat.
A vault of blue sky, traildust, the sweet medicinal
scent of mountain grasses, and at trailside—
I'm a little ashamed that I want to end this poem
singing, but I want to end this poem singing—the wooly
closed-down buds of the sunflower to which, in English,
someone gave the name, sometime, of pearly everlasting.

Time and Materials

IOWA, JANUARY

In the long winter nights, a farmer's dreams are narrow.
Over and over, he enters the furrow.

After Trakl

October night, the sun going down,
Evening with its brown and blue
(Music from another room),
Evening with its blue and brown.
October night, the sun going down.

ENVY OF OTHER PEOPLE'S POEMS

In one version of the legend the sirens couldn't sing.
It was only a sailor's story that they could.
So Odysseus, lashed to the mast, was harrowed
By a music that he didn't hear—plungings of sea,
Wind-sheer, the off-shore hunger of the birds—
And the mute women gathering kelp for garden mulch,
Seeing him strain against the cordage, seeing
The awful longing in his eyes, are changed forever
On their rocky waste of island by their imagination
Of his imagination of the song they didn't sing.

A Supple Wreath of Myrtle

Poor Nietzsche in Turin, eating sausage his mother
Mails to him from Basel. A rented room,
A small square window framing August clouds
Above the mountain. Brooding on the form
Of things: the dangling spur
Of an Alpine columbine, winter-tortured trunks
Of cedar in the summer sun, the warp in the aspen's trunk
Where it torqued up through the snowpack.

"Everywhere the wasteland grows; woe
To him whose wasteland is within."

Dying of syphilis. Trimming a luxuriant mustache.
In love with the opera of Bizet.

FUTURES IN LILACS

"Tender little Buddha," she said
Of my least Buddha-like member.
She was probably quoting Allen Ginsberg,
Who was probably paraphrasing Walt Whitman.
After the Civil War, after the death of Lincoln,
That was a good time to own railroad stocks,
But Whitman was in the Library of Congress,
Researching alternative Americas,
Reading up on the curiosities of Hindoo philosophy,
Studying the etchings of stone carvings
Of strange couplings in a book.

She was taking off a blouse,
Almost transparent, the color of a silky tangerine.
From Capitol Hill Walt Whitman must have been able to see
Willows gathering the river haze
In the cooling and still-humid twilight.
He was in love with a trolley conductor
In the summer of—what was it?—1867? 1868?

Three Dawn Songs in Summer

1.

The first long shadows in the fields
Are like mortal difficulty.
The first birdsong is not like that at all.

2.

The light in summer is very young and wholly unsupervised.
No one has made it sit down to breakfast.
It's the first one up, the first one out.

3.

Because he has opened his eyes, he must be light
And she, sleeping beside him, must be the visible,
One ringlet of hair curled about her ear.
Into which he whispers, "Wake up!"
"Wake up!" he whispers.

The Distribution of Happiness

Bedcovers thrown back,
Tangled sheets,
Lustrous in moonlight.

Image of delight,
Or longing,
Or torment,

Depending on who's
Doing the imagining.

(I know: you are the one
Pierced through, I'm the one
Bent low beside you, trying
To peer into your eyes.)

ETYMOLOGY

Her body by the fire
Mimicked the light-conferring midnights
Of philosophy.
Suppose they are dead now.
Isn't "dead now" an odd expression?
The sound of the owls outside
And the wind soughing in the trees
Catches in their ears, is sent out
In scouting parties of sensation down their spines.
If you say it became language or it was nothing,
Who touched whom?
In what hurtle of starlight?
Poor language, poor theory
Of language. The shards of skull
In the Egyptian museum looked like maps of the wind-eroded
Canyon labyrinths from which,
Standing on the verge
In the yellow of a dwindling fall, you hear
Echo and reecho the cries of terns
Fishing the worked silver of a rapids.
And what to say of her wetness? The Anglo-Saxons
Had a name for it. They called it *silm*.
They were navigators. It was also
Their word for the look of moonlight on the sea.

THE PROBLEM OF DESCRIBING COLOR

If I said—remembering in summer,
The cardinal's sudden smudge of red
In the bare gray winter woods—

If I said, red ribbon on the cocked straw hat
Of the girl with pooched-out lips
Dangling a wiry lapdog
In the painting by Renoir—

If I said fire, if I said blood welling from a cut—

Or flecks of poppy in the tar-grass scented summer air
On a wind-struck hillside outside Fano—

If I said, her one red earring tugging at her silky lobe,

If she tells fortunes with a deck of fallen leaves
Until it comes out right—

Rouged nipple, mouth—

(How could you not love a woman
Who cheats at the Tarot?)

Red, I said. Sudden, red.

The Problem of Describing Trees

The aspen glitters in the wind
And that delights us.

The leaf flutters, turning,
Because that motion in the heat of August
Protects its cells from drying out. Likewise the leaf
Of the cottonwood.

The gene pool threw up a wobbly stem
And the tree danced. No.
The tree capitalized.
No. There are limits to saying,
In language, what the tree did.

It is good sometimes for poetry to disenchant us.

Dance with me, dancer. Oh, I will.

Mountains, sky,
The aspen doing something in the wind.

WINGED AND ACID DARK

A sentence with "dappled shadow" in it.
Something not sayable
spurting from the morning silence,
secret as a thrush.

The other man, the officer, who brought onions
and wine and sacks of flour,
the major with the swollen knee,
wanted intelligent conversation afterward.
Having no choice, she provided that, too.

Potsdamer Platz, May 1945.

When the first one was through he pried her mouth open.
Bashō told Rensetsu to avoid sensational materials.
If the horror of the world were the truth of the world,
he said, there would be no one to say it
and no one to say it to.
I think he recommended describing the slightly frenzied
swarming of insects near a waterfall.

Pried her mouth open and spit in it.
We pass these things on,
probably, because we are what we can imagine.

Something not sayable in the morning silence.
The mind hungering after likenesses. "Tender sky," etc.,
curves the swallows trace in air.

A Swarm of Dawns, A Flock of Restless Noons

There's a lot to be written in the Book of Errors.
The elderly redactor is blind, for all practical purposes,

He has no imagination, and field mice have gnawed away
His source text for their nesting. I loved you first, I think,

When you stood in the kitchen sunlight and the lazy motes
Of summer dust while I sliced a nectarine for Moroccan salad

And the seven league boots of your private grief. Maybe
The syntax is a little haywire there. Left to itself,

Wire must act like Paul Klee with a pencil. *Hay*
Is the Old English word for *strike*. You strike down

Grass, I guess, when it is moan. Mown. The field mice
Devastated the monastery garden. Maybe because it was summer

And the dusks were full of marsh hawks and the nights were soft
With owls, they couldn't leave the herbs alone: gnawing the roots

Of rosemary, nibbling at sage and oregano and lemon thyme.
It's too bad *eglantine* isn't an herb, because it's a word

I'd like to use here. Her coloring was a hybrid
Of rubbed amber and the little flare of dawn rose in the kernel

Of an almond. It's a wonder to me that I have fingertips.
The knife was very sharp. The scented rose-orange moons,

Quarter moons, of fruit fell to the cutting board
So neatly it was as if two people lived in separate cities

And walked to their respective bakeries in the rain. Her bakery
Smelled better than his. The sour cloud of yeast from sourdough

Hung in the air like the odor of creation. They both bought
Sliced loaves, they both walked home, they both tripped

In the entry to their separate kitchens, and the spilled slices
Made the exact same pattern on the floor. The nectarines

Smelled like the Book of Luck. There was a little fog
Off the bay at sundown in which the waning moon swam laps.

The Miwoks called it Moon of the Only Credit Card.
I would have given my fingertips to touch your cheekbone,

And I did. That night the old monk knocked off early. He was making it
All up anyway, and he'd had a bit of raisin wine at vespers.

BREACH AND ORISON

1. Terror of Beginnings

What are the habits of paradise?
It likes the light. It likes a few pines
On a mass of eroded rock in summer.

You can't tell up there if rock and air
Are the beginning or the end.

What would you do if you were me? she said.

If I were you-you, or if I were you-me?

If you were me-me.

If I were you-you, he said, I'd do exactly
What you're doing.

—All it is is sunlight on granite.
Pines casting shadows in the early sun.

Wind in the pines like the faint rocking
Of a crucifix dangling
From a rear-view mirror at a stop sign.

2. The Palmer Method

The answer was
The sound of water, *what*

What, what, the sprinkler
Said, the question

Of resilvering the mirror
Or smashing it

Once and for all the
Tea in China-

Town getting out of this film
Noir intact or—damaged

As may be—with tact
Was not self-evident

(they fired the rewrite man).
Winters are always touch

And go, it rained,
It hovered on the cusp

Between a *drizzle*
And a *shower*, it was

A reverie and inconsolable.
There but for the grace

Of several centuries
Of ruthless exploitation,

We said, hearing
Rumors, or maybe whimpers

From the cattle car—
The answer was within

A radius of several
Floor plans for the house

Desire was always building
And destroying, the

Produce man misted
Plums and apple-pears

The color of halogen
Street lamps in a puddle.

They trod as carefully
As haste permitted,

She wept beside him
In the night.

3. Habits of Paradise

Maybe if I made the bed,
It would help. Would the modest diligence
Seem radiant, provoke a radiance?
(Outside aspens glittering in the wind.)

If I saw the sleek stroke of moving darkness
Was a hawk, high up, nesting
In the mountain's face, and if,
For once, I didn't want to be the hawk,
Would that help? Token of earnest,
Spent coin of summer, would the wind
Court me then, and would that be of assistance?

The woman who carries the bowl
Bows low in your presence, bows to the ground.
It doesn't matter what she's really thinking.
Compassion is formal. Suffering is the grass.
She is not first thought, not the urgency.

The man made of fire drinks. The man
Made of cedar drinks.

Two kinds of birds are feasting in the cottonwoods.
She sprinkles millet for the ones that feast on grief.
She strews tears for the thirsty ones
Desire draws south when the leaves begin to turn.

The World as Will and Representation

When I was a child my father every morning—
Some mornings, for a time, when I was ten or so,
My father gave my mother a drug called antabuse.
It makes you sick if you drink alcohol.
They were little yellow pills. He ground them
In a glass, dissolved them in water, handed her
The glass and watched her closely while she drank.
It was the late nineteen forties, a time,
A social world, in which the men got up
And went to work, leaving the women with the children.
His wink at me was a nineteen-forties wink.
He watched her closely so she couldn't "pull
A fast one" or "put anything over" on a pair
As shrewd as the two of us. I hear those phrases
In old movies and my mind begins to drift.
The reason he ground the medications fine
Was that the pills could be hidden under the tongue
And spit out later. The reason that this ritual
Occurred so early in the morning—I was told,
And knew it to be true—was that she could
If she wanted, induce herself to vomit,
So she had to be watched until her system had
Absorbed the drug. Hard to render, in these lines,
The rhythm of the act. He ground two of them
To powder in a glass, filled it with water,
Handed it to her, and watched her drink.
In my memory, he's wearing a suit, gray,
Herringbone, a white shirt she had ironed.
Some mornings, as in the comics we read
When Dagwood went off early to placate
Mr. Dithers, leaving Blondie with crusts

Of toast and yellow rivulets of egg yolk
To be cleared before she went shopping—
On what the comic called a shopping spree—
With Trixie, the next-door neighbor, my father
Would catch an early bus and leave the task
Of vigilance to me. "Keep an eye on Mama, pardner."
You know the passage in the *Aeneid*? The man
Who leaves the burning city with his father
On his shoulders, holding his young son's hand,
Means to do well among the flaming arras
And the falling columns while the blind prophet,
Arms upraised, howls from the inner chamber,
"*Great Troy is fallen. Great Troy is no more.*"
Slumped in a bathrobe, penitent and biddable,
My mother at the kitchen table gagged and drank,
Drank and gagged. We get our first moral idea
About the world—about justice and power,
Gender and the order of things—from somewhere.

AFTER THE WINDS

My friend's older sister's third husband's daughter—
That's about as long as a line of verse should get—
Karmic debris? A field anthropologist's kinship map?
Just sailed by me on the Berkeley street. A student
Of complex mathematical systems, a pretty girl,
Ash-colored hair. I might have changed her diapers.
And that small frown might be her parents' lives.
Desire that hollows us out and hollows us out,
That kills us and kills us and raises us up and
Raises us up. Always laughable from the outside:
The English wit who complained of sex that the posture
Was ridiculous had not been struck down by the god
Or goddess to whose marble threshing floor offerings
Of grapes or olive boughs and flowers or branches
Laden with new fruit or bundles of heavy-headed wheat
Were brought as to any other mystery or power.
My friend sat on the back steps on a summer night
Sick with her dilemma, smoking long cigarettes
While bats veered in the dark and the scraping sound
Of a neighbor cleaning a grill with a wire brush
Ratcheted steadily across the backyard fence.
"He's the nicest man I could imagine," she had said,
"And I feel like I'm dying." Probably in her middle thirties
Then. Flea markets on Saturday mornings, family dinners
On Sunday, a family large enough so that there was always
A birthday, a maiden aunt from the old neighborhood
In San Francisco, or a brother-in-law, or some solemn child
Studying a new toy in silence on the couch.
Had not lived where, tearing, or like burnished leaves
In a vortex of wind, the part of you that might observe
The comedy of gasps and moans gives way, does not

Demur. Though she did laugh at herself. An erotic
Attachment one whole winter to the mouth
Of a particular television actor—she'd turn the TV on—
Watch him for a minute with a kind of sick yearning—
Shake her head—turn the TV off—go back to the translation
Of Van Gogh's letters which was her project that year—
Or do some ironing—that always seemed to calm her—
The sweet iron smell of steam and linen. "Honest to God,"
She'd say, an expression the elderly aunts might have used,
"For Pete's sake," she'd say, "Get yourself together."
Hollow flute, or bell not struck, sending out a shimmering
Not-sound, in waves and waves, to the place where the stunned dead
In the not-beginning are gathered to the arms of the living
In the not-noon: the living who grieve, who rage against
And grieve the always solicited, always unattended dead
In the tiered plazas or lush meadows of their gathered
Absence. A man wants a woman that way. A person a person.
Down on all fours, ravenous and humbled. And later—
"Lovers, you remember the shoeshine boys in Quito
In the city market? Missing teeth, unlaced tennis shoes.
They approach you smiling. Their hands are scrofulous,
They have no rules, and they'll steal anything and so
Would you if you were they." The old capital has always
Just been sacked, the temple hangings burned, and peasants
In the ruins are roasting the royal swans in a small fire
Coaxed from the sticks of the tax assessor's Empire chair
Up against a broken wall. Lent: the saints' bodies
Dressed in purple sacks to be taken off at Easter.
For Magdalen, of course, the resurrection didn't mean
She'd got him back. It meant she'd lost him in another way.
It was the voice she loved, the body, not the god
Who, she had been told, ascended to his heaven,
There to disperse tenderness and pity on the earth.

For Czesław Miłosz in Kraków

The fog has hovered off the coast for weeks
And given us a march of brilliant days
You wouldn't recognize—who have grumbled
So eloquently about gray days on Grizzly Peak—
Unless they put you in mind of puppet pageants
Your poems remember from Lithuanian market towns
Just after the First World War. Here's more theater:
A mule-tail doe gave birth to a pair of fawns
A couple of weeks ago just outside your study
In the bed of oxalis by the redwood trees.
Having dropped by that evening, I saw,
Though at first I couldn't tell what I was seeing,
A fawn, wet and shivering, curled almost
In a ball under the thicket of hazel and toyon.
I've read somewhere that does hide the young
As best they can and then go off to browse
And recruit themselves. They can't graze the juices
In the leaves if they stay to protect the newborns.
It's the glitch in engineering through which chance
And terror enter on the world. I looked closer
At the fawn. It was utterly still and trembling,
Eyes closed, possibly asleep. I leaned to smell it:
There was hardly a scent. She had licked all traces
Of the rank birth-smell away. Do you remember
This fragment from Anacreon?—the context,
Of course, was probably erotic: ". . . her gently,
Like an unweaned fawn left alone in a forest
By its antlered mother, frail, trembling with fright."
It's a verse—you will like this detail—found
In the papyrus that wrapped a female mummy
A museum in Cairo was examining in 1956.

I remember the time that a woman in Portland
Asked if you were a reader of Flannery O'Connor.
You winced regretfully, shook your head,
And said, "You know, I don't agree with the novel."
I think you haven't agreed, in this same sense,
With life, never accepted the cruelty in the frame
Of things, brooded on your century, and God the Monster,
And the smell of summer grasses in the world
That can hardly be named or remembered
Past the moment of our wading through them,
And the world's poor salvation in the word. Well,
Dear friend, you resisted. You were not mute.
Mark tells me he has seen the fawns grazing
With their mother in the dusk. Gorging on your roses—
So it seems they made it through the night
And neither dog nor car has got to them just yet.

Time and Materials

Gerhard Richter: Abstrakte Bilder

1.

To make layers,
As if they were a steadiness of days:

It snowed; I did errands at a desk;
A white flurry out the window thickening; my tongue
Tasted of the glue on envelopes.

On this day sunlight on red brick, bare trees,
Nothing stirring in the icy air.

On this day a blur of color moving at the gym
Where the heat from bodies
Meets the watery, cold surface of the glass.

Made love, made curry, talked on the phone
To friends, the one whose brother died
Was crying and thinking alternately,
Like someone falling down and getting up
And running and falling and getting up.

2.

The object of this poem is not to annihila

To not annih

The object of this poem is to report a theft,
In progress, of everything
That is not these words
And their disposition on the page.

The object o f this poem is to report a theft,
 In progre ss of everything that exists
That is not th ese words
 And their d isposition on the page.

The object of his poe is t repor a theft
 In rogres f ever hing at xists
Th is no ese w rds
 And their disp sit on o the pag

3.

To score, to scar, to smear, to streak,
To smudge, to blur, to gouge, to scrape.

"Action painting," i.e.,
The painter gets to behave like time.

4.

The typo wound be "paining."

(To abrade.)

5.

Or to render time and stand outside
The horizontal rush of it, for a moment
To have the sensation of standing outside
The greenish rush of it.

6.

Some vertical gesture then, the way that anger
Or desire can rip a life apart,

Some wound of color.

ART AND LIFE

You know that milkmaid in Vermeer? Entirely absorbed
In the act of pouring a small stream of milk—
Shocking in the Mauritshuis Museum in The Hague
To have seen how white it is, and alive, as seeing people
Reading their poetry or singing in a chorus, you think
You see the soul is an animal going about its business,
A squirrel, its coat sheening toward fall, stretching
Its body down a slim branch to gather one ripe haw
From a hawthorne, testing the branch with its weight,
Stilling as it sinks, then gingerly reaching out a paw.
There is nothing less ambivalent than animal attention
And so you honor it, admire it even, that her attention,
Turned away from you, is so alive, and you are melancholy
Nevertheless. It is best, of course, to be the one engaged
And being thought of, to be the pouring of the milk.
In The Hague, in the employee's cafeteria, I wondered
Who the restorer was. The blondish young woman
In the boxy, expensive Japanese coat picking at a dish
Of cottage cheese—cottage cheese and a pastry? The sugar
On the bun, long before she woke up, had suffered
Its transformation in the oven. She seems to be a person
Who has counted up the cost and decided what to settle for.
It's in the way her soft, abstracted mouth
Receives the bits of bread and the placid sugars.
Or the older man, thinning brown hair, brown tweed coat,
Brown buckskin shoes like the place where dust and sunset
Meet and disappear. A mouth formed by private ironies,
As if he'd sat silent in too many meetings with people
He thought more powerful and less intelligent than he.
Or the whip-thin guy with black, slicked-back hair
And a scarified zigzag flash of lightning at the temple?

I didn't know if there was a type. I wanted
To interview her, or him. What do you do with your life?
I am an acolyte. I peel time, with absolute care,
From thin strips of paint on three-hundred-year-old canvas.
I make the milk milk that flows from the gray-brown paint
Of a pitcher held by a represented woman, young, rose
And tender yellow for the cheek the light is lucky enough
To seem to touch, by a certain window that refracts it.
I am the servant of a gesture so complete, a body
So at peace, it has become a thought, entirely its own,
And, though it stills desire, infinitely to be desired,
Though neither known nor possessed by you
Or anyone else. The man in black must be an assistant curator.
He looks like he thinks he is a work of art. Everywhere
In The Hague the low-lying smell of sea salt.
We don't know a thing about the mother of Vermeer.
Obviously he displaced her nipple there, took
The whole Madonna tradition and turned it into light and milk
By some meticulous habit of mind the geometries
Of composition worked in him. And her: strong Dutch body,
Almost tender light, the plainness of the room,
The rich red rug her skin, reddened a little
From the roughness of a towel perhaps, picks up.
And the upward thrust of what longing stirs in you
Toward what dark and what dazed, grateful afterward.
One of you touches the vein in the other's neck,
Feels the pulse there as a shock, the current of a river
Or the drawing down of milk. Who wants Amida's Western Paradise
When there is all this world for tongue to taste,
Fingers to touch, small hairs like spun silkweed
Furling on another's arms and legs and lower back.
And so you talk. Always then the other shock
Of the singular, lived life, a mother in a rest home,
Maybe, a difficult person, grievous or vindictive.

The gossip of the other servants. A brother who works
As a hosteler at an inn and has grand plans.
You listen. You learned long ago the trick
Of not thinking what you're going to say next
When the other person's speaking. Part of you
Drinks her in like milk. Part of you begins to notice
That she is trying out self-deceptions in the account
Of some difficulty, lazily formulated. You watch her
Shake her head in self-correction; you notice
That she has a mind that wants to get things right.
The tremor of her body makes a nuzzling notion
Along your flank and you reach down to feel again
The wetness which is what we have instead of the luminosity
Of paint. Afterward, in one of those tracks the mind
Returns to when it's on its feet again, she speaks
Of Hans, the butler, how he bullies the girls,
Prays vigorously at hourly intervals on Sunday.
It is Sunday. Now she's getting dressed. You've agreed
To call the cab and take her to her mother
Up in Gronigen. She's grateful, a little teary,
Makes her first small gesture of possession,
Brushing off your coat. Outside you can hear
The hoofbeats of shod horses on the cobbles.
It's the moment when the burden of another person's life
Seems insupportable. We want to be reborn incessantly
But actually doing it begins—have you noticed?
To seem redundant. Here is the life that chose you
And the one you chose. Here is the brush, horsehair,
Hair of the badger, the goat's beard, the sable,
And here is the smell of paint. The volatile, sharp oils
Of linseed, rapeseed. Here is the stench of the essence
Of pinewood in a can of turpentine. Here is the hand,
Flick of wrist, tendon-ripple of the brushstroke. Here—
Cloud, lake water lifting on a summer morning,

Ash and ash and chalky ash—is the stickiness of paint
Adhering to the woven flax of the canvas, here
Is the faithfulness of paint on paint on paint on paint.
Something stays this way, something comes alive
We cannot have, can have because we cannot have it.

DOMESTIC INTERIORS

I.

A house of old, soft, gray, salt-lustered wood,
Windows onto dune grass and a beach.
His wife is upstairs working in her study
When the doorbell rings. The young man at the door,
A Jehovah's Witness, has an Adam's apple
So protuberant it's conducting a flirtation
With deformity. The man, trying not to stare,
Has a saddened panicked premonition
That his wife needs help, and then a stronger feeling
That he has no wife, has never had a wife.
The young man, eyes contracted by concentration,
Is talking about what he calls "the first awakening."

2.

When the lights went out, she drove to town
And bought a lot of candles. The whole village
Was in the general store buying flashlights,
Batteries, oil lamps, oil lamp mantles, fuel,
Telling the story of where they were
When everything went dark, lingering
Awhile in this sudden village in the village.
When she got home, the power was restored.
That's how the radio described it: "power restored."

3.

She woke him to say that everything was loud,
The night bird's song, the white of the daisies
In the garden in the dark. Then she woke him
To describe headlights on the road across the bay:
They seemed as lonely as the earth. He said
At that hour it must have been a fisherman,
Who was probably baiting line for sand sharks
As they spoke. He fell asleep imagining
The man setting the line, pouring coffee,
Blowing on his hands, shivering against the cold.
She was awake beside him, her panic like the wind.

4.

It was hot. She was stripping a kitchen chair
She'd bought at a garage sale up the bay.
She was working indoors because the sun
Outside would dry the paint remover
As fast as she applied it. So she worked
In the kitchen, opening the windows
And hoping for a little breeze. Which came and went.
There were three layers of paint on the chair,
She discovered, white, an evergreen shade of green,
Then red, and underneath the paint what looked like cedar.
She scraped hard and watched her mind
Shying from the notion of endeavor.

TWIN DOLPHINS

A paradise of palm and palm and palm
And glittering sea.

Rocks, pelicans, then pure horizon,
Angular white villas on a hillside
Tumbling to the sea.

"Gracias." "De nada."

A flycatcher in an ironwood,
Sulfur belly, whitish throat,
A thin rind of brown-gold on ash-gray wings.
Utterly alert. He has his work to do.

After breakfast they went their separate ways.

Gulls and lulls and glittering sea.

"The papaya was lovely this morning."
"Yes, but the guava was not quite ripe."

Expressionist crucifix: the frigate bird.

Sand-colored day, bright heat.
"What do you call a lot of pelicans?"
"A flotilla." "Ah, a little float."
"A baby fleet." Smell of vanilla
In the desert, and, oddly, maple
(yerba santa?). Making love after,
To the sound of waves,
The sound of waves.

Eden, limbo.

Fan palms and the sea; festoons
Of big-leaved fan palms
Fanning out; the sea on which they pitch
Raking sand and raking sand, sighing
And pitching and raking sand.

Harlequin sparrows in a coral tree.
One halcyon harrying another in the desert sky,
Blue, and would be turquoise,
Would be stone.

Bone china handle of a coffee mug: the moon.

What's old? The silence
In this black, humped porous mass
Of "prefossiliferous rock"
The ocean beats against.

No animals, no plants,
The tides of fire before there was a sea.

Before skin, words.

"Sonorous nutshells rattling vacantly."

Brilliant welter, azure welter,
Occurs—the world occurs—
only in the present tense.

"I'll see you after lunch."
(Kisses him lightly)

"—As if raspberry tanagers in palms,
High up in orange air, were barbarous."

THEN TIME

In winter, in a small room, a man and a woman
Have been making love for hours. Exhausted,
Very busy wringing out each other's bodies,
They look at one another suddenly and laugh.
"What is this?" he says. "I can't get enough of you,"
She says, a woman who thinks of herself as not given
To cliché. She runs her fingers across his chest,
Tentative touches, as if she were testing her wonder.
He says, "Me too." And she, beginning to be herself
Again, "You mean you can't get enough of you either?"
"I mean," he takes her arms in his hands and shakes them,
"Where does this come from?" She cocks her head
And looks into his face. "Do you really want to know?"
"Yes," he says. "Self-hatred," she says, "longing for God."
Kisses him again. "It's not what it is," a wry shrug,
"it's where it comes from." Kisses his bruised mouth
A second time, a third. Years later, in another city,
They're having dinner in a quiet restaurant near a park.
Fall. Earlier that day, hard rain: leaves, brass-colored
And smoky crimson, flying everywhere. Twenty years older,
She is very beautiful. An astringent person. She'd become,
She said, an obsessive gardener, her daughters grown.
He's trying not to be overwhelmed by love or pity
Because he sees she has no hands. He thinks
She must have given them away. He imagines,
Very clearly, how she wakes some mornings
(He has a vivid memory of her younger self, stirred
From sleep, flushed, just opening her eyes)
To momentary horror because she can't remember
What she did with them, why they were gone,
And then remembers, and calms herself, so that the day
Takes on its customary sequence once again.

She asks him if he thinks about her. "Occasionally,"
He says, smiling. "And you?" "Not much," she says,
"I think it's because we never existed inside time."
He studies her long fingers, a pianist's hands,
Or a gardener's, strong, much-used, as she fiddles
With her wineglass and he understands, vaguely,
That it must be his hands that are gone. Then
He's describing a meeting that he'd sat in all day,
Chaired by someone they'd felt, many years before,
Mutually superior to. "You know the expression
'A perfect fool,'" she'd said, and he had liked her tone
Of voice so much. She begins a story of the company
In Maine she orders bulbs from, begun by a Polish refugee
Married to a French-Canadian separatist from Quebec.
It's a story with many surprising turns and a rare
Chocolate-black lily at the end. He's listening,
Studying her face, still turning over her remark.
He decides that she thinks more symbolically
Than he does and that it seemed to have saved her,
For all her fatalism, from certain kinds of pain.
She finds herself thinking what a literal man he is,
Notices, as if she were recalling it, his pleasure
In the menu, and the cooking, and the architecture of the room.
It moves her—in the way that earnest limitation
Can be moving, and she is moved by her attraction to him.
Also by what he was to her. She sees her own avidity
To live then, or not to not have lived might be more accurate,
From a distance, the way a driver might see from the road
A startled deer running across an open field in the rain.
Wild thing. Here and gone. Death made it poignant, or,
If not death exactly, which she'd come to think of
As creatures seething in a compost heap, then time.

THAT MUSIC

The creek's silver in the sun of almost August,
And bright dry air, and last runnels of snowmelt,
Percolating through the roots of mountain grasses,
Vinegar weed, golden smoke, or meadow rust,

Do they confer, do the lovers' bodies
In the summer dusk, his breath, her sleeping face
Confer—, does the slow breeze in the pines?
If you were the interpreter, if that were your task.

CZESŁAW MIŁOSZ: IN MEMORIAM

In his last years, when he had moved back to Kraków, we worked on the translation of his poems by e-mail and phone. Around the time of his ninetieth birthday, he sent me a set of poems entitled "Oh!" I wrote to ask him if he meant "Oh!" or "O!" and he asked me what the difference was and said that perhaps we should talk on the phone. On the phone I explained that "Oh!" was a long breath of wonder, that the equivalent was, possibly, "Wow!" and that "O!" was a caught breath of wonder and surprise, more like "Huh!" and he said, after a pause, "O! for sure." Here are the translations we made:

O!
1.

O happiness! To see an iris.

The color of indigo, as Ella's dress was once, and the delicate scent was like that of her skin.

O what a mumbling to describe an iris that was blooming when Ella did not exist, nor all our kingdoms, nor all our desmesnes!

2.

GUSTAV KLIMT (1862–1918)
Judith (detail)
OESTERREICHISCHE GALERIE

O lips half-opened, eyes half-closed, the rosy nipple of your unveiled nakedness, Judith!

And they, rushing forward in an attack with your image preserved in their memories, torn apart by bursts of artillery shells, falling down into pits, into putrefaction.

O the massive gold of your brocade, of your necklace with its rows of precious stones, Judith, for such a farewell.

3.

SALVATOR ROSA (1615–1673)
A Landscape with Figures
YALE UNIVERSITY MUSEUM

O the quiet of water under the rocks, and the yellow silence of the afternoon, and flat white clouds reflected!

Figures in the foreground dressing themselves after bathing, figures on the other shore tiny, and in their activities mysterious.

O most ordinary, taken from dailiness and elevated to a place like this earth and not like this earth!

4.

EDWARD HOPPER (1882–1967)
Hotel Room
THYSSEN COLLECTION, MADRID

O what sadness unaware that it's sadness!
What despair that doesn't know it's despair!

A business woman, her unpacked suitcase on the floor, sits on a bed half undressed, in red underwear, her hair impeccable; she has a piece of paper in her hand, probably with numbers.

Who are you? Nobody will ask. She doesn't know either.

Horace: Three Imitations

1.

Odes, 1.38 *Persicos odi, puer, apparatus*

I hate Persian filigree, and garlands
Woven out of lime tree bark.
On no account are you to hunt up, for my sake,
The late-blooming rose.

Plain myrtle will do nicely for a crown.
It's not unbecoming on you as you pour
Or on me as I sip, in the arbor's shade,
A glass of cool wine.

Here, by the way, is your manumission.
Let it be noted that after two thousand years
The poet Horace, he of the suave Greek meters, has
At last freed his slaves.

2.

Odes, 3.2 *Angustam amice pauperiem pati*

Let the young, toughened by a soldiers' training,
Learn to bear hardship gladly
And to terrify Parthian insurgents
From the turrets of their formidable tanks,

Also to walk so easily under desert skies
That the mother of some young Sunni

Will see a marine in the dusty streets
And turn to the daughter-in-law beside her

And say with a shudder: Pray God our boy
Doesn't stir up that Roman animal
Whom a cruel rage for blood would drive
Straight to the middle of any slaughter.

It is sweet, and fit, to die for one's country,
Especially since death doesn't spare deserters
Or the young man without a warrior's instincts
Who goes down with a bullet in his back.

Civic courage is a more complicated matter.
Of itself it shines out undefiled.
It neither lies its way into office, nor mistakes
The interests of Roman oil for Roman honor.

The kind of courage death can't claim
Doesn't go very far in politics.
If you are going to speak truth in public places
You may as well take wing from the earth.

Knowing when not to speak also has its virtue.
I wouldn't sit under the same roof beams
With most of the explainers of wars on television
Or set sail on the same sleek ship.

They say the gods have been known
To punish the innocent along with the guilty
And nemesis often finds the ones it means,
With its limping gait, to track down.

3.

ODES, 3.19 *QUANTEM DISTET AB INACHO*

You talk very well about Inachus
And how Codrus died for his city,
And the offspring of old Aeacus
And the fighting at sacred Ilium under the walls,

But on the price of Chian wine,
And the question of who's going to warm it,
Under whose roof it will be drunk,
And when my bones will come unfrozen, you are mute.

Boy, let's drink to the new moon's sliver,
And drink to the middle of the night, and drink
To good Murena, with three glasses
Or with nine. Nine, says the madman poet

Whom the uneven-numbered Muses love.
Three, says the even-tempered Grace who holds
Her naked sisters by the hands
And disapproves altogether of brawling,

Should do a party handsomely.
But what I want's to rave. Why is the flute
From Phrygia silent? Why are the lyre
And the reed pipe hanging on the wall?

Oh, how I hate a pinching hand.
Scatter the roses! Let jealous old Lycus
Listen to our pandemonium,
And also the pretty neighbor he's not up to.

Rhoda loves your locks, Telephus.
She thinks they glisten like the evening star.
As for me, I'm stuck on Glycera:
With a love that smoulders in me like slow fire.

State of the Planet

On the occasion of the fiftieth anniversary of the Lamont-Doherty
Earth Observatory

1.

October on the planet at the century's end.
Rain lashing the windshield. Through blurred glass
Gusts of a Pacific storm rocking a huge, shank-needled
Himalayan cedar. Under it a Japanese plum
Throws off a vertical cascade of leaves the color
Of skinned copper, if copper could be skinned.
And under it, her gait as elegant and supple
As the young of any of earth's species, a schoolgirl
Negotiates a crosswalk in the wind, her hair flying,
The red satchel on her quite straight back darkening
Splotch by smoky crimson splotch as the rain pelts it.
One of the six billion of her hungry and curious kind.
Inside the backpack, dog-eared, full of illustrations,
A book with a title like *Getting to Know Your Planet.*

The book will tell her that the earth this month
Has yawed a little distance from the sun,
And that the air, cooling, has begun to move,
As sensitive to temperature as skin is
To a lover's touch. It will also tell her that the air—
It's likely to say "the troposphere"—has trapped
Emissions from millions of cars, idling like mine
As she crosses, and is making a greenhouse
Of the atmosphere. The book will say that climate
Is complicated, that we may be doing this,
And if we are, it may explain that this
Was something we've done quite accidentally,

Which she can understand, not having meant
That morning to have spilled the milk. She's
One of those who's only hungry metaphorically.

2.

Poetry should be able to comprehend the earth,
To set aside from time to time its natural idioms
Of ardor and revulsion, and say, in a style as sober
As the Latin of Lucretius, who reported to Venus
On the state of things two thousand years ago—
"It's your doing that under the wheeling constellations
Of the sky," he wrote, "all nature teems with life"—
Something of the earth beyond our human dramas.

Topsoil: going fast. Rivers: dammed and fouled.
Cod: about fished out. Haddock: about fished out.
Pacific salmon nosing against dams from Yokohama
To Kamchatka to Seattle and Portland, flailing
Up fish ladders, against turbines, in a rage to breed
Much older than human beings and interdicted
By the clever means that humans have devised
To grow more corn and commandeer more lights.
Most of the ancient groves are gone, sacred to Kuan Yin
And Artemis, sacred to the gods and goddesses
In every picture book the child is apt to read.

3.

Lucretius, we have grown so clever that mechanics
In our art of natural philosophy can take the property
Of luminescence from a jellyfish and put it in mice.

In the dark the creatures give off greenish light.
Their bodies must be very strange to them.
An artist in Chicago—think of a great trading city
In Dacia or Thracia—has asked to learn the method
So he can sell people dogs that glow in the dark.

4.

The book will try to give the child the wonder
Of how, in our time, we understand life came to be:
Stuff flung off from the sun, the molten core
Still pouring sometimes rivers of black basalt
Across the earth from the old fountains of its origin.
A hundred million years of clouds, sulfurous rain.
The long cooling. There is no silence in the world
Like the silence of rock from before life was.
You come across it in a Mexican desert,

A palo verde tree nearby, moss-green. Some
Insect-eating bird with wing feathers the color
Of a morning sky perched on a limb of the tree.
That blue, that green, the completely fierce
Alertness of the bird that can't know the amazement
Of its being there, a human mind that somewhat does,
Regarding a black outcrop of rock in the desert
Near a sea, charcoal-black and dense, wave-worn,
and all one thing: there's no life in it at all.

It must be a gift of evolution that humans
Can't sustain wonder. We'd never have gotten up
From our knees if we could. But soon enough
We'd fashioned sexy little earrings from the feathers,

Highlighted our cheekbones by rubbings from the rock,
And made a spear from the sinewy wood of the tree.

5.

If she lived in Michigan or the Ukraine,
She'd find, washed up on the beach in a storm like this
Limestone fossils of Devonian coral. She could study
The faint white markings: she might have to lick the stone
To see them if the wind was drying the pale surface
Even as she held it, to bring back the picture of what life
looked like
Three hundred million years ago: a honeycomb with mouths.

6.

Cells that divided and reproduced. From where? Why?
(In our century it was the fashion in philosophy
Not to ask unanswerable questions. That was left
To priests and poets, an attitude you'd probably
Approve.) Then a bacterium grew green pigment.
This was the essential miracle. It somehow unmated
Carbon dioxide to eat the carbon and turn it
Into sugar and spit out, hiss out the molecules
Of oxygen the child on her way to school
Is breathing, and so bred life. Something then
Of DNA, the curled musical ladder of sugars, acids.
From there to eyes, ears, wings, hands, tongues.
Armadillos, piano tuners, gnats, sonnets,
Military interrogation, the Coho salmon, the Margaret Truman rose.

7.

The people who live in Tena, on the Napo River,
Say that the black, viscid stuff that pools in the selva
Is the blood of the rainbow boa curled in the earth's core.
The great trees in that forest house ten thousands of kinds
Of beetle, reptiles no human eyes has ever seen changing
Color on the hot, green, hardly changing leaves
Whenever a faint breeze stirs them. In the understory
Bromeliads and orchids whose flecked petals and womb-
Or mouthlike flowers are the shapes of desire
In human dreams. And butterflies, larger than her palm
Held up to catch a ball or ward off fear. Along the river
Wide-leaved banyans where flocks of raucous parrots,
Fruit-eaters and seed-eaters, rise in startled flares
Of red and yellow and bright green. It will seem to be poetry
Forgetting its promise of sobriety to say the rosy shinings
In the thick brown current are small dolphins rising
To the surface where gouts of the oil that burns inside
The engine of the car I'm driving ooze from the banks.

8.

The book will tell her that the gleaming appliance
That kept her milk cold in the night required
Chlorofluorocarbons—Lucretius, your master
Epictetus was right about atoms in a general way.
It turns out they are electricity having sex
In an infinite variety of permutations, Plato's
Yearning halves of a severed being multiplied
In all the ways that all the shapes on earth
Are multiple, complex; the philosopher
Who said that the world was fire was also right—

Chlorofluorocarbons react with ozone, the gas
That makes air tingle on a sparkling day.
Nor were you wrong to describe them as assemblies,
As if evolution were a town meeting or a plebiscite.
(Your theory of wind, and of gases, was also right
And there are more of them than you supposed.)
Ozone, high in the air, makes a kind of filter
Keeping out parts of sunlight damaging to skin.
The device we use to keep our food as cool
As if it sat in snow required this substance,
And it reacts with ozone. Where oxygen breeds it
From ultraviolet light, it burns a hole in the air.

9.

They drained the marshes around Rome. Your people,
You know, were the ones who taught the world to love
Vast fields of grain, the power and the order of the green,
then golden rows of it, spooled out almost endlessly.
Your poets, those in the generation after you,
Were the ones who praised the packed seed heads
And the vineyards and the olive groves and called them
"Smiling" fields. In the years since we've gotten
Even better at relentless simplification, but it's taken
Until our time for it to crowd out, savagely, the rest
Of life. No use to rail against our curiosity and greed.
They keep us awake. And are, for all their fury
And their urgency, compatible with intelligent restraint.
In the old paintings of the Italian Renaissance,
—In the fresco painters who came after you
(It was the time in which your poems were rediscovered—
There was a period when you, and Venus, were lost;
How could she be lost? You may well ask). Anyway

In those years the painters made of our desire
An allegory and a dance in the figure of three graces.
The first, the woman coming toward you, is the appetite
For life; the one who seems to turn away is chaste restraint,
And the one whom you've just glimpsed, her back to you,
Is beauty. The dance resembles wheeling constellations.
They made of it a figure for something elegant or lovely
Forethought gives our species. One would like to think
It makes a dance, that the black-and-white flash
Of a flock of buntings in October wind, headed south
Toward winter habitat, would find that the December fields
Their kind has known and mated in for thirty centuries
Or more, were still intact, that they will not go
The way of the long-billed arctic curlews who flew
From Newfoundland to Patagonia in every weather
And are gone now from the kinds on earth. The last of them
Seen by any human alit in a Texas marsh in 1964.

10.

What is to be done with our species? Because
We know we're going to die, to be submitted
To that tingling dance of atoms once again,
It's easy for us to feel that our lives are a dream—
As this is, in a way, a dream: the flailing rain,
The birds, the soaked red backpack of the child,
Her tendrils of wet hair, the windshield wipers,
This voice trying to speak across the centuries
Between us, even the long story of the earth,
Boreal forests, mangrove swamps, Tiberian wheat fields
In the summer heat on hillsides south of Rome—all of it
A dream, and we alive somewhere, somehow outside it,

Watching. People have been arguing for centuries
About whether or not you thought of Venus as a metaphor.
Because of the rational man they take you for.
Also about why your poem ended with a plague,
The bodies heaped in the temples of the gods.
To disappear. First one, then a few, then hundreds,
Just stopping over here, to vanish in the marsh at dusk.
So easy, in imagination, to tell the story backward,
Because the earth needs a dream of restoration—
She dances and the birds just keep arriving,
Thousands of them, immense arctic flocks, her teeming life.

Poem with a Cucumber in It

Sometimes from this hillside just after sunset
The rim of the sky takes on a tinge
Of the palest green, like the flesh of a cucumber
When you peel it carefully.

✷

In Crete once, in the summer,
When it was still hot at midnight,
We sat in a taverna by the water
Watching the squid boats rocking in the moonlight,
Drinking retsina and eating salads
Of cool, chopped cucumber and yogurt and a little dill.

✷

A hint of salt, something like starch, something
Like an attar of grasses or green leaves
On the tongue is the tongue
And the cucumber
Evolving toward each other.

✷

Since *cumbersome* is a word,
Cumber must have been a word,
Lost to us now, and even then,
For a person feeling encumbered,
It must have felt orderly and right-minded
To stand at a sink and slice a cucumber.

✷

If you think I am going to make
A sexual joke in this poem, you are mistaken.

✷

In the old torment of the earth
When the fires were cooling and disposing themselves
Into granite and limestone and serpentine and shale,
It is possible to imagine that, under yellowish chemical clouds,
The molten froth, having burned long enough,
Was already dreaming of release,
And that the dream, dimly
But with increasing distinctness, took the form
Of water, and that it was then, still more dimly, that it imagined
The dark green skin and opal green flesh of cucumbers.

Drift and Vapor (Surf Faintly)

How much damage do you think we do,
making love this way when we can hardly stand
each other?—I can stand you. You're the rare person
I can always stand.—Well, yes, but you know what I mean.
—I'm not sure I do. I think I'm more lighthearted
about sex than you are. I think it's a little tiresome
to treat it like a fucking sacrament.—Not much of a pun.
—Not much. (She licks tiny wavelets of dried salt
from the soft flesh of his inner arm. He reaches up
to whisk sand from her breast.)—And I do like you. Mostly.
I don't think you can expect anyone's imagination
to light up over the same person all the time. (Sand,
peppery flecks of it, cling to the rosy, puckered skin
of her aureola in the cooling air. He studies it,
squinting, then sucks her nipple lightly.)—*Umnh.*
—I'm angry. You're not really here. We come
as if we were opening a wound.—Speak for yourself.
(A young woman, wearing the ochre apron of the hotel staff,
emerges from dune grass in the distance. She carries
snow-white towels they watch her stack on a table
under an umbrella made of palm fronds.)—Look,
I know you're hurt. I think you want me
to feel guilty and I don't.——I don't want you
to feel guilty.—What do you want then?
—I don't know. Dinner. (The woman is humming something
they hear snatches of, rising and fading on the breeze.)
—That's the girl who lost her child last winter.
—How do you know these things? (She slips
into her suit top.)—I talk to people. I talked
to the girl who cleans our room. (He squints

down the beach again, shakes his head.)
—Poor kid. (She kisses his cheekbone.
He squirms into his trunks.)

"... WHITE OF FORGETFULNESS, WHITE OF SAFETY"

My mother was burning in a closet.

Creek water wrinkling over stones.

Sister Damien, in fifth grade, loved teaching mathematics.
Her full white sleeve, when she wrote on the board,
Swayed like the slow movement of a hunting bird,
Egret in the tidal flats,
Swan paddling in a pond.

Let A equal the distance between x and y.

The doves in the desert,
Their cinnamon coverts when they flew.

People made arguments. They had reasons for their appetites.
A child could see it wasn't true.

In the picture of the Last Supper on the classroom wall,
All the apostles had beautiful pastel robes,
Each one the color of a flavor of sherbet.

A line is the distance between two points.

A point is indivisible.

Not a statement of fact; a definition.

It took you a second to understand the difference,
And then you loved it, loved reason,
Moving as a swan moves in a millstream.

I would not have betrayed the Lord
Before the cock crowed thrice,
But I was a child, what could I do
When they came for him?

Ticking heat, the scent of sage,
Of pennyroyal. The structure of every living thing
Was praying for rain.

I Am Your Waiter Tonight and My Name Is Dmitri

Is, more or less, the title of a poem by John Ashbery and has
No investment in the fact that you can get an adolescent
Of the human species to do almost anything (and when adolescence
In the human species ends is what The Fat Man in *The Maltese Falcon*
Calls "a nice question, sir, a very nice question indeed")
Which is why they are tromping down a road in Fallujah
In combat gear and a hundred and fifteen degrees of heat
This morning and why a young woman is strapping
Twenty pounds of explosives to her mortal body in Jerusalem.
Dulce et decorum est pro patria mori. Have I mentioned
That the other law of human nature is that human beings
Will do anything they see someone else do and someone
Will do almost anything? There is probably a waiter
In this country so clueless he wears a T-shirt in the gym
That says Da Meat Tree. Not our protagonist. American amnesia
Is such that he may very well be the great-grandson
Of the elder Karamazov brother who fled to the Middle West
With his girlfriend Grushenka—he never killed his father,
It isn't true that he killed his father—but his religion
Was that woman's honey-colored head, an ideal tangible
Enough to die for, and he lived for it: in Buffalo,
New York, or Sandusky, Ohio. He never learned much English,
But he slept beside her in the night until she was an old woman
Who still knew her way to the Russian pharmacist
In a Chicago suburb where she could buy sachets of the herbs
Of the Russian summer that her coarse white nightgown
Smelled of as he fell asleep, though he smoked Turkish cigarettes
And could hardly smell. Grushenka got two boys out of her body,
One was born in 1894, the other in 1896,
The elder having died in the mud at the Battle of the Somme

From a piece of shrapnel manufactured by Alfred Nobel.
Metal traveling at that speed works amazing transformations
On the tissues of the human intestine; the other son worked construction
The year his mother died. If they could have, they would have,
If not filled, half-filled her coffin with the petals
Of buckwheat flowers from which Crimean bees made the honey
Bought in the honey market in St. Petersburg (not far
From the place where Raskolnikov, himself an adolescent male,
Couldn't kill the old moneylender without killing her saintly sister,
But killed her nevertheless in a fit of guilt and reasoning
Which went something like this: since the world
Evidently consists in the ravenous pursuit of wealth
And power and in the exploitation and prostitution
Of women, except the wholly self-sacrificing ones
Who make you crazy with guilt, and since I am going
To be the world, I might as well take an ax to the head
Of this woman who symbolizes both usury and the guilt
The virtue and suffering of women induces in men,
And be done with it). I frankly admit the syntax
Of that sentence, like the intestines slithering from the hands
Of the startled boys clutching their belly wounds
At the Somme, has escaped my grip. I step over it
Gingerly. Where were we? Not far from the honey market,
Which is not far from the hay market. It is important
To remember that the teeming cities of the nineteenth century
Were site central for horsewhipping. Humans had domesticated
The race of horses some ten centuries before, harnessed them,
Trained them, whipped them mercilessly for recalcitrance
In Vienna, Prague, Naples, London, and Chicago, according
To the novels of the period which may have been noticing this
For the first time or registering an actual statistical increase
In either human brutality or the insurrectionary impulse
In horses, which were fed hay, so there was, of course,
In every European city a hay market like the one in which

Raskolnikov kissed the earth from a longing for salvation.
Grushenka, though Dostoyevsky made her, probably did not
Have much use for novels of ideas. Her younger son,
A master carpenter, eventually took a degree in engineering
From Bucknell University. He married an Irish girl
From Vermont who was descended from the gardener
Of Emily Dickinson, but that's another story. Their son
In Iwo Jima died. Gangrene. But he left behind, curled
In the body of the daughter of a Russian Jewish cigar maker
from Minsk, the fetal curl of a being who became the lead dancer
In the Cleveland Ballet, radiant Tanya, who turned in
A bad knee sometime in early 1971, just after her brother ate it
In Cao Dai Dien, for motherhood, which brings us
To our waiter, Dmitri, who, you will have noticed, is not in Baghdad.
He doesn't even want to be an actor. He has been offered
Roles in several major motion pictures and refused them
Because he is, in fact, under contract to John Ashbery
Who is a sane and humane man and has no intention
Of releasing him from the poem. You can get killed out there.
He is allowed to go home for his mother's birthday and she
Has described to him on the phone—a cell phone, he's
Walking down Christopher Street with such easy bearing
He could be St. Christopher bearing innocence across a river—
Having come across a lock, the delicate curl of a honey-
Colored lock of his great-grandmother's Crimean-
Honey-bee-pollen-, Russian-spring-wildflower-sachet-
Scented hair in the attic, where it released for her
In the July heat and raftery midsummer dark the memory
Of an odor like life itself carried to her on the wind.
Here is your sea bass with a light lemon and caper sauce.
Here is your dish of raspberries and chocolate; notice
Their subtle transfiguration of the colors of excrement and blood;
And here are the flecks of crystallized lavender that stipple it.

A Poem

"You would think God would relent," the American poet Richard
Eberhardt wrote during World War II, "listening to the fury of
aerial bombardment." Of course, God is not the cause of aerial
bombardment. During the Vietnam War, the United States hired the
RAND Corporation to conduct a study of the effects in the peasant
villages of Vietnam of their policy of saturation bombing of the
countryside. That policy had at least two purposes: to defoliate the
tropical forests as a way of locating the enemy and to kill the enemy if
he happened to be in the way of the concussion bombs or the napalm
or the firebombs. The RAND Corporation sent a young scholar named
Leon Goure to Vietnam. His study was rushed by the Air Force which
was impatient for results, but he was able to conduct interviews
through interpreters with farmers in the Mekong Delta and the
mountainous hillside farm regions around Hue. He concluded that the
incidental damage to civilian lives was very considerable and that the
villagers were angry and afraid, but he also found that they blamed the
Viet Cong—the insurrectionist army the U.S. was fighting—and not
the United States for their troubles, because they thought of the Viet
Cong as their legitimate government and felt it wasn't protecting them.
Seeing that the bombing was alienating the peasantry from the enemy
Vietnamese, Robert McNamara, the secretary of defense, General
William Westmoreland, the commander in charge of prosecuting the
war, and Lyndon Johnson, the president of the United States, ordered
an intensification of the bombing. In the end, there were more bombs
dropped on the villages and forests of South Vietnam than were
dropped in all of World War II. The estimated Vietnamese casualties
during the war is two million. It was a war whose principal strategy
was terror. More Iraqi civilians have now been incidental casualties of
the conduct of the war in Iraq than were killed by Arab terrorists in
the destruction of the World Trade Center. In the first twenty years
of the twentieth century 90 percent of war deaths were the deaths of

combatants. In the last twenty years of the twentieth century 90 percent of war deaths were deaths of civilians. There are imaginable responses to these facts. The nations of the world could stop setting an example for suicide bombers. They could abolish the use of land mines. They could abolish the use of aerial bombardment in warfare. You would think men would relent.

BUSH'S WAR

I typed the brief phrase, "Bush's War,"
At the top of a sheet of white paper,
Having some dim intuition of a poem
Made luminous by reason that would,
Though I did not have them at hand,
Set the facts out in an orderly way.
Berlin is a northerly city. In May
At the end of the twentieth century
In the leafy precincts of Dahlem-Dorf,
South of the Grunewald, near Krumme Lanke,
The northern spring begins before dawn
In a racket of birdsong, when the *amsels*,
Black European thrushes, shiver the sun up
As if they were shaking a great tangle
Of golden wire. There are two kinds
Of flowering chestnuts, red and white,
And the wet pavements are speckled
With petals from the incandescent spikes
Of their flowers; the shoes at U-Bahn stops
Are flecked with them. Green of holm oaks,
Birch tassels, the soft green of maples,
And the odor of lilacs is everywhere.
At Oskar-Helene-Heim station a farmer
Sells white asparagus from a heaped table.
In a month he'll be selling chanterelles;
In the month after that, strawberries
And small, rosy crawfish from the Spree.
The piles of stalks of the asparagus
Are startlingly phallic, phallic and tender
And deathly pale. Their seasonal appearance
Must be the remnant of some fertility ritual

Of the German tribes. Steamed, they are the color
Of old ivory. In May, in restaurants
They are served on heaped white platters
With boiled potatoes and parsley butter,
Or shavings of Parma ham and lemon juice
Or sprigs of sorrel and smoked salmon. And,
Walking home in the slant, widening,
Brilliant northern light that falls
On the new-leaved birches and the elms,
Nightingales singing at the first, subtlest
Darkening of dusk, it is a trick of the mind
That the past seems just ahead of us,
As if we were being shunted there
In the surge of a rattling funicular.
Flash forward: firebombing of Hamburg,
Fifty thousand dead in a single night,
"The children's bodies the next day
Set in the street in rows like a market
In charred chicken." Flash forward:
Firebombing of Tokyo, a hundred thousand
In a night. Flash forward: forty-five
Thousand Polish officers slaughtered
By the Russian Army in the Katyn Woods,
The work of half a day. Flash forward:
Two million Russian prisoners of war
Murdered by the German army all across
The eastern front, supplies low,
Winter of 1943. Flash: Hiroshima.
Flash: Auschwitz, Dachau, Theresienstadt,
The train lurching and the stomach woozy
Past the displays of falls of hair, the piles
Of monogrammed valises, spectacles. Flash:
The gulags, seven million in Byelorussia
And Ukraine. In innocent Europe on a night

In spring, among the light-struck birches,
Students holding hands. One of them
Is carrying a novel, the German translation
Of a slim book by Marguerite Duras
About a love affair in old Saigon. (Flash:
Two million Vietnamese, fifty-five thousand
Of the American young, whole races
Of tropical birds extinct from saturation bombing)
The kind of book the young love
To love, about love in time of war.
Forty-five million, all told, in World War II.
In Berlin, pretty Berlin, in the springtime,
You are never not wondering how
It happened, and these Germans, too,
Children then, or unborn, never not
Wondering. Is it that we like the kissing
And bombing together, in prospect
At least, girls in their flowery dresses?
Someone will always want to mobilize
Death on a massive scale for economic
Domination or revenge. And the task, taken
As a task, appeals to the imagination.
The military is an engineering profession.
Look at boys playing: they love
To figure out the ways to blow things up.
But the rest of us have to go along.
Why do we do it? Certainly there's a rage
To injure what's injured us. Wars
Are always pitched to us that way.
The well-paid newsreaders read the reasons
On the air. And the us who are injured,
Or have been convinced that we are injured,
Are always identified with virtue. It's
That—the rage to hurt mixed up

With self-righteousness—that's murderous.
The young Arab depilated himself as an act
Of purification before he drove the plane
Into the office building. It's not just
The violence, it's a taste for power
That amounts to contempt for the body.
The rest of us have to act like we believe
The dead women in the rubble of Baghdad,
Who did not cast a vote for their deaths
Or the raw white of the exposed bones
In the bodies of their men or their children,
Are being given the gift of freedom
Which is the virtue of the injured us.
It's hard to say which is worse, the moral
Sloth of it or the intellectual disgrace.
And what good is indignation to the dead?
Or our mild forms of rational resistance?
And death the cleanser, Walt Whitman's
Sweet death, the scourer, the tender
Lover, shutter of eyelids, turns
The heaped bodies into summer fruit,
Magpies eating dark berries in the dusk
And birch pollen staining sidewalks
To the faintest gold. *Balde nur*—Goethe—no,
Warte nur, balde ruhest du auch. Just wait.
You will be quiet soon enough. In Dahlem,
Under the chestnuts, in the leafy spring.

PEARS

My English uncle, a tall, shambling man, is very old
In the dream (he has been dead for thirty years)
And wears his hound's-tooth jacket of soft tweed.
Standing against one wall, he looks nervous, panicked.
When I walk up to him to ask if he's all right, he explains
In his wry way that he is in the midst of an anxiety attack
And can't move. I see that his hands are trembling. "Fault
Of Arthur Conan Doyle." I remembered the story.
He was raised among almond orchards on a ranch
In the dry, hot California foothills. Something
About reading a description of an illness—
Scarlet fever, I think (in the dream it was scarlet fever)—
And the illustration of a dying child, "the dew of death"
Spotting her forehead in the Edwardian etching—
Reading by oil lamp a book that his parents had brought
From Liverpool, the deep rural dark outside of winter
And night and night sounds at the turn of the last century—
He had cried out and hurled the book across the room.
He had told this story in an amused drawl (but not
In the dream, in my memory of a childhood summer
Which was not a dream, may not have been a dream)
In a canoe on the river, paddle in his hand, eyes
Looking past us at the current and the green surface
Of the water. "Agggh." He had imitated the sound—
I must have been six, the story not addressed to me—
And made the gesture of hurling with the stem of the paddle.
In the dream something had triggered this memory
And the paralyzing fear. I ask him how I can help.
"Just don't go away," he says, calling me "young Robert,"
As he did, as I remember he did. He takes my hand
And his helplessness in my dream—he was

The most competent of men, had served in the infantry
In the Meuse-Argonne—brings me, in the dream,
To tears. There is a view onto a garden from the upper room
Where he stands with his back pinned to the wall.
He has begun to weep, his shoulders shaking.
Now, outside the dream, I remember overhearing
Him describe the battle of —was it Belleau Wood?—
The Argonne forest??—as a butcher shop, also in his dry,
Slightly barking voice, and then he put down a card,
My parents and my aunt and he played bridge—
And said, "A very smoky butcher shop." Now,
Not in the dream, an image of the small cut glass dish
Into which my aunt put small festively colored candies
That were called "a bridge mix." And the memory
Of a taste like anise, like a California summer.
Though I don't know how I know it, I know
That there had been a long and lavish party
On the lawn outside which resembles, oddly,
The Luxembourg Gardens and, somewhere
In the dream, I notice, to my surprise, a bird,
Brilliantly yellow, a European goldfinch, perhaps,
Red in the wing tips, high up among the leaves
Of an espaliered pear tree, on which each of the pears
Has been wrapped in a translucent paper packet.
I experience my interest in the bird as irresponsible.
My uncle is holding my hand very tightly and I
Lean just a little to the left to see the bird more clearly—
I think it is red on the wing tips——and from that angle
I can see the child's body slumped under the pear tree,
And think, "Well, that explains his panic," and,
When I look again, the bird, of course, has flown.

THE DRY MOUNTAIN AIR

Our Grandma Dahling arrived from the train station
In a limousine: an old Lincoln touring car
With immense, black, shiny, rounded fenders
And a silver ornament of Nike on the hood.
She wore a long black coat and pearl-gray gloves.
White hair, very soft white, and carefully curled.
Also rimless glasses with thin gold frames.
Once in the house, having presented ourselves
To be hugged completely, the important thing
Was to watch her take off her large, black,
Squarish, thatched, and feathered confection of a hat.
She raised both hands above her head, elbows akimbo,
Lifting the black scrim of a veil in the process,
Removed a pin from either side, and lifted it,
Gingerly, straight up, as if it were a saucer of water
That I must not spill, and then she set it down,
Carefully, solicitously even, as if it were a nest
Of fledgling birds (which it somewhat resembled),
And then there arrived, after she had looked at the hat
For a moment to see that it wasn't going to move,
The important thing. Well, she would say, well, now,
In a musical German-inflected English, touching together
Her two soft, white, ungloved hands from which emanated
The slightly spiced, floral scent of some hand lotion
That made the hands of great-grandmothers singularly soft,
And regard us, and shake her head just a little, but for a while,
To express her wonder at our palpable bodies before her,
And then turn to her suitcase on the sea chest in the hall,
Not having been transferred yet to her bedroom by my father
Who had hauled it up the long, precipitous front stairs;
She flipped open the brass clasps and the shield-shaped lock

She had not locked and opened the case to a lavender interior
From which rose the scent of chocolate, mingled faintly
With the smell of anise from the Christmas cookies
That she always baked. But first were the paper mats
From the dining car of the California Zephyr, adorned
With soft pastel images of what you might see
From the Vista Car: Grand Canyon, Mount Shasta,
A slightly wrinkled Bridal Veil Falls, and, serene, contemplative
Almost, a view of Lake Louise, intimate to me because,
Although it was Canadian, it bore my mother's name.
My brother and I each got two views. He, being the eldest,
Always took Grand Canyon, which I found obscurely terrifying
And so being second was always a relief. I took Lake Louise
And he took Half Dome and the waterfall, and she looked surprised
That we were down to one and handed me the brooding angel,
Shasta. And then from under layers of shimmery print dresses,
She produced, as if relieved that it wasn't lost, the largest chocolate bar
That either of us had ever seen. Wrapped in dignified brown paper,
On which ceremonial, silvery capital letters must have announced—
I couldn't read—the sort of thing it was. These were the war years.
Chocolate was rationed. The winey, dark scent rose like manna
In the air and filled the room. My brother, four years older,
Says this never happened. Not once. She never visited the house
On Jackson Street with its sea air and the sound of foghorns
At the Gate. I thought it might help to write it down here
That the truth of things might be easier to come to
On a quiet evening in the clear, dry, mountain air.

First Things at the Last Minute

The white-water rush of some warbler's song.
Last night, a few strewings of ransacked moonlight
On the sheets. You don't know what slumped forward
In the nineteen-forties taxi or why they blamed you
Or what the altered landscape, willowy, riparian,
Had to do with the reasons why everyone
Should be giving things away, quickly,
From a spendthrift sorrow that, because it can't bear
The need to be forgiven, keeps looking for something
To forgive. The motion of washing machines
Is called agitation. Object constancy is a term
Devised to indicate what a child requires
From days. Clean sheets are an example
Of something that, under many circumstances,
A person can control. The patterns moonlight makes
Are chancier, and dreams, well, dreams
Will have their way with you, their way
With you, will have their way.

POET'S WORK

1.

You carry a saucer of clear water,
Smelling faintly of lemon, that spills
Into the dark roots of what
Was I saying? Hurt or dance, the stunned
Hours, arguments for and against:
There's a tap here somewhere.

2.

This dream: on white linen, in the high ceiling'd room,
Marie and Julia had spread baskets of focaccia,
A steaming zucchini torte, ham in thin, almost deliquescent slices,
Mottled ovals of salami, around a huge bowl in which chunks of crab-
meat,
With its sweet, iodine smell of high tide, were strewn
Among quarter moons of sun-colored tomatoes and lettuce leaves
Of some species as tender-looking as the child's death had been.

3.

If there is a way in, it may be
Through the corolla of the cinquefoil
With its pale yellow petals,
In the mixed smell of dust and water
At trailside in the middle reaches of July.
Soft: an almost phospher gleam in twilight.

MOUTH SLIGHTLY OPEN

The body a yellow brilliance and a head
Some orange color from a Chinese painting
Dipped in sunset by the summer gods
Who are also producing that twitchy shiver
In the cottonwoods, less wind than river,
Where the bird you thought you saw
Was, whether you believe what you thought
You saw or not, and then was not, had
Absconded, leaving behind the emptiness
That hums a little in you now, and is not bad
Or sad, and only just resembles awe or fear.
The bird is elsewhere now, and you are here.

OLD MOVIE WITH THE SOUND TURNED OFF

The hatcheck girl wears a gown that glows;
The cigarette girl in the black fishnet stockings
And a skirt of black, gauzy, bunched-up tulle
That bobs above the pert muffin of her bottom,
She must be twenty-two, would look like a dancer
In Degas except for the tray of cigarettes that rests
Against her—*tummy* might have been the decade's word,
And the thin black strap which binds it to her neck
And makes the whiteness of her skin seem swan's-down
White. Some quality in the film stock that they used
Made everything so shiny that the films could not
Not make the whole world look like lingerie, like
Phosphorescent milk with winking shadows in it.
All over the world the working poor put down their coins,
Poured into theaters on Friday nights. The manager raffled—
"Raffled off," we used to say in San Rafael in my postwar
Childhood into which the custom had persisted—
Sets of dishes in the intermission of the double feature—
Of the kind they called Fiestaware. And now
The gangster has come in, surrounded by an entourage
Of prizefighters and character actors, all in tuxedos
And black overcoats—except for him. His coat is camel
(Was it the material or the color?—my mind wanders
To earth-colored villages in Samara or Afghanistan).
He is also wearing a white scarf which seems to shimmer
As he takes it off, after he takes off the gray fedora
And hands it to the hatcheck girl. The singer,
In a gown of black taffeta that throws off light
In starbursts, wears black gloves to her elbows
And as she sings, you sense she is afraid.

Not only have I seen this film before—the singer
Shoots the gangster just when he thinks he's been delivered
From a nemesis involving his brother, the district attorney,
And a rival mob—I know the grandson of the cigarette girl,
Who became a screenwriter and was blackballed later
Because she raised money for the Spanish Civil War.
Or at least that's the story as I remember it, so that,
When the gangster is clutching his wounded gut
And delivering a last soundless quip and his scarf
Is still looking like the linen in Heaven, I realize
That it is for them a working day and that the dead
will rise uncorrupted and change into flannel slacks,
Hawaiian shirts; the women will put on summer smocks
Made from the material superior dish towels are made of
Now, and they'll all drive up to Malibu for drinks.
All the dead actors were pretty in their day. Why
Am I watching this movie? you may ask. Well, my beloved,
Down the hall, is probably laboring over a poem
And is not to be disturbed. And look! I have rediscovered
The sweetness and the immortality of art. The actress
Wrote under a pseudonym, died, I think, of cancer of the lungs.
So many of them did. Far better for me to be doing this
(A last lurid patch of fog out of which the phrase "The End"
Comes swimming; the music I can't hear surging now
Like fate) than reading with actual attention my field guides
Which inform me that the flower of the incense cedar I saw
This morning by the creek is "unisexual, solitary, and terminal."

EZRA POUND'S PROPOSITION

Beauty is sexual, and sexuality
Is the fertility of the earth and the fertility
Of the earth is economics. Though he is no recommendation
For poets on the subject of finance,
I thought of him in the thick heat
Of the Bangkok night. Not more than fourteen, she saunters up to you
Outside the Shangri-la Hotel
And says, in plausible English,
"How about a party, big guy?"

Here is more or less how it works:
The World Bank arranges the credit and the dam
Floods three hundred villages, and the villagers find their way
To the city where their daughters melt into the teeming streets,
And the dam's great turbines, beautifully tooled
In Lund or Dresden or Detroit, financed
By Lazard Frères in Paris or the Morgan Bank in New York,
Enabled by judicious gifts from Bechtel of San Francisco
Or Halliburton of Houston to the local political elite,
Spun by the force of rushing water,
Have become hives of shimmering silver
And, down river, they throw that bluish throb of light
Across her cheekbones and her lovely skin.

ON VISITING THE DMZ AT PANMUNJON:
A HAIBUN

The human imagination does not do very well with large numbers.
More than two and a half million people died during the Korean War. It
seems that it ought to have taken more time to wreck so many bodies.
Five hundred thousand Chinese soldiers died in battle, or of disease. A
million South Koreans died, four fifths of them civilians. One million
one hundred thousand North Koreans. The terms are inexact and
thinking about them can make you sleepy. Not all "South Koreans"
were born in the south of Korea; some were born in the north and went
south, for reasons of family, or religion, or politics, at the time of the
division of the country. Likewise the "North Koreans." During the war
one half of all the houses in the country were destroyed and almost all
industrial and public buildings. Pyongyang was bombarded with one
thousand bombs per square kilometer in a city that had been the home
to four hundred thousand people. Twenty-six thousand American
soldiers died in the war. There is no evidence that human beings have
absorbed these facts, which ought, at least, to provoke some communal
sense of shame. It may be the sheer number of bodies that is hard to
hold in mind. That is perhaps why I felt a slight onset of nausea as we
were moved from the civilian bus to the military bus at Panmunjon.
The young soldiers had been trained to do their jobs and they carried
out the transfer of our bodies, dressed for summer in the May heat,
with a precision and dispatch that seemed slightly theatrical. They
were young men. They wanted to be admired. I found it very hard
to describe to myself what I felt about them, whom we had made our
instrument.

The flurry of white between the guard towers
 —river mist? a wedding party?
is cattle egrets nesting in the willows.

CONSCIOUSNESS

First image is blue sky, nothing in it, and not understood as sky, a field of blue.

The second image is auditory: the moan of a foghorn.

We had been arguing about the nature of consciousness, or avoiding arguing, talking.

Dean had read a book that said that consciousness was like a knock-knock joke, some notion of an answering call having brought it into being which was, finally, itself anticipating an answer from itself, echo of an echo of an echo.

My mind went seven places at once.

One place was a line of ridge somewhere in a dry Western landscape just after sundown, I saw a pair of coyotes appear suddenly on the ridge edge and come to a loping stop and sniff the air and look down toward a valley in the moonlight, tongues out in that way that looks to us like happiness, though it isn't necessarily; I suppose they were an idea of mammal consciousness come over the event horizon in some pure form, hunter-attention, life-in-the-body attention.

CD said human consciousness shows up in the record as symbolic behavior toward the dead.

My mind also went to Whitman, not interested, he said, in the people who need to say that we all die and life is a suck and a sell and two plus two is four and nothing left over.

I think I respond with such quick hostility to anything that smells like reductionist materialism because it was my father's worldview.

"Bobby," he was sitting in a chair on the porch of the old house on D Street, "it's a dog-eat-dog world out there." I was drawing with crayons on the stairs. Across the street the Haleys' collie Butch was humping the McLaughlins' collie Amanda on the Mullens' front lawn, their coats shuddering like a wheat field in August.

Those stairs: there were five of them. I took three in a leap, coming home from school, and then four, and one day five, and have complicated feelings about the fact that it was one of the vivid pleasures of my life.

When I came into the room where he was dying of cancer, my father gave me a look that was pure plea and I felt a flaring of anger. What was I supposed to do? He was supposed to teach me how to die.

And a few minutes later when he was dead, I felt such a mix of love and anger and dismay and relief at the sudden peacefulness of his face that I wanted to whack him on the head with his polished walnut walking stick which was standing against the wall in a corner like the still mobile part of him.

My mind also went to Paris, steam on summer mornings rising off the streets the municipal workers had watered down at the corner of rue de l'Ecole Médicine and rue Dupuytren, I suppose because that city is a product, among other things, of human consciousness, and whatever else it is, it isn't a knock-knock joke.

My grandmother used to say what a good baby I was, that they would put me in a crib on the roof of the house on Jackson Street in the sunlight and the smell of sea air from the Golden Gate and that I never cried; they'd check to see if I was sleeping and I wasn't; my eyes would be wide open, I seemed to be content to lie there looking at the sky.

So I think that first image of consciousness in my consciousness is not the memory of a visual perception but the invention of the image of a visual perception—the picture of a field of pure blue—that came into my head when my grandmother told me that story.

Outside the sound of summer construction starting up. From my window I see a chickaree come out of the dry grasses, pale gold in the early morning light, and raise little puffs of dust as it bounds across the road, going somewhere, going about its chickaree business, which at this season must be mostly provision.

It was years before I understood that my father was telling his young son that he hated the job he had to go to every day.

It's hard to see what you're seeing with, to see what being is as an activity through the instrument of whatever-it-is we have being in.

Consciousness, "that means nothing," Czesław wrote. "That loves itself," George Oppen wrote. My poor father.

Exit, Pursued by a Sierra Meadow

That slow, rhythmic flickering of the wings,
As if from the ache of pleasure—
A California tortoiseshell
Fastened to the white umbel of a milkweed stalk.

Smell of water in the dry air,
The almost nutmeg smell of dust.

White fir, Jeffrey pine,
I have no way of knowing whether you prefer
Summer or winter,
Though I think you are more beautiful in winter.

Scarlet fritillary, corn lily,
I don't know which you prefer, either.
So long, horsemint,
Your piebald mix of lavender and soft gray-green under the cottonwoods
On a shelf of lichened granite near a creek
May be the most startling thing in these mountains,
Besides the mountains.
It's good that we stopped just a minute
To look at you and then walked down the trail
Because we had things to do
And because beauty is a little unendurable,
I mean, getting used to it is unendurable,
Because if we can't eat a thing or do something with it,
Human beings get bored by almost everything eventually,
Which is why winter is such an admirable invention.
There's another month of summer here.
August will squeeze the sweetness out of you
And drift it as pollen.

SEPTEMBER, INVERNESS

Tomales Bay is flat blue in the Indian summer heat.
This is the time when hikers on Inverness Ridge
Stand on tiptoe to pick ripe huckleberries
That the deer can't reach. This is the season of lulls—
Egrets hunting in the tidal shallows, a ribbon
Of sandpipers fluttering over mudflats, white,
Then not. A drift of mist wisping off the bay.
This is the moment when bliss is what you glimpse
From the corner of your eye, as you drive past
Running errands, and the wind comes up,
And the surface of the water glitters hard against it.

Notes and Acknowledgments

"Palo Alto: The Marshes"
Mariana Richardson was the daughter of William Richardson, a sailor from Liverpool who became the first harbormaster of San Francisco Bay and married the daughter of a Mexican officer at the Presidio. The story of John Frémont's order to Kit Carson to execute Sr. Berryessa and the de Haro brothers can be found in a number of accounts of "the Bear Flag Revolt," one of the earliest accounts of which is Josiah Royce's *California*. There are also a number of accounts of the destruction of the Klamath fishing village of Dokdokwass near what is now the Oregon-California border. A recent one is by Hamilton Sides, *Blood and Thunder*, 2006. Frémont and Carson undertook the massacre and the burning of the village as revenge for attacks on their party. Historians have established that they attacked the Klamaths by mistake for harryings against them carried out by young men of a nearby Modoc tribe. I first read the story when the U.S. Army was doing the same thing to villages in Vietnam.

"Concerning the Afterlife, the Indians of Central California Had Only the Dimmest Notions"
 The title is taken from a sentence in Hubert Bancroft's *History of California*, 1889.

"Like Three Fair Branches From One Root Deriv'd"
A description of the three graces in *The Faerie Queen*. The book I was reading at the time, which seemed to help with the subjects of desire and beauty and sexuality, was Edgar Wind's *Pagan Mysteries in the Renaissance*, 1968, a study of, among other things, the neo-Platonist symbolism in Pre-Raphaelite painting.

"Santa Lucia"
Santa Lucia is the name of the virgin saint and martyr to whom several
early Christian legends are attached, and also the name of a mountain
range on the central California coast. There is, in the Mission Santa
Ynez near Santa Barbara, a Native American painting of a young
Indian-looking St. Lucy offering her plucked-out eyes to the viewer on
a small plate, something the legendary St. Lucy was said to have done
to the Roman patrician who wished to force her into marriage.

"*Rusia en 1931*"
is the original title of a book about the Soviet Union published in
Paris in 1931 by César Vallejo. The archbishop is the Reverend Oscar
Romero. Since this poem was written, his assassination has been clearly
linked to El Salvador's right-wing death squads.

"Santa Lucia II "
See the note on "Santa Lucia. " I seem to have imagined the speaker as
a woman professionally involved with art.

"Berkeley Eclogue"
The phrase "a century of clouds" is borrowed, of course, from
Guillaume Apollinaire, but also from a book of stories with that title
by Bruce Boone, published by Black Star Press.

"Dragonflies Mating"
Jaime de Angulo was a well-known folklorist and collector of native
California myths and stories. I owe this story about him to my friend
Malcom Margolin.

"Regalia for a Black Hat Dancer"
The shrine of the Buddha of Sokkaram is situated on a mountaintop
near Kyongju, forty miles inland from Pusan and the site of one of
Korea's oldest Buddhist monasteries.